THE ARTS AND PUBLIC POLICY
IN THE UNITED STATES

 The American Assembly, *Columbia University*

THE ARTS
AND PUBLIC POLICY
IN THE UNITED STATES

Prentice-Hall, Inc., *Englewood Cliffs, New Jersey* A SPECTRUM BOOK

Library of Congress Cataloging in Publication Data
Main entry under title:

THE ARTS AND PUBLIC POLICY IN THE UNITED STATES.

Background papers for the 67th American Assembly
held at Arden House, Harriman, N.Y., May 31-June 3, 1984.
"A Spectrum Book."
Includes index.
1. United States—Cultural policy—Addresses, essays,
lectures. 2. Art and state—United States—Addresses,
essays, lectures. 3. Art patronage—United States—
Addresses, essays, lectures. I. American Assembly.
NX730.A775 1984 700'.79 84-17686
ISBN 0-13-047697-8
ISBN 0-13-047689-7 (pbk.)

NX730
A775
1984
cop. 2

This book is available at a special discount when ordered in bulk quantities. Contact Prentice-Hall, Inc., General Publishing Division, Special Sales, Englewood Cliffs, N. J. 07632.

Excerpts on pages 82, 83, 85, and 89 from *Selected Letters of P. T. Barnum,* edited by A. H. Saxon (New York: Columbia University Press, 1983) are used by permission of A. H. Saxon.

Editorial/production supervision by Betty Neville
Cover design © 1984 by Jeannette Jacobs
Manufacturing buyers: Edward Ellis and Anne Armeny

10 9 8 7 6 5 4 3 2 1

ISBN 0-13-047697-8

ISBN 0-13-047689-7 {PBK.}

PRENTICE-HALL INTERNATIONAL, INC. *(London)*
PRENTICE-HALL OF AUSTRALIA PTY. LIMITED *(Sydney)*
PRENTICE-HALL OF CANADA, INC. *(Toronto)*
PRENTICE-HALL OF INDIA PRIVATE LIMITED *(New Delhi)*
PRENTICE-HALL OF JAPAN, INC. *(Tokyo)*
PRENTICE-HALL OF SOUTHEAST ASIA PTE. LTD. *(Singapore)*
WHITEHALL BOOKS LIMITED *(Wellington, New Zealand)*
EDITORA PRENTICE-HALL DO BRASIL LTDA. *(Rio de Janeiro)*

Table of Contents

v

Preface

As a nation that has taken pride in pragmatism, the United States has always found it rather difficult to establish the proper place for the arts in its constellation of public values. While other governments have had their ministries of culture and have decreed national policies with respect to the arts, our political leaders have generally shied away from attempts to define an American public policy toward the arts.

Nevertheless, the arts have flourished in our society, and our artists have come to be recognized as among the foremost in the world in almost all media of artistic expression. It is therefore apparent that the mix of influences and inspirations that has nourished art in this country has a tangible vitality that constitutes a public policy. It is also clear that artists and the arts have assumed important roles in our national culture.

In some measure, these developments have been accelerated by the fact that our several levels of government have, in recent years, established funding support for the arts and for education in the arts. However, in relative terms, governmental financial support for the arts has been but a fraction of the entire reservoir of philanthropy, private patronage, and corporate contributions that reflect the pluralism of our political, economic, and social systems.

In order to achieve a definition of the factors that constitute public policy in the United States with respect to the arts, to locate the arts in our system of national values, and to assess the public and private actions that would make the status of the arts more secure in our society, The American Assembly convened a meeting at Arden House, Harriman, New York from May 31 to June 3, 1984. Participants represented government, business, universities, foundations, and associations; the performing, graphic, plastic, and literary arts; artistic direction and administration; and patrons of the arts and critics. In preparation for that meeting, The American Assembly retained W. McNeil Lowry, formerly of The Ford Foundation, as editor and director of the undertaking. Under his editorial supervision, back-

ground papers on various aspects of the arts and public policy were prepared and read by the participants in the Arden House discussions. These papers used by the participants have been compiled into the present volume, which is published as a stimulus to further thinking and discussion on this subject.

The participants, in the course of their deliberations, achieved a substantial consensus on recommendations for public policy. The text of their report is appended to the text of these papers. Additional copies can be obtained by writing directly to The American Assembly, Columbia University, New York, New York 10027.

Funding for this project was provided by The Ford Foundation, The Rockefeller Foundation, The Mary Duke Biddle Foundation, The L. J. Skaggs and Mary C. Skaggs Foundation, and The New York Community Trust. The opinions expressed in this volume are those of the individual authors and not necessarily those of the sponsors nor of The American Assembly, which does not take stands on the issues it presents for public discussion.

William H. Sullivan
President
The American Assembly

W. McNeil Lowry

1

Introduction

To most Americans who might give it any thought, it would not appear a good idea to have a public policy in the arts that was official. And the United States has none. If there indeed exists public policy about the arts, which even many in the field are not clear about, it is the product of plural influences, and government is only a most recent, if vivid, example.

In this volume we shall examine the question whether the United States has a public policy (or cluster of policies) about the arts, reconstruct how we got where we are, and, understanding that, if we can, ask ourselves where we should now be headed.

Plural Influences

No policy in any field is truly coherent or consensual, and a policy is not inherently a manifesto. What we may really be digging for are clues to the values placed on the arts by society.

Compare on this score the arts with education. It is fairly clear that the American society has always assumed the values of education even long before there could be said to be a public, let alone a federal, policy in that field. Certainly the substance

W. McNEIL LOWRY, *since retiring as vice president, Division of Humanities and the Arts, the Ford Foundation, has remained involved in the development of public attitudes and policies in these fields. The first part of his chapter was adapted from his article in* The Journal of Arts Management and Law, *Vol. 13, No. 1, 1983.*

and the quantity of press and television coverage of education even today assume that it is a subject not only of importance but of interest to the nation. Yet even after two centuries American officials today can show how pitifully thin is their knowledge of policies about schools and colleges, their evolution and the distribution of responsibilities for their development.

To call a policy "public" does not negate the influence of individuals on it, whether artists or patrons or philanthropists or merely a few motivated laypeople in a voluntary society. Public policy may simply be policy that has impact in public, and whether in education, in the arts, in health, or in other fields, we may be more strictly speaking about a set of influences. What we need to distinguish are the sources of influence and how they have interacted in American cultural history.

THE COMPONENTS IN THE ARTS

Influences on public policy, in the arts as in other fields, originate with those who either afford support to particular activities or who, while doing so, both choose what to support and explain their objectives. Public policy in the arts is national, though neither federal nor official, but a pluralism of private and governmental. Today the pluralistic components include private patrons; philanthropic foundations; business corporations; federal, state, and local governments; and the influences of the marketplace. They also, under optimal circumstances, include artists and artistic directors, whose influence on decision making is crucial in converting any infusion of financial resources into principles or policies about creativity and creative resources in the United States.

Voluntary societies, whose importance to the American republic has so long been recognized, made the first organized commitments to the arts. In 1804 a group of artists and their friends in Philadelphia collected works of art to aid in the training of painters and sculptors. Retrospectively the Pennsylvania Academy of Fine Arts, though established more than a century before income and inheritance taxes, has become a symbol of what later was legalized as the tax-exempt corporation. And it was the tax-exempt corporation which enabled artists and artistic directors to take the lead in developing companies and institutions.

Prior to the First World War, private patronage was restricted to those wealthy enough to contribute directly from their incomes. Indeed, some dominant patrons literally owned opera companies, symphonic orchestras, even museums. At the end of the nineteenth and the beginning of the twentieth centuries, there was no great distinction between a Kahn or a Higginson and commercial entrepreneurs except the presumed taste of the audiences at which they aimed. In the decades just before the advent of the automobile and of moving pictures, even small hamlets across the continent, provided they were located on main railway lines, saw such luminaries as Adelina Patti, Sarah Bernhardt, and Oscar Wilde.

In 1913 and 1916, inheritance and income tax legislation became the means of widening the number of private patrons beyond the very rich. Neither President Wilson nor the Congress saw the legislation as a historic commitment to the arts, however. Its language referred to educational, scientific, and charitable activities but not to artistic or cultural.

Following the establishment of the inheritance tax, more great personal fortunes became the endowments of national philanthropic foundations. In the main, these again looked at the arts as a means to education, or even as frivolous and unworthy objects of the philanthropic dollar. Prior to the midpoint of the century this began to change, but conspicuously only after 1957 and the multimillion dollar program of artistic patronage from the Ford Foundation. A change in the taxes on excess profits of corporations at least made possible something of the same result. Corporations took advantage of the new provisions only very slowly, and education and health were the beneficiaries. Only in the 1970s did corporations begin to pay more attention to the arts.

ELEVATION OF PUBLIC TASTE

In 1807 the architect Benjamin Latrobe dedicated the building for the Pennsylvania Academy. He emphasized that art was an indispensable element in a democracy, serving both to elevate public taste and to celebrate the free atmosphere of the new United States. It is significant that the collection of works of art was originally aimed at their function in the training of painters and sculptors. The art academy and the public display of works of art were united, and as the late Joshua Taylor observed, "This

duality of purpose, to provide education through the eyes or
creative activity for the hands . . . still presents itself as a problem
to the American art museum."

DUALITY OF PURPOSE

He might have added that it also foreshadowed the duality in
cultural policy in the public sector, which more readily accepted
primary obligation to the viewing public than one to the local
painter or to the profession of curatorship when that began to
emerge. The first use of tax funds for patronage of the arts was
municipal, frequently in modest annual grants to a museum
either for maintenance of a building or waivers of ad valorem
taxes on its site. It is when government rather than private
patronage is at stake that pressures toward the mass diffusion of
culture begin to affect the operations, the practices, and even
the concept of an art museum. True, the idea of art's having a
moral and aesthetic existence of its own had become a public
cliché in America before the establishment of our greatest mu-
seums in the 1870s. But it had motivated artists and patrons rather
than government officials. Museums did not depend upon it for
their fiscal foundations. In the last decade all of them have been
forced to deal with rubrics about the "accessibility" of the arts,
the "broad dissemination of cultural resources," and the "en-
hancement of the quality of life" of our nation—generalized
objectives of the National Endowment for the Arts (NEA) with
which institutions in the arts must somehow cope. The govern-
ment's approach, in turn, affects large corporations. Like the city
fathers of a century ago, they find it easier, as well as more product
oriented, to think of the viewing public rather than of the artist
or of the museum professional. And that approach has also
largely characterized their use of the performing arts.

Even in so brief and summary a statement of our subject, we
can identify the pluralistic influences. The United States possesses
a public policy about the arts and cultural affairs, and we can
see its impact all about us. Whether it is a national rather than
a public policy depends upon a clear understanding that it is not
controlled or expressed by federal agencies, which even in the
legislation mandating their existence are clearly placed in the
pluralistic complex traditional in American society and are as
clearly subordinated to it.

Motivation and Objective

What are some of the motives and objectives natural to the identifiable components within the complex?

Even at that end of the historical spectrum when the private patron was all, art was also justified as an indispensable element in a democracy, serving both to elevate public taste and to celebrate freedom in the new Republic. In their own building of a private collection, some patrons had a second motive, the presentation or bequest of art for education and enlightenment of the citizenry, and this was policy, whether objective or patronizing. In short, it did not wait for governmental agencies to discover a cultural policy using art as a means to education or enlightenment. The motive was buried deep in the origins of American society. The critic George Steiner has reminded us of "the great Jeffersonian hope . . . [with] its crystalline power and dignity [that] as we learn more, as our imagination becomes more educated, certain kinds of bestiality won't be possible to us anymore."

THE ARTISTIC PROCESS

Private patronage, even in unorganized and individual expression, consciously or unconsciously embodied another motive in cultural policy, what I shall term here the artistic process. This criterion remains difficult to define when we are in the realm of motivation. Words like "excellence" or even "quality" suffer, of course, from subjectivity and invite meaningless antitheses between "high art" and "popular art." But whatever the semantics, what is meant is that many works of art and many artists somehow set standards of comparison for others. Professionalism is both the goal and the bench mark, and no matter what the style or the medium employed, craft and technique and process are recognizable. This is as true of the most "modern" or "experimental" work as of the most "classical": the distinction is not historical or temporal.

However difficult to label, the artistic process as an identifiable motive and objective within public policy is at the heart of the whole complex. It distinguishes not only between one work of art and another, one set of aesthetic values and another, but in practice also between the commercial producer fashioning a single

artifact and the nonprofit artistic institution. As this volume hopefully will reflect, economic, political, and social forces peculiar to the United States transformed the voluntary society into the tax-exempt corporation. The same forces permitted this mechanism to develop in response to the objectives of the artists themselves. In practice, patrons—single and later organized or institutional—make a catalytic use of the artists' objectives as a guide to philanthropy. When the patrons observe that the nonprofit institution exists only for the continuous creation, display, or performance of works of art, they are reassured as to their philanthropic choices and their social utility. When they help a Broadway or Hollywood producer subsidize a single production, they are well aware that they gamble for a gain or a loss on their tax returns, either one of which may profit them in a given year. The opportunities to enrich the creative repertoire and to train artists in many fields account for so many nonprofit theatre companies today, though their total cost to policy and patronage (normally about 30 percent of their expenditures) is vastly exceeded by the cost of tax write-offs each year made for commercial producers. The sharp dividing line between the commercial artifact and the process of the nonprofit institution permeates every aspect of American culture. For example, in chapter 4, Paul DiMaggio explains that foundation, government, and corporate support of the arts, like the patronage of individuals, helps to shelter nonprofit arts institutions from many effects of the marketplace, but by virtue of being more organized in their policies, these supporters actually increase other market pressures. The justification for both the subsidy and the influence is one and the same—the nonprofit organization's dedication to the artistic process.

OTHER MOTIVES OF POLICY

In summary then of the earliest motives and objectives natural to the various influences on policy, we have seen that the private patron both looked upon art as elevating public taste and sought to associate patronage somehow with the artistic process. What have been other motives within the complex?

The opportunities of people to have daily experience of art, to have access to it, to participate in its creation and performance, were objects of patronage before government agencies made

them central. Government's heavy concentration on this democratic and popular service, increasing in the 1970s, has indirectly impinged on all other elements in cultural policy and on other important sources of financial support.

The preservation and conservation of works and monuments of art, sometimes defined to include standard or classical repertoire in the performing arts, make another cultural policy natural to any society, young or old, and have motivated all resource bases from the private patron to the government agency. For some institutional donors and some individuals this means of approaching the arts appears less controversial than supporting living artists or new artistic ventures.

NEW REPERTOIRE

On the other hand, the value of experimentation and the creation of new repertoire have in the past generation been a dominant motive for many private patrons and national foundations and forced itself, though with attendant difficulties, upon public agencies. Since many new works of art, for example, operas and symphonies and new buildings, have no existence except in performance or actuality, heavy tolls upon available resources have to be accepted not only by the donors but by the performing or exhibiting group. Many other experiments in new repertoire, normally with more modest expenditures, sometimes occasion only a brief happening. In our early history, when art in America was almost totally derivative of European models, the only artists who felt free of alienation may have been those, primarily plastic artists, whose works were bought before they were created.

THE ARTS AS PROFESSIONS

A new value in cultural policy, arguable only in the objectives of the most convinced of the national sources, is the importance of the arts as professions or would-be professions of many persons who believe they have a social function equivalent to that of other skilled and unskilled workers. A fixed dilemma in America's commitment to the arts is that on the one hand, both art and the artist can be made to appear as secondary to another goal—education, social uplift, urban renewal, tourism—while on the other, the artist himself or herself is often led to feel an alien in a

materialistic society. In a young country proclaiming a manifest destiny blessed by Providence, the theme of alienation emerged surprisingly early. I think we can risk saying that at this much later era in our history, there has been a change. In these complex and perilous times, the arts possess an immediacy perhaps no other of the humanities can quite reach. I believe that this power had its increment in the larger and larger audiences. There is scarcely any external source of motivation comparable to a feeling of being needed, of having a use, and creators, performers, directors, and managers begin to feel that.

Finally and obviously, a value underlying the evolution of cultural policy in the United States is pluralism and diversity itself. Free expression and protection of the free marketplace of ideas are not ideals upon which any country has a patent. But they were vital to the goals of the American Republic as it was conceived, as were the multiple cultures on which it was forged and to which it opened itself. Perhaps no other country has a better opportunity to test whether common cultural values can be discovered while supporting the expression, and protecting the identity, of ethnic, national, religious, and social traditions enriching society from almost every culture known to the world.

The Need for Definitions

Perhaps only in the last decade have most professionals in the arts realized they could not leave policy, or even advocacy, to lay perceptions. They began to realize that not only the need to justify contributed income but the mission of a cultural institution, even its governance, are in one way or another affected by principles and policies that cannot be taken for granted. When one understands that the artistic institution devotes all its resources to the process, one is often thought to be making only a qualitative judgment. The point lies much deeper than that. The artistic process rests upon choices, and choices are everywhere *in* the process. Creation itself is an exercise of choice. Choices of standards, of craft, and of technique define all that artists do. Artists create both themselves and their artifacts through their choices, most of them conscious, some of them not. The training of artists and scholars depends upon standards they are free to choose. The growth and expansion of cultural

groups devoted to process have in our time greatly extended opportunities for apprenticeship. And to come to full circle, it should be noted that when artistic professionals are the spokespersons, the concentration on quality, on professional standards of training, and on creative repertoire remains the chief justification for patronage and subsidy, no matter how many other justifications—social, educational, or economic—are given importance.

Voluntary Societies

Even such a general inventory of objectives and motives on the part of private and public influences upon the arts reemphasizes a pluralistic pattern. The first elements were private; it was as individuals that persons voluntarily came together in the name of music, art, and literature. When the efforts of one of these voluntary societies produced something palpable to civic pride in a community, there might be an early, if quite modest, public element in the mix. But for a long and even now unending period, the private patronage of individuals dominated the whole scene. It was, moreover, their influence that was largely felt whenever local school systems or city councils were moved to expend a few dollars to enhance the experience of young people outside the formal classroom. Though almost none of the Founding Fathers even in principle attached responsibility for support of the arts to the federal government, almost all believed their cultivation was a worthy and even necessary goal for the individual states. John Quincy Adams, however, told Congress that if the powers granted to it could be used for "the cultivation and encouragement of the mechanic and of the elegant arts, the advancement of literature, and the progress of the sciences, to refrain from exercising such powers would be treachery to the most sacred of trusts."

The U.S. vs. the U.K.

But it was private patronage that was the reality. It is significant that even in New England and the Northeast the visual arts and art museums remained responsibilities of the private patron after the founding of the British Museum in 1753, an event

which signaled in the United Kingdom a steady trend away from private behests toward public support—the National Gallery in 1823, the Victoria and Albert in 1852, the National Portrait Gallery in 1856, the Tate in 1892. The live performing arts did not become the government's charge until World War II, though radio and film in the 1920s and 1930s prompted both the British Broadcasting Corporation and the British Film Institute. The United States Congress created a charter for the patrimony of the Smithsonian Institution in 1846, but this was not the onset of a trend toward public support, and seventy-five years later when the Smithsonian was used as the umbrella for the National Gallery of Art, it was again to accept gifts, this time including private collections, of which Andrew Mellon's was the chief. The Treasury and Work Projects Administration (WPA) art programs of the thirties were justified as temporary employment programs, and began and ended as such, though in 1939 Franklin Roosevelt, in a radio address dedicating a new addition to the Museum of Modern Art, was eloquent about the function of art in a democratic society.

Foundations and Trusts

At its outset the twentieth century marked continuing growth of private foundations and trusts, and income and inheritance tax legislation helped institutionalize private support. Instead of single advisors in philanthropy like those used by John D. Rockefeller I, there were entire foundation staffs identified with the Rockefeller, Carnegie, and Mellon families, the most conspicuous examples prior to World War II. Raymond Fosdick, Fred Keppel, Beardsley Ruml, Abraham Flexner, and others raised organized philanthropy to the level of a profession. Keppel of Carnegie and Fosdick and his associate, David Stevens, of Rockefeller worked professionally toward identified objectives in the humanities, but in programs of modest scale and viewing art largely as the handmaiden of education. The Rockefeller and Mellon families, with and without the foundations as instruments, made the kind of large gifts to artistic institutions that reflected an individual patron's preferences or crowned his position as a citizen.

Not until 1957 did any philanthropic institution or agency

consciously and publicly make the arts and the careers of artists an objective on a national scale. It is significant that this break with precedent came in the Ford Foundation only seven years after its trustees approved a totally social science and problem oriented program in which neither the humanities nor the arts had any standing except as means to other ends.

THE IMPACT ON POLICY

The impact of the multimillion dollar Ford Foundation program upon public policy in the arts, including upon the National Endowment for the Arts funded in 1966, has yet to be fully described. (But see examples in four artistic fields given by W. McNeil Lowry in another American Assembly volume, *The Performing Arts and American Society,* 1978). If we look only to extract the program's reflection of any public policy about the arts, it exists in the concept of a foundation staff making responses to objectives of the artists themselves, a catalytic use of those objectives as a guide to philanthropic goals consciously addressed. This is sequentially ahead of and distinct from what is generally termed "peer review," which comes when actual choices of particular grants are to be made. But long before, foundation staff ideally have been approaching the field in the artists' own terms, learning what those are as individual experience rather than reacting to an application.

BASIC CRITERIA BEHIND FORD

Digging a little deeper, embodying this criterion also subsumes focusing on the artistic process, both in supporting the artists as individuals and in helping them shape the process in companies, ensembles, and institutions. As noted earlier in this introductory chapter, there is a sharp dividing line between the artistic process (and the nonprofit institution) and the single artifact (and the commercial entrepreneur). Inculcating this principle in a large variety of programs accounted perhaps for the most radical change of climate produced by the Ford Foundation in nurturing artistic resources nationally.

Other criteria indirectly affected the impact on policy. The Foundation made no effort to choose between "serious" and "light" art or "elite" and "popular" art but only between good

and bad art. The choices were made by artists, artistic directors, and curators, whether of individual artists, a work of art, or a commission.

At some weighted value there arose the question whether the program or grant would really do what was wanted. Was it realistic to judge that? If not, the Foundation moved on to the next most promising or potentially fruitful opportunity.

Was the action or program needed? Or was the Foundation indulging its own sense of power or its own prejudice?

Did the program need the Ford Foundation? Some activities are less in need of subsidy than others. An informed program of patronage can better advance the totem of art even in the general public than one that appears accidental.

In the twenty years the Ford Foundation maintained its significant commitment in the arts, the nonprofit corporation which was its chief instrument for investment multiplied in every field. On that instrument have depended the extent and quality of American dance, theatre, opera, music, the museum of fine arts, and in large part the career opportunities of individual artists outside Broadway, the film industry, galleries, and concert management.

THE NONPROFIT CORPORATION

There are basic factors intrinsic to the economy of the non-profit corporation, and these will be extensively discussed in chapter 4 of this volume. In sum, however, the most basic is that the nonprofit corporation in the arts is labor intensive—from two-thirds to three-fourths of its expenditures are in personnel. The next is that its economic resources are devoted to the artistic process itself rather than to a single artifact, performance, or production. It is an institution rather than an entrepreneur. These two most basic factors produce the third: the inability to convert to the economics of scale—to increase volume through extensive tours outside the institution's own home and (to as yet any significant degree) to extend it through telecommunications. The three factors produce the fourth, namely a dependency on unearned (contributed) income varying historically from 25 to 50 percent, and more recently from 35 to 45 percent among major art fields.

It is interesting to note that in the fifties some of the early

grantees of the new Ford Foundation program had previously accrued so little contributed income they had not incorporated as not-for-profit. One of these was the Arena Stage in Washington, directed by Zelda Fichandler. In an essay in 1984, "The New American Theatre," Fichandler in effect incapsulates both the Ford Foundation's objectives in the theatre and the economics of the nonprofit corporation:

> The instrument for achieving theatre as art was the nonprofit corporation, previously associated with education, science, social welfare and certain performing arts, but not the theatre. Without the nonprofit provision in the income tax code our American theatre, as we have it today, would simply not exist. . . . The originating thought at the base of the [theatre] Revolution was, when you look back at it, really quite simple, and one wonders why it took so long to reclaim it from past cultures and every other major country of the world. It was that theatre should stop serving the function of making money, for which it has never been and will never be suited . . . that theatre should be restored to itself as a form of art.

THE IMPACT UPON OTHER SOURCES

The major impact of Ford Foundation activity in the arts was, of course, upon artistic resources in each field and upon the career opportunities of artists. The economics of the nonprofit corporation was known, though somewhat vague in its implications, nine years before the definitive work of William Baumol and William Bowen *(Performing Arts: The Economic Dilemma)* and even more before the Ford Foundation's own amassing of data *(The Finances of the Performing Arts,* 1974). But a secondary and a pervasive effect of the Ford program was the enlightenment that began to spread not only about the importance of nonprofit artistic enterprises but more precisely their justifications for subsidy. The mixing, in many cities throughout the country, of Ford Foundation with local monies, from private patrons, foundations, and corporations, helped prepare the way for the National Endowment and the state and local arts councils.

The Stirring of Federal Interest

Though the Federal Art Project of the WPA makes perhaps the most fascinating story of government in the arts, it had no linear (and very little causal) relationship to the legislative inter-

vention of 1965. Neither the WPA project nor the Treasury's
Section of Fine Arts survived the depression, and Franklin
Roosevelt, despite his own tastes, supported no attempt to make
such agencies permanent. There were reports and commissions
under both Truman and Eisenhower but their functions were
advisory and hortatory, and even efforts to legislate an advisory
council failed one House or the other. A few months before he
was killed, President Kennedy, who had opposed direct federal
subsidy of the arts in the campaign of 1960, issued an executive
order creating an Arts Commission. (Already in 1962 he had
appointed August Heckscher, director of the Twentieth Century
Fund, a special consultant on the arts.) Appointments to the
commission had not yet been announced when the President was
assassinated.

In 1954, a subcommittee of Education and Labor in the House
reported unfavorably on all of some fifteen bills in one way or
another promoting the arts. In hindsight there was the making
of a little drama in this fact because in the same year, Frank
Thompson of New Jersey was elected to the House, and by 1965
he chaired another Education and Labor subcommittee which in
September of that year managed to reach the floor of the House
with a bill to create the National Foundation on the Arts and
the Humanities.

The arguments made for federal support of the arts between
1963 and 1965 were in the main those used today. Even persons
who were then very much engaged (including the author) have
never known exactly how decisive arguments about the general
welfare and the public interest proved to be. They saw too
plainly, perhaps, the skillful use of particular interests and for-
tuitous events—the Kennedys' embracing the arts at the level of
the White House, the ambitions of President and Mrs. Johnson,
the lead by the National Commission of the Humanities that
broadened grass-roots support in every congressional district, and
not least the enormous House majority subjected to President
Johnson after the 1964 election. There was much greater harmony
of views as to capitalizing on these circumstances than upon
which arguments of the public's interest should be given priority.

ARGUMENTS FOR FEDERAL INTERVENTION

Before attempting a general precis of the federal government's
role, it would do no harm to let one of the recent critics of
government subsidy cast up the arguments made in the sixties

by its advocates. Professor Edward C. Banfield in *The Demo-cratic Muse* (1984) finds five given priority:

1. that a federal agency and a national cultural policy would give official recognition to the arts;
2. that this at the same time would promote the prestige and general welfare of the United States;
3. that federal support of the arts would contribute to international under-standing;
4. that only new sources of support like public funds could help institutions in the arts serve the ever increasing demands of the "cultural explosion";
5. that federal support could help such institutions give access to all classes of citizens through subsidized or free admissions.

"In the discussions leading to the passage of the law," Banfield complains, "no one asked whether the anticipated benefits . . . were properly the concern of government. It was simply assumed that, if an end were worthy, the government ought to pursue it."

ACTION VERSUS PLANNING

Though Congress had formally included in its statement of purpose that the new agency should "develop and promote a broadly conceived national policy of support for the humanities and the arts," the National Endowment for the Arts had to begin operations with very little planning, only the most general of policies, and no research. Even if we listen only to its strong congressional advocates like Representative Sidney R. Yates of Illinois, NEA largely continued to shirk planning and evaluation as means of focusing its objectives, and since 1979 Congressman Yates has used hearings before his Appropriations subcommittee to exact more systematic planning and priorities for the NEA program. The need for priorities was pointedly expressed at the hearings in 1979.

This question continues to merit exposition, and in April and May 1984, the National Endowment for the Arts submitted in hearings before Congressman Yates the results of a review of various fields of the arts and general plans of the Endowment in those fields through 1989. But we should note that no chairman of the NEA has accepted responsibility for developing "a broadly conceived national policy" for the arts but only, as the 1965 legislation says, "for the support of the arts." And in the periodic Senate and House hearings on reauthorization of the Endowments is abundant evidence that both the framers of the 1965 legislation and their successors interpreted "national" only as "federal."

Whether liberals or conservatives in their construction of the
"general welfare" clause in the Preamble to the Constitution, they
constantly reiterated that the private sector's role in supporting
the arts was and should remain paramount. The point was not
difficult to illustrate while the Ford Foundation maintained its
large program in the arts through 1975. In the period 1966–73
the NEA had spent $128.7 million including the funds through
state councils, compared with $249.8 million from Ford in the
1957–73 period.

The Nature of a Federal Policy

But what of a "broadly conceived" policy for federal support
of the arts? There has been no lack of broad statements of prin-
ciple from the NEA. Quality is to be preserved, new opportunities
to be found for individual artists, and the arts are to be made
accessible to all citizens everywhere. The best and the most are
seen as reconcilable and given equal weight. There can be no real
argument over priorities because we opt for quality and its dis-
semination at one and the same time. This is surely what the
people's representatives in Congress would have the government
do.

But it could also be argued Congress had a right to expect that
a new agency, working with professionals in the field, would
interpret the language of the authorization and make priorities
and choices that could be defended or at least argued about. In
the sixteen different program offices of the NEA we have some-
thing for everybody, every conceivable use that can be made of the
arts or even of talking about the arts, including many social,
educational, welfare, community, and consumer services that were
not expected in the first federal agency ever established to make
the arts the object of public policy. This is not to say that the
NEA has ignored the criterion of quality among its grantees. It
has merely treated everything else it does as equally important.

ITS CATALYTIC ROLE

In his preface to the 1981 annual report of the NEA, Chairman
Frank Hodsoll wrote:

The Endowment made available less than five percent of the total contribu-

tions to the arts in the nation in 1981. . . . However, this . . . is an indication of that vital partnership of support—no one source dominating—that assures excellence and diversity. . . . Both legislatively and by Council policy, the Arts Endowment was conceived as a catalyst to increase opportunities for artists and to spur involvement in the arts on the part of private citizens, public and private organizations, and the states and communities.

In that 1981 year, NEA grants, including challenge grants, were $150.7 million. Appropriations to states arts agencies were $111.7 million. From the private sector the arts and humanities (which include museums and public broadcasting) received $3.3 billion. So it is clear what Hodsoll, in his first report as chairman, meant in minimizing the role of government and emphasizing the roles of private patrons, foundations, and corporations. (Corporate giving to *all* fields hit a peak in 1981; but was only 1.29 percent of pretax net income; the share to the arts was again minimal but on the rise.)

THE NEW BUREAUCRACY

One of the growing pains in blending government into the mix of influences on public policy in the arts springs from overlaps in federal, state, and municipal delivery systems. Congressional review of the relations between federal programs and those first of state and now of municipal councils is long overdue. Through the seventies we saw an almost total admixturing of funds and programs. Sometimes it appeared that the NEA was in a position to manipulate the state councils, at others that the federal program was in part captive to the states. A case has often been made against bloc grants to the states in congressional appropriations to the Endowment, and against any NEA funds for projects through state councils, but both Congress and the NEA have successfully frustrated these reforms. Mandated grants through NEA to the states were increased to $30 million a year, and in 1982 the NEA started distributing a minimum of $2 million annually through municipal councils. Without much more rigorous data and evaluation than either the executive branch or the Congress exacts, it is impossible to determine that the delivery system itself will not constitute a constituency as urgent and as influential as the arts constituency it theoretically is designed to serve.

WELFARE AND EDUCATION

More than a decade after legislation in the field, there is no generally understood and defined federal policy about the arts. To determine the policy of the National Endowment for the Arts, one must begin by looking at the beneficiaries of its expenditures rather than at either legislative authorization or the general objectives which introduce NEA's reports to the President. But this exercise is clarifying only to a point, and it leaves in suspension the question whether the federal government's priorities are the provision of career opportunities for artists and the stabilization and expansion of artistic enterprises or more importantly the education of young children, the provision of community and welfare services, and the general education of adults.

The generalizing of activities labeled cultural through government support has had its effect also upon an even newer and less developed source, the corporation. Corporate support and the policies which appear to govern it in the last few years have become serious subjects, though the support itself is not yet of major proportions.

Corporate Policies in Flux

Ten years ago it was relatively simple to generalize upon corporate policies. Moneys from the corporation's operating budget came indirectly when they came at all, were aimed at institutional advertising, and brought exposure on television, in the press, in a staged event, or through contributed services like transportation, printing, and communication, or block purchases of tickets for employees. Direct grants from the corporate contributions or corporate foundation officer were very hard to get, went to only a few organizations, and were regularly considered outside grants committee guidelines. The most significant grants were really outside the guidelines, reflected the personal interests of individual officers, and went to the largest and most visible organizations.

This was a stereotype, of course, and like most stereotypes no longer serves. Corporate philanthropy is in evolution, and outside efforts to help focus it (including cooperative efforts in one or

another art field) have not always produced a commensurate result. Among the more interesting trends in the evolution is the corporation's pressing the community upon the artistic organization. At bottom this is not new. Corporations have always thought of themselves as good citizens in a community, purchased better conditions for their employees, and appealed thereby both to their customers and to elected officials. But now their technical assistance is ramified in new ways that offer up the corporation as some kind of partner to the artistic institution. If the organization finds itself enlisted as a corporate service to the community, well that is quid pro quo.

Voluntarism

The coincidence, since 1981, with the Reagan administration's promotion of volunteer services in the arts as a substitute for federal money has put new pressures on the governance of non-profit institutions. Another point at which the convergence of government and corporate support has influenced priorities is in the premiums put upon audiences through large community events like the so-called "blockbuster" exhibits in art museums. In almost all of these the major supporters are corporations and government agencies, and taken together their community objectives often dominate museum exhibition policies.

Weighing the Components

The mix of external influences on public policy coming into the eighties included private patrons, foundations, federal, state, and local governments, and corporations. At this point in discussion we are dealing with conscious influences; we are not now examining either the voluntary societies themselves or the influences of marketing and the marketplace.

Each element in the mix has been touched upon in this introductory chapter, and now and then its impact has been measured by one or another yardstick. A very particular—but not universally familiar—yardstick can also be found in the proportions among these same elements in the financing of the arts.

Coming into the eighties we had seen for a number of years a fairly consistent proportion of one-third public to two-thirds private sources of contributed income. Since 1975 the corporate

component has increased dramatically, having started at a very small base. Contributions by individuals used to equal those from all other sources; they still lead foundations, corporations, and the federal government in each field. In the last year for which the American Association of Fund-Raising Counsel has data (1983) the arts and humanities received from the private sector $4.08 billion. This compares with $623 million in 1970 and with $226 million in the year the National Endowment was established.

What is not universally understood about the pattern of funding in the United States is the persistence of individual private patronage thirty years after foundations raised the level of their activities in the arts and almost twenty years since federal and state support. In April 1982, NEA Chairman Frank Hodsoll, attempting to defend before a Senate Appropriations subcommittee the administration's proposed 30 percent cut in funding, based private support solely upon tax incentives:

> Private support for the arts has always represented over 90 percent of all support for the arts. That is this country's tradition. And it is buttressed by the tax deductions allowed for philanthropy. In fact, when one adds in government's tax forebearance, federal contributions to the arts compare favorably with government support in Western Europe. The difference is that government in this country encourages multiple sources of support; in Europe, central government support is primary.

Distinctions in the Terms

If it has even in part achieved its purpose, the discussion to this point may have made it a little easier to distinguish among "public," "national," and "federal" policy about the arts. In simplest terms, most of us can agree that there is not—and perhaps should not be—a "national" policy, and that "public" does not add up only federal, state, and municipal, but all private elements as well.

In making such a distinction at this point I do nothing more than state one thesis on which this volume can be coherently developed. It may even have few advantages over any other thesis, but it does have one: it allows a clearer distinction between "policy" and "advocacy" than most discussions in this field are able to manage. Public policy in the arts is the sum of private

and governmental interests (of which individual patrons, foundations, corporations, and national and local arts councils are examples) with particular or general values in mind. Advocacy is any argument, action, publication, or coalition promoting increased contributed income for the arts.

After the National Foundation on the Arts and Humanities became law, artists and performers again generally shunned the advocate's function except when working with a specific institution supporting the arts. When the expenditures of the NEA were divided between the support of artists and artistic institutions, on the one hand, and, on the other, a variety of social and educational objectives, many professionals in the field concluded that they must speak more clearly, for they found that to lobby for greater federal budgets did not automatically translate itself into greater stabilization of institutional resources or greater opportunities for artists. If the question were not how much money but why money for the arts, advocacy was not enough. The clarification of public policy about the arts was essential. But how was it to be defined? Could it be that the future of nonprofit enterprises in the arts depended on the importance of the arts to the American society? What, at any rate, had appeared to be their importance in the cultural history of the United States, even long before either tax incentives or the advent of government in the mix?

CAN WE MAINTAIN THEM?

If indeed it is now possible to distinguish policy from advocacy, and at least for purposes of argument agree that public policy comprises the private elements as well, we are nevertheless not free of semantic difficulties. (In fact, this introductory chapter has already illustrated many such!) The most difficult distinction of all is between "policy" and "influence" and even worse the distinction between singular and plural forms of both. When defining public policy as a complex of private and government "elements" or "interests," one is very close to equating "policy" with "influence." This connotation will emerge frequently in more than one of the chapters to follow, and it creates no great problem so long as we are clear that when "policies" are consciously directed they easily become "influences." (This came out very plainly, for example, at the outset of the symposium from which chapter 5 was edited.)

How the Argument Unfolds

It is in keeping with this exposition that chapters 2 to 4 are keyed to influences as well as to policies. In chapter 2 Stanley Katz examines multiple influences on public policy as a general phenomenon in the American society. Perry Rathbone then focuses upon personal examples of the most important element in the pluralism, the private patron. Paul DiMaggio analyzes in detail the influences of marketing and the marketplace on nonprofit institutions in the arts. (The terms in which his discussion is cast make any separate treatment of the nonprofit instrument unnecessary.) Finally, all the components in the mix—the private patron, foundations, corporations, the government, the artists themselves—figure in chapter 5 in issues addressed by eight participants in a symposium.

Despite a mass of legislation, there is no single policy about energy, the environment, conservation, surface transportation, or public housing. But there are policies that can be *understood,* and they are regularly debated in each of these fields. A defined public policy exists when it is generally understood; it need not be generally agreed upon.

Stanley N. Katz

2

Influences on Public Policies in the United States

Among artists and aficionados of the arts, it is commonplace to remark that the United States has no cultural policy. Like all truisms, this statement bears some relationship to social fact, but it does not tell us much. In order to know whether we have a cultural policy, one would have to be very clear about what one meant by "policy," and one would also have to wonder what the alternatives were.

It will be the argument of this chapter that the United States does have a set of public policies with relation to culture, but that it does not have a single policy. It will also be argued that many of the "public" policies are created in the so-called "private" sector, and that they display important regional variation. Finally, insofar as we do have a general policy or attitude toward culture, it is in fact the result of the push and pull of a multitude of con-

STANLEY N. KATZ *is the Class of 1921 Bicentennial Professor of the History of American Law and Liberty and professor of public and international affairs at the Woodrow Wilson School of Princeton University, and he also serves as visiting professor at the University of Pennsylvania Law School. Dr. Katz is a noted lecturer and has published numerous articles in prestigious journals. Dr. Katz is the author, with Barry D. Karl, of "The American Private Philanthropic Foundation and the Public Sphere, 1890–1930," in* Minerva *(1981), from which the first portion of his chapter is largely drawn.*

flicting public and private policies, most of which were never specifically intended to impact upon the arts. All of this sets Americans apart from Europeans, for whom at least a plausible claim of national cultural policy might be made.

Historical Excursus:
Origins of National Public Policy

It may help to take a brief historical detour in order to understand why the history of public policy in the United States is so curious, or at least hard for present day Americans to understand. The growing use of the term "public policy" to describe programs planned, supported, and administered by the federal government may conceal one of the most profound social revolutions in American history. The power of the federal government to command compliance with the aims of social reform, which vast majorities of Americans may agree are noble, rests on a legal authority that those same majorities, even a few years ago, would not have believed existed. Federal administrators, backed by federal courts, are able now not only to withhold money appropriated by Congress for support of local schools, transportation, and police and fire protection, but also to take private business firms to court to enforce social changes which may have played little or no part in the legislation which authorized the original programs. Even those who supported the need for social reform can be puzzled by the size and shape of the federal authority which has emerged to bring it about.

In some respects, the peculiarly American aspects of the problem of regionalism versus nationalism offer us the best historical point of departure. The major political debates of the first century of American government centered on the issue of the power of the federal government to control national policy. The hard fought battles which ultimately produced a measure of agreement on such issues as banking, currency, and the tariff also produced a Civil War which abolished slavery. Underneath what we now acknowledge as the limited success of such national crusades, however, was the commitment to government which began at home—in state legislatures, in traditional county and town systems, and in the growing urban governments. The compromises which followed the Civil War affirmed the limitations of the

federal goverment where the making of policy was concerned, but most of all in the formulation of policy on social issues. This was an important affirmation for the South in particular where "social issues" meant not only the treatment of Negroes but the whole problem of poverty in what was, in effect, an under-industrialized and recently defeated colony with relatively little industry. State and local governments were perceived as inde-pendent entities pursuing locally determined "public" aims pursued by other "publics" in other communities and regions. The term "public" itself was loosely applied, stretched to include the interests of business and professional groups whose concern with the health and well-being of the community, as well as its moral and charitable needs, could be defined by many different organizations and associations which no one would have called governmental.

Awareness of the need for some kind of national institutions and procedures for influencing the quality of the lives of all citizens came basically from two sources, one quite traditional and the other quite new. The older of the two, the charitable and religious beliefs and institutions which had served as the organiza-tional base for national, educational, and social reform since the Jacksonian era, no longer appeared to be effective, even though for many the benevolent motive remained unchanged. The Civil War had taught a lot of lessons, among them the divisiveness of denominational interests and transience of religious enthusiasm. At the same time, however, the growing consciousness of the needs of the technological revolution under way had led some entrepreneurs and managers engaged in the building of national industry in the nineteenth century to see a new range of national needs in education, in scientific research, and in the relation of the two to human welfare more generally.

FEDERALISM

What made the combination of charity and technology unique in American society was the tradition of federalism—the unwilling-ness of Americans to give their national government the authority to set national standards of social well-being, let alone to enforce them. Part of the problem lay in the diversity of ethnic, racial, and cultural groups which had been affected dramatically by the successive waves of late nineteenth century immigration and the

unprecedentedly rapid expansion and settlement of the western
lands. The traditional American idea of equality did not reflect
a national standard according to which communities could mea-
sure the quality of education, medical care, treatment of the aged
or the unemployed, even from neighborhood to neighborhood
in the growing cities, let alone from state to state. For better or
for worse, federalism in the nineteenth century had become a
way of making pluralism palatable by confining unresolvable
differences and accepting them.

From the vantage point of historical distance, one can see the
problem more clearly than it was perceived at the time. Among a
national elite of modern industrial reformers, a growing conscious-
ness of the desirability of national programs of social welfare
collided with a general political culture which would not accept
a national government bent on such reform. It was a culture which
would have been threatened down to its partisan and regional
roots by any attempt to create a nationally unified conception
of social policy. Not until the New Deal would the federal
government move into areas dominated by private philanthropy
and local government, and then only in a very limited form
engendered by the Great Depression and accomplished by emer-
gency measures that many believed would not become permanent.
Even Americans who looked upon the social programs of the
New Deal as the origins of the American welfare state still accepted
the fact that solutions to such national problems as compensation
for unemployed, the children of the poor, or the indigent and
disabled elderly (not to mention emergency employment of artists)
would vary widely according to the resources provided by state
and local governments as much as by regional traditions.

Federal financial support was always deemed to be supple-
mentary, encouraging rather than controlling state and local
policies. Private organizations supported by associations of well-
to-do citizens and religious groups worked jointly with agencies
managed by local communities and bore the major responsibility
for dealing with the condition of those unable to care for them-
selves. Such institutions as the numerous Charity Organization
Societies, the Associated Charities of Boston, the United Hebrew
Charities of Philadelphia and New York are obvious late nine-
teenth century examples of the phenomenon, forerunners of the
modern Community Chest–United Way approach to local, private

provision for welfare needs. Schools run by various local committees and boards would continue to hold a widely differing range of powers to tax citizens within their jurisdictions and to distribute educational services the quality of which depended largely on the willingness and financial ability of citizens to supply the necessary funds. Wealthier communities would educate their children differently from less wealthy communities, while ethnic and racial distinctions would play their traditional roles in determining balances of quality. Needless to say, control of culture from music to museums (and especially including higher education) was quintessentially a local affair in the nineteenth century.

The point is that the emergence of the federal government as the controlling presence in the management of national public policy is a remarkably recent phenomenon. While in many aspects of social policy, most particularly those relating to relief, we can date the origins of a national, governmentally created public policy as a product of the New Deal, for most of us the enormous range of federal public responsibility for policy is really a phenomenon of the Johnson years of the 1960s. The Reagan reaction against "big government" is, from this point of view, really an attempt to set the clock back twenty years rather than a century. It plays upon and corresponds to the localist elite sentiments which characterized the formulation of public policy in the United States prior to 1964.

Public Policy and Culture

From the point of view of culture, the process is particularly difficult to disentangle and explicate. While localist sentiment made federal intrusion into the major areas of social policy unpalatable to most Americans, the twin pressures of reform politics and economic necessity achieved grudging acceptance of the need for, if not the desirability of, federal and governmental solutions to certain social problems. But this was almost never the case with culture, and it is not hard to understand why. The cynical might say that society requires bread to feed hungry mouths, but that it does not *require* sculpture, symphony, and ballet. There is some truth in this position, but it ignores the less obvious fact that Americans have defined themselves locally and regionally until fairly recently, and that they have been fundamentally committed

to the notion that culture in a republic is the product of voluntary patrons and societies, though animated by civic pride and civic duty.

Education and Public Policy

The clearest case here is education. Even when national government provided sustenance for education at the local level —by setting aside lands in the Northwest Ordinance of 1787, or in the dramatic gesture of the Morrill Act of 1862 which created the land-grant universities—there was never any suggestion that federal government should set operational education policy. That was a task for the local electorate, or at any rate, the leaders of the localities. This feeling remains very strong today. One only has to think of the anguish of desegregation or expenditure equalization—national state policies imposed upon localities— to sense the depth of American commitment to local determination of the most important aspects of cultural life.

Setting aside the short-lived Work Projects Administration (WPA) program in the arts in the 1930s, this situation in the arts began to be transformed only by the establishment of the National Endowment for the Arts (NEA) in 1965. For the first time, significant sums of tax-based funds were available for expenditure at the state and local level in the arts. The situation any intelligent observer might have anticipated then came about: on the one hand, local artists and artistic groups eagerly competed for the newly available money, and, on the other hand, artists and philanthropists complained that national policy concerns ought not to guide the distribution of the newly available funds. The message was clear: "Give us the funds and we will determine what to do with them"; or, at best, permit the National Council of the Arts to determine the use of the funds without intervention from politicians and bureaucrats. The question was seldom asked, however, why the federal government should behave in such a way. Should federal tax monies be returned to individuals for local expenditure without undergoing distribution through ordinary political and bureaucratic channels? Is NEA a properly democratic method of allocating federal funds? Can culture really remain above politics once the federal government intervenes? Intelligent artists and laypeople interested in the arts have half-

perceived all of these problems, but they have seldom been faced up to with sufficient honesty.

The Metropolitan Opera Example

It may help to take a brief glance at a specific problem in order to make the point concrete. Consider, for instance, such an institution as the Metropolitan Opera. What would it mean to ask whether or not there is a public policy toward opera in New York City? On the surface, the question may seem absurd, since I take it no one would argue that opera in New York is the result of principled governmental policy directed specifically at the question: how is grand opera to be brought to the residents of the city?

The history of the Met, however, demonstrates that its current status is the result of a series of policies formulated and effectuated over nearly a century's time. If I understand the matter correctly, the Met was initially a profit-making enterprise for small groups of individuals. Ticket revenues almost sufficed to pay the singers and musicians, as well as the other technicians involved. The Met served a constituency of wealthy New Yorkers who made gifts from "the incomes on their incomes," but whose major contribution was through the purchase of season subscriptions. Even before the depression, however, it was no longer possible to sustain the operation of the Met largely from ticket sales, and its more modern incarnation as a philanthropic activity emerged.

That is to say, the Met was now run by a board of trustees who, through their own contributions and their efforts at soliciting others, made up the operating deficit left at the close of each opera season. The position of the company changed again with the emergence of the Lincoln Center effort in the 1960s and the building of the new opera house. Today the board of the Met is considerably more diverse than in earlier years, and it relates a little more directly to the government of the city, but the non-profit corporation's function remains that of making up the short-fall between revenues and expenditures that is the lot of any modern opera company. The audience now, however, is no longer composed primarily of the New York social elite, but is rather a heterogeneous middle-class group drawn from within the city and from large numbers of visitors. Through radio broadcasts and

television, the company of course since the thirties is in fact carried on a regular basis throughout the country and even occasionally abroad.

The Met is big business, even if it is unprofitable; it has a major cultural impact nationally and internationally. Who gets the credit —or the fault? It is relatively easy to understand how in the early years of this century the decisions were made which led to the creation and the sustenance of the original Metropolitan Opera. It was the desire (policy) of certain members of New York's social elite to have such a company, and their demand coincided with a sufficiently attractive entrepreneurial prospect to result in the creation of an opera company. Thus it was not only social policy on the part of an elite, but also a response to the current business policy of the United States in the environment of New York. When for various reasons the situation was transformed, however, and the market could no longer suffice as an incentive to maintain the company, a new set of imperatives took over. The opera became primarily a philanthropic enterprise, in large part at the behest of the descendants of the original elite patrons. The preservation of opera in the city became an aspect of local philanthropic cultural policy. The board felt that the city (and they) needed opera, and they supported the effort financially. The fairly narrow initial group of private patrons was augmented after the 1930s and 1940s by significant new individual patronage and by the substantial support of the large philanthropic foundations, especially Ford and Rockefeller. While the private philanthropic framework remained in place and essential in the period after the Second World War, cooperation, material sustenance, and even advice from other public groups became an essential part of the operation. The trustees still set policy, but they were different sorts of people responding to different sorts of pressures.

The Modern Met

The most obvious example of this process is the creation of Lincoln Center. How would one describe the policy which led to such a development? Surely not in unitary terms. One could think of the Center in terms of urban renewal and the reclamation of the neighborhood, for instance. One could also think of it in terms of the preservation of the entertainment revenue of New York

City. One could think of it in terms of the need to coordinate musical and theatrical culture in the city. And one could also think of it in terms of the artistic and educational needs of the city and the nation. Each of these motives, and policies, was involved, and the resulting Center (with all of its implications for the Met) was the result of a series of negotiations and compromises rather than any set of policies designed purely to establish operatic policy for New York City. Any newspaper reader with a good memory of the sixties can recall the complexity of the process: conflict within the cultural elite; negotiation with city, state, and federal governments; relations with the residents of the neighborhood in which the Center was to be built; decisions by national and local foundations; the national investment climate; and so on.

These distinct conflicts which produced the results which led to Lincoln Center were the result of a process which resolved an almost infinite series of conflicting social policies and goals. By the 1960s, private cultural policy in a city was inextricably bound up with governmental policy at local, state, and federal levels. It was also complicated by the fact that culture in this country is no longer dominated by a small and self-contained elite, such as the small group of patrons and entrepreneurs who began opera in New York City. The city itself is composed of a constantly changing set of people and cultures. Equally obviously, singers, orchestral musicians, conductors, directors, scenic designers, radio and television executives, and a host of others all have their own agendas and the resources to effectuate them, when it comes to an institution like the Met.

Another way to look at the problem would simply be to think of the policies which result in the actual activity of the Met in any given year. How can one describe the policy which led, for instance, to the programing of the 1984 season? Surely one could gather quite a lot from understanding the taste and intentions of Mr. Bliss, Maestro Levine, and the trustees, but one would have to be naive to think that they were the only, or even the principal, determinants of the season. Think only of the financial constraints under which such a company is managed, and the sorts of artistic decisions which are made under the pressure of money. What will sell season tickets? What will stimulate single sales? What will Texaco prefer for radio broadcast—and what will television de-

sire for "Live from the Met"? What will the response of the major newspaper and magazine critics be to particular productions? What will generate revenue from recordings and other promotional sales? What will bring in grants from the National Endowment for the Arts, from the Gramma Fisher Foundation, from individual donors? The offerings of a season must be constructed with all of these constraints in mind, and these constraints are the result of the policies of a wide variety of interested groups. There are other obvious factors. What productions can be borrowed at reasonable costs from other companies? Who is available to sing and conduct? What are the preferences of the musicians and craftsmens unions? They all have policies of their own.

Plural Influences

There is not really time to go into detail. but if one thinks about the matter in the abstract, it becomes apparent that an almost infinite variety of policies need to be taken into account in running an organization as complicated as the Met, and not all of them are policies which were intended to have an immediate or primary impact on an opera company. The policies of the Kennedy and Johnson administrations toward urban renewal, and those of Mayor John Lindsay, for instance, obviously had almost as much to do with the decision to build Lincoln Center as did the inclinations of John D. Rockefeller III, Charles Spofford, and the Ford Foundation. The laws on copyright have an immediate impact on cost and choice of artistic works. Federal income tax policy with respect to deductibility of charitable contributions has an obvious effect. Direct subsidies from the National Endowment for the Arts and the policies of the National Council of the Arts and the chairman of the NEA may have an immediate bearing upon activities at the Met. More indirectly, in terms of the participation of foreign artists in the training of American artists, national policies with respect to immigration, foreign labor, and educational-cultural exchange will be very important. These are classically "public" policies, but the Met will also respond to "private" policies, ranging from trends in aesthetic taste through the network of interrelationships among the several national opera companies, and extending to the incentives offered

by corporate donors and sponsors. It is all very complicated, and it is very hard to see how it could be otherwise.

The Emergence of a National Policy?

What we do not have, however, is what exists in some of our European counterpart societies—a governmental ministry of culture which sets explicit policies for opera, ranging from the determination of subsidies for particular companies to the financing of artistic education for singers and musicians, and in some cases extending even to the determination of the actual works of art to be performed. We have all heard about the number of local opera companies in Germany or the centralization of artistic policy making in France, but whatever one thinks of German opera or French theatre, the centralized solutions are not possible in American political culture. We prefer to do these things locally and privately, just as we have preferred to locate social reform locally. We think of them as exclusively private and artistic in their origins, even in the face of evidence that since the early seventies at least, cultural policies are affected not only by the private patron and the private philanthropic sector, but also by a congeries of local and national governmental policies. American pluralism and regionalism create a constant pressure for the decentralization of cultural public policy which increasingly runs athwart steadily mounting demands for nationalization of cultural policy. How long will it take for the implementation of the nationalizing pressures beyond bureaucratic and legislative manifestos is impossible to guess.

GOVERNMENT POLICY

To speak for a moment of government policy, it is obvious that there are relatively few areas of direct state or federal cultural policy making. I have already spoken of the NEA (and I could mention its state analogues, the arts councils), but such examples of direct and intentional government policy making are few. More often, governmental policies which have a critical impact on cultural decision making are indirect and unintended, whether they emanate from legislation, judicial action, or the executive branch. The most obvious general area is perhaps tax policy, for

it must be clear to all of us that the structure of taxation has an immediate effect on the financing and therefore the policy making of cultural organizations.

What would the situation be, for instance, without state and federal deductions for charitable contributions and, indeed, without the whole structure of our legal system of inheritance? So much of our cultural activity is predicated upon philanthropic principles that it is hard for us to imagine a system which does not run on some combination of the market and philanthropy, despite European examples to the contrary. But of course we need not have charitable deductions, and in fact current proposals for tax reform envisage the possibility of doing without them. Such a "flat-tax" policy might have the most dramatic impact on cultural activity. State and federal policy with respect to education, to name another obvious area, clearly has a great deal to do with the training of young artists and with the employment of mature artists. The federal government has played an increasing role in creating a national educational policy going back to the National Defense Act of 1965, but states and localities have nevertheless always been more centrally important in education. Certain federal policies designed for more general purposes have occasionally had a dramatic impact on culture—the WPA is only the most obvious example, but others could be cited. In analyzing the situation of the Met, I have already referred to a wide variety of governmental policies which have an obvious relationship to the cultural life of this country, even though we have no ministry of culture and even though we have no cultural policy as understood by European standards.

PRIVATE POLICY: COMMERCIAL

The private sector provides a similar picture of a complex, interlocking, and sometimes conflicting set of policies with respect to culture. Consider first the commercial side of the private sector. The market itself is of course a powerful force in culture, whether we are talking about setting the agenda for symphony programing or helping to create the "New York Style" in painting. Print and electronic media are essential to the welfare of artistic institutions and individual artists, and I do not suppose that any of us would want to deny that these institutions are driven by

considerations which are not in the first instance aesthetic. The commercial entertainment industry itself, through the pressure of competition and the setting of public tastes, provides an important part of the environment in which cultural institutions must operate, and it surely impacts upon their decision making. Likewise, from the other side of the bargaining table, the organization of labor and the development of a labor agenda have also transformed the context of the arts. One need only look at the budgets of symphony orchestras before and after the onset of the unionization of classical musicians to see what a determining effect labor power has had upon musical life in the United States. I suppose that these policies and influences are self-evident, but we sometimes take them for granted.

PRIVATE POLICY: NONPROFIT

Even more obvious, though less understood, is the impact of the private not-for-profit sector. We are accustomed to recognize the importance of patrons in the development of cultural policy, but of course patronage, like so much else in American life, has now also corporate forms. That is to say that much of the finance and decision making in cultural life now comes via foundations and corporations, just as it traditionally came from individuals, churches, and voluntary organizations. The private patron is still the largest source of support, but the funding of artistic activity has been substantially driven by the policies of nonprofit organizations. And so, perhaps more important, have the education of artists and their sustenance throughout artistic careers. Decisions, for instance, about the nature and finance of musical conservatories have had the greatest relevance to the production of the great numbers of competent instrumentalists currently available for America's burgeoning orchestral sector. There has been no national policy on the creation of bassoonists, for instance, but it is no accident that 154 candidates turned out a few years ago when there was an opening for the first desk at the New York Philharmonic. Equally obviously, what Philip Morris or Exxon want to support in the way of art shows, dramatic television series, or Egyptian archeology is likely to have a very big influence over what is available to the modern public. Doing well by doing good is an old American tradition.

PRIVATE POLICY: INDIVIDUAL

It is harder to describe the behavior of individuals as one of policy making. The major patrons have had a clear impact on the maintenance and transformation of culture, but then so have volunteers and more modest individual donors. The same might be said for groups of individuals working through institutions ranging from libraries through civic associations. Voluntarism has indeed been a critical aspect of policy making in the United States, even if the coherence and independence of such groups have characteristically been exaggerated. And, finally, of course the artists themselves are the most important individuals involved. At least in the performing arts, however, it is very difficult to argue that most performing artists have been able individually to determine the conduct and texture of institutional culture in their own fields. Most artistic performance is driven by institutional imperatives, and not only by the imperatives of finance. It is largely upon such institutions that the varieties of policy making on which I have tried to elaborate have had determining effect.

Conclusion

As must be painfully obvious from what I've already said, I am not a professional student of the arts. My field is rather the history of public policy in the United States and, in particular, the history of philanthropy. Nevertheless, it does seem clear to me as an avid consumer of art (and the father of a bassoonist) that the dynamics of public policy formulation in the United States apply to artistic policy as well as to those areas of social policy with which I am more familiar. The lessons, I would say, are really four.

The *first* lesson is that to have no policy is to have a policy. That we do not have a national cultural policy, in other words, means that we have made a decision (this going far back in our history) to leave to private and local institutions the determination of the decisions most overtly affecting the creation and conduct of cultural institutions. *Second,* no public policy can be understood in isolation. We do not have a national cultural policy, but we have tax policies, urban renewal policies, immigration policies,

and a number of other public and governmental policies which limit the ways in which cultural institutions can operate.

Third, if by policy we mean the creation of norms according to which action is determined, the public-private line is not very helpful in determining "public" policy. The norms which have operational significance for artists and cultural institutions derive equally from private and public sources, and it is a mistake to think of them as primarily governmentally derived. Indeed, in this country, private policy making has been predominant. At this point in our history, the interconnections between public and private are so complex and so intimate that it makes little sense to try to polarize our understanding of the policy-making process.

Finally, the increasing involvement of American cultural life with the overt process of public policy formulation has costs as well as benefits. While most of us are appreciative of the growing amounts of governmental funds which have been made available to American artists, we must recognize that the price tag for this "public" support is a swelling demand for public accountability. There is an inevitable tension between high culture and democracy, and as cultural policy moves from the domain of the private, the elite, and the artist to that of public and popular taste, there will almost certainly be impacts upon the artistic process itself. The one sure thing is that this tension will produce a wide variety of responses in our localistic culture, despite the best (worst?) efforts of federal government to achieve a more unified national policy.

What we must do, then, is to examine the situation of the arts with greater analytical sophistication than has ordinarily been employed in order to understand the diversity and multiplicity of influences upon cultural decision making. It is only then that we will be able to identify the critical variables, and to try to affect them—assuming we can agree upon what an appropriate cultural policy might be.

Perry T. Rathbone

3

Influences of Private Patrons:
The Art Museum as an Example

American philanthropy exceeds that of any other nation. And if we attempt to locate and define the impulse at the origin of this compelling American tradition, I think it is to be found in the Puritan ethic. By now the intolerance of Puritanism and the strictness of its moral code may have tarnished its reputation for beneficence, so that the religion of the Puritans can be widely misunderstood and mocked in our society. It is well, therefore, to read E. Digby Baltzell's elucidation of its theology in his *Puritan Boston and Quaker Philadelphia.*

Private Philanthropies: "The Right Use of Riches"

He writes: "Puritanism was indeed no radical or sentimental creed, but a new and demanding system of order and authority . . . nor was it a doctrine that permitted the unregulated and individualistic pursuit of profit." Professor Baltzell draws attention to William Perkins, the noted sixteenth century English theologian whose writings had a formative influence on Puritanism. Perkins wrote:

A vocation or calling is a certain kind of life, ordained and imposed on man by God . . . *for the common good:* that is, for the benefite and good

PERRY T. RATHBONE *is senior vice president and director of Christie's International. He is also director emeritus of the Museum of Fine Arts, Boston.*

estate of mankinde . . . And that common saying *Every man for himselfe
and God for us all*, is wicked and is directly against the end of every
calling or honeste kind of life (italics Baltzell's).

Baltzell also emphasizes the Puritan attitude toward riches as
expressed by Perkins. Perkins wrote: "Men are honored for their
riches: I mean not riches simple but the use of riches; namely as
they are made instruments to uphold and maintain virtue." In
other words, as Baltzell points out, the Puritan emphasis on the
"right use of riches" led to the characteristically American tradi-
tion of private philanthropy.

To illustrate the point one could not cite a more far-reaching
example of Puritan philanthropy than that of the Rev. John
Harvard; his will in 1638 provided for the infant college of Cam-
bridge a legacy which thereafter bore his name, consisting of
one half of his estate of £780 and his entire library of some 300
volumes. How could anyone imagine that the first philanthropic
seed thus planted for the common good in American soil in the
seventeenth century would flower so prodigiously in the twen-
tieth?

The Private Origins of American Art Museums

American art museums are unique in the world, not by
reason of their collections nor of their administrative structure,
not for their size or their age, but because of the personal factor
that lies at their foundation. To be sure, a governmental action
licensed their founding, but the private sector, not the operation
of the state, brought these institutions into being. Personal in-
spiration, conviction, and commitment produced their charters,
and museum founders and their successors have supported our
museums with private money and guided their philosophy and
their principles to this day.

> The museums of America are one of the most remarkable achievements
> of a free society. In less than two centuries they have been organized
> and filled with treasures from the whole wide world. With academic
> institutions they share the exciting burden of curatorially preserving
> and educationally interpreting the cultural history of the human race.

This was George Heard Hamilton's comprehensive description of
the American art museum in his essay on "Education and Scholar-

ship in American Museums" published in 1975 in the American Assembly volume *On Understanding Art Museums.* Professor Hamilton could have added that it was an achievement with only marginal assistance from the public sector.

Americans today can well take pride in this longstanding and widespread concern with visual culture. Institutions dedicated to preserving and interpreting the art of the world are to be found in nearly every state in the Union and have taken an increasingly prominent place in American public life. It is not surprising therefore that more often than not they are assumed to be establishments of the body politic like public schools, public libraries, or parks. That art museums have been almost exclusively built and maintained by the private sector is not sufficiently understood. Indeed it is fair to question whether without the leadership of private philanthropy there would be any art museum at all in our Republic.

Absence of Government Policy

Stephen E. Weil, a lawyer and deputy director of the Hirschhorn Museum in Washington, has pointed out in "Museums and the Law" in *Museum News,* February 1984, that "with few exceptions, there is no body of law that is particular to museums. There are few laws—not even the cornerstone of our tax exemptions, the blessed 501(c)(3)—that even mention museums, whether to include them or exclude them." This fact reflects the obvious—a longstanding lack of concern for museums in the public sector of our national life. Visitors from overseas are unfailingly surprised to learn that the typical American museum, though having every appearance of being publicly owned and conducted, is ordinarily not the property of city, state, or nation, but a private institution operating on endowments and gifts and governed by a selfperpetuating board of trustees.

In respect to their founding and funding, European museums are radically at variance with their American counterparts. European museums in many cases have taken their rise from simple fiat or from state expropriation of art property from royal or ecclesiastical ownership; likewise, a palace or ecclesiastical edifice has often become the museum building itself with the state supporting the entire establishment from the beginning. Generally

speaking, in contrast to American museums, the European museum is in every sense a public institution.

Private Patronage in Three Settings

It is the purpose of this chapter to show by selected examples the philosophies and procedures by which the private patron, sometimes with the help of foundations and private corporations, has operated in nourishing the cultural life of the nation through its museums. For cogent reasons, examples will be drawn largely from museums on whose staffs I served from 1934 to 1972 and are therefore best known to me: the Detroit Institute of Arts, the St. Louis Art Museum, and the Museum of Fine Arts, Boston, of which I was director from 1954 to 1972.

The Museum of Fine Arts as Model

The Museum of Fine Arts, Boston, enjoys pride of place as the oldest mainstream art museum in America; this to be sure is hardly more than a technicality since Boston's charter is dated only some ten weeks earlier than that of its principal rival, New York's Metropolitan Museum. What matters is the philanthropic impulse behind the establishment and the example set by the Museum of Fine Arts for those museums that were to follow. The years after the Civil War saw tremendous industrial expansion with its consequent increase of wealth in the northern states. Not the least conspicuous evidence of this new affluence was the founding of four of our greatest museums in the decade of the seventies. With Boston's reputation as a center of culture, the young Museum of Fine Arts easily became the model for other museums founded in the same decade. In addition to the Metropolitan, they were the museums of Philadelphia in 1876 and Chicago in 1879.

The Boston Museum offered a model in stated purpose and philosophy, in setting professional standards, in its dependence upon private patrons, and in the quality of those who were to guide its destinies as trustees and staff. The words of the Boston charter make it clear that the motivation drew upon the inherited ethic—"for the common good." The founders were leading private citizens in both the learned and financial spheres of Boston—men

like Charles William Eliot, the president of Harvard; William Barton Rogers, founder of the Massachusetts Institute of Technology; Henry P. Kidder, banker; Martin Brimmer, the first director—men who upon their own initiative believed in creating and maintaining a museum for the "elevated enjoyment of all" with money to be privately raised. Here was a perfect example of the Puritan "right use of riches."

EXPANDING THE BASE

In the middle years of the nineteenth century single-patron art museums bearing the names of their donors had been established by Daniel Wadsworth in Hartford and by William Corcoran in Washington. But Boston in 1870 launched the first art museum to be established and maintained by soliciting support from the general public. This brave venture, chartered by the state and propounding lofty ideals of uplift and education, so impressed the city fathers of Boston that within a short time a site on what was to become Copley Square in the developing Back Bay was granted by the city for the new building, a vivid instance of public policy influenced by a private sector museum.

The private sector provided not only the founding sums of money but also the philosophy of the new institution. The principal spokesman of the incorporators was Charles C. Perkins, a devotee of art who had studied abroad and had become a teacher. He expressed the fundamental argument that "nations as well as individuals should aim at that degree of aesthetic culture which will enable them to recognize and appreciate the beautiful in nature and art." And without being sanctimonious he further said that

> there exists a capacity for improvement in all men who can be . . . developed by familiarity with . . . works of art. Their humblest function is to give enjoyment to all classes; their highest, to elevate men by purifying the taste and acting upon the moral nature; their most practical . . . by the creation of a standard of taste . . . in all branches of industry, by the purifying of forms, and a more tasteful arrangement of colors in all objects made for daily use.

And in speaking of the museum's contents he further states:

> As its aims are educational these objects must be . . . of such a nature as to place the institutions . . . high . . . in the esteem of the community

as a means of culture to the public, of education to artists and artisans, and of elevated enjoyment to all (Walter M. Whitehill, *Museum of Fine Arts, Boston: A Centennial History,* 1970.)

ONE THOUSAND PATRONS

From the first fund raising by the founders of the Museum of Fine Arts the democratic nature of the enterprise was made clear. The initial subscription resulted in $261,000 from about 1,000 individual donors; a little less than one-half of this sum was contributed by 22 donors, the largest gift being $25,000, the smallest, $2,000. The balance came in small sums. The workmen at the Chickering Piano factory subscribed $4,404; public school teachers, $764; the mayor and city officers, $362; the employees of the Smith Organ Co., $361; and an anonymous "believer in fine arts" contributed $1. There were three gifts of 50 cents and one of 35 cents! This show of interest and support from a wide segment of the local citizenry embracing the affluent and the impecunious made it clear that the institution would have to be tax-free like other charitable and cultural establishments. This tax policy under the influence of private philanthropy has almost invariably since that time been observed as self-evident. (An exception was the ill-advised assault in 1983 by Mayor Edward Koch to revoke the tax-free status of New York City museums, a move that was terminated with admirable dispatch and accompanied by outspoken indignation.)

NEW PRIVATE COLLECTIONS

Like most museums the Museum of Fine Arts had its financial ups and downs; but anxieties, deficits, and disappointments notwithstanding, the Museum was able barely thirty years after its first building opened to plan the erection of a new building nearly three times the size of the original on a twelve-acre site which the trustees had purchased and improved in the Back Bay Fens at a cost of $1,214,000. In Boston there was no free land in a public park to settle on as it profited the Metropolitan Museum to do in New York's Central Park. The new Museum of Fine Arts opened in 1909 and in the next few years received gifts of collections that are world renowned, collections of Japanese and Chinese art gathered by Ernest Fenollosa and William Sturgis

Bigelow; classical art collected by E. P. Warren; and the beginnings of the great Egyptian Collections, the yield of the Museum's expedition on the Nile which was to continue for forty seasons. Two years after the new Museum opened, Mrs. Robert Dawson Evans pledged $1 million for an entire wing of 130,000 square feet to house the painting and print collections. Another milestone was passed in 1912 when Francis Bartlett, a Boston lawyer, gave the Museum a commercial building in Chicago with a value of $1,350,000 and yielding $50,000 per annum, a gift which in today's terms would amount to perhaps $15 million. Bartlett's generosity was already expressed in 1900 with his gift of $100,000 (today's value: $1.5 million) for the purchase of classical art. By 1903 the entire sum had been spent for 290 first-class objects, including the famous Greek marble head of Aphrodite!

THE BEGINNING OF RETRENCHMENT

From this period just before the outbreak of World War I until the beginning of my directorship forty years later, the Museum continued to receive bequests, usually restricted to the purchase of works of art; but neither bequests nor gifts could in this long period match those earlier prodigal gifts of Francis Bartlett. This circumstance together with rising costs and deferred maintenance of the plant had presented the Museum with a financial crisis before I assumed office in 1954. As early as 1927 an admission charge was instituted as an emergency measure, but was discontinued as the depression worsened. The public sector remained unmoved by the Museum's plight. As if to prove it, the city commenced to bill the Museum for a sewer tax!

In 1958, asked by the editor of the *Christian Science Monitor* to answer the question "what is the major problem of the art museum administrator in America today?" I wrote the following:

> The major problem of the art museum administrator in America is a financial one. This is the fundamental and central concern. In the future the quality and extent of every aspect of museum performance will rest upon the solution of this problem. No amount of idealistic thought, imaginative planning, or specialized knowledge will quicken the future existence of our proud treasuries of art unless there is also that tangible asset essential to the job—hard cash. Industry and commerce created the immense private fortunes of the past which financed our museums. From the same ultimate source must come the support in the future. . . .

I pointed out that until the federal personal income tax commenced to be imposed in 1913, the excess wealth of a private citizen was apt to be applied to the enhancement of his own community, witness the Museum of Fine Arts; instead, since then the ever increasing personal income tax was siphoning away to the federal treasury large sums for federal purposes. This circumstance drove the great patron from the scene; the local benefactor could no longer afford the role of a Maecenas. Certainly the discontinuance of his largess contributed to the financial crisis which the Museum experienced by mid-century.

GOVERNMENT SUPPORT

Only with the first challenge grant of $2 million to the Boston Museum from the National Endowment for the Arts (NEA) for climate control in 1977 did the imbalance begin to be redressed. The Museum of Fine Arts was one of the great museums of the world; it was an immeasurable cultural resource for the citizens of Boston and the city's huge student body; it had embellished the honor and prestige of the city, the state, and the nation. This single-handed accomplishment by private philanthropy was itself sufficient witness to justify making the first federal grant. In the ensuing years the Museum has been receiving annually an average of $200,000 to $250,000 from all or one of the three federal agencies—National Endowment for the Humanities (NEH), National Endowment for the Arts, and the Institute of Museum Services—as well as the federal indemnity for borrowed works of art.

The very first public money (beyond the original Copley Square site) ever granted the Museum was received in 1966 from the Commonwealth of Massachusetts. Mounting deficits had forced the Museum to commence again to charge admission. This applied to all visitors except children up to six years of age. It was made clear to key legislators that free admission of school children could not be offered without a subvention from the state. Not wishing to dishonor themselves by depriving innocent children of this privilege, the legislature found it possible after nearly 100 years to provide $100,000 (now $137,000) in the annual budget for the Museum of Fine Arts. Soon thereafter it was only proper to expunge from the central rotunda of the Museum the longstanding magisterial inscription in gold letters:

Museum of Fine Arts.
Founded, Built and Maintained
Entirely with the Gifts of
Private Citizens.

From the Massachusetts State Art Council, the Museum now receives an average grant of about $150,000 based upon application for specific projects.

The Metropolitan in the Park

The experience of the Metropolitan Museum, though almost as private an institution as the Museum of Fine Arts, was of wide variance in influencing the public policy of New York City. Fundamental to this difference was the fact that the original building was erected at the expense of the city and stood on public parkland. New York City was thus committed from the beginning to the welfare of the Metropolitan. The gifts received and the popularity of the Metropolitan in its first years had their effect on the city fathers, so much so that as early as 1896, the Boston trustees, bitterly suffering their deficits, could look with envy upon their rival which had received $90,000 from the New York City treasury for current expenses. Such municipal "care and feeding" ordained by public policy has continued in lesser or greater degree ever since. In 1983 the Metropolitan Museum received nearly one-third of its annual operating income from public sources as a whole. The balance was private income from securities, memberships and contributions, admissions, services, and sales.

The St. Louis Art Museum

Two of the oldest museums in the Middle West had histories which were almost the opposite to those of New York and Boston; the St. Louis Museum of Art and the Detroit Museum of Art both "went public" when each was no more than forty years old. This is of course a simplification but in essence the truth. The St. Louis Art Museum, dedicated in 1881, combined with it an art school. It was built by one man, Wayman Crow, a merchant and state senator, as a department of Washington Uni-

versity. The first director of this privately created Museum, Halsey Ives, who took office at the dedication, was an artist and educator. His experience as advisor to the Columbian Exposition in 1893 qualified him for similar responsibility at the immensely successful St. Louis World's Fair of 1904 which featured an art pavilion designed as a permanent Museum building. Wayman Crow's example led to the concept of a large independent Museum to be supported by the city on the basis of a mill tax levied on real property. The exposition company donated the building to the city, the city tax law was upheld by the Supreme Court in 1911, and the Museum was reborn on a new and solid public footing.

BLENDING PUBLIC AND PRIVATE

Nevertheless, in time it became clear that the Museum could not grow and prosper on the inflexible mill-tax income that was supposed to leave a balance for the purchase of works of art after operating expenses were met. The Museum had not generated the personal commitment in the community that was needed to advance its fortunes. Thirty years after the Museum became a municipal institution, it had received a mere $200,000 in bequests for purchases of art. The return of private patrons and their influence was overdue. In 1950 the Friends of the Museum was founded; its principal purpose was to raise funds for enriching the artistic content of the institution. Not only was the first objective swiftly accomplished, but the personal commitment to the Museum thus generated among thousands of members created an influential body of support which succeeded in persuading the electorate to vote to apply the mill tax to the entire county of St. Louis. As a result, the Museum today is in sounder financial situation than ever, and has a huge constituency of members (now numbering over 11,000 and producing over $460,500 annually) prepared to defend and protect the Museum in times of political or financial crisis.

Such a crisis, in fact, was acted out during my directorship. The city comptroller, Louis Nolte, objecting to a certain Museum purchase with city funds, threatened to transfer our rightful apportionment to the zoo (also mill-tax supported) and scornfully referred to the Museum's purchase of an Egyptian bronze cat for $14,400 in 1938. Our president, the late Daniel K. Catlin, met the

challenge head-on by reminding Nolte of a purchase also in 1938 of a sea lion by the zoo for $10,000. Six weeks later the sea lion contracted pneumonia and died, uninsured. Which, Catlin demanded, was the better investment? Nolte, vanquished by a word, restored the Museum's apportionment then and there.

Detroit Museum of Art

The Detroit Museum of Art was founded by a group of private citizens in 1880 and developed its collections slowly and without conspicuous success during its first forty years. Nevertheless the Museum had pioneered and won an undeniable place in the cultural life of the city. Under the leadership of an ambitious president of the trustees, the Honorable Ralph H. Booth, it was deemed advisable for a city under swiftly changing conditions, physical expansion, and rising population to give the Museum a boost by transferring it to the public sector, enlarging its role and housing it in a splendid new building under the name of the Detroit Institute of Arts. This was accomplished in 1927. But the private sector has remained a vital component of the city-owned Institute to this day. Known as the Founders Society in recognition of the original Museum, its principal function is to raise money for enriching the collections of the Museum and for special projects.

The city of Detroit did not provide funds for the purchase of art sufficient to satisfy the inspired and enterprising new scholar-director, Dr. W. R. Valentiner. He knew the value of the private collector from his experience before the First World War on the staff of the Metropolitan Museum under the presidency of J. Pierpont Morgan, one of the greatest of all collector-benefactors. So Valentiner accepted the challenge of *creating* Detroit collectors by organizing a private art seminar under his own instruction. It would not surprise anyone to learn that this small circle included Edsel and Eleanor Ford, Mrs. Ford's cousin and her husband, Josephine and Ernest Kanzler, and Robert H. Tannahill, heir-to-be to the J. L. Hudson mercantile fortune. The circle of cousins became a circle of collectors of formidable means and newly cultivated taste. The Detroit Institute of Arts is vastly richer today, thanks to the gifts and bequests of works of art from these seminar pupils of the director.

Creating a Museum Public

Needless to say, without art there can be no art museum, hence no museum constituency. In colonial America (in addition to family portraits and folk paintings) copper plate prints, aquatints, and, in time, lithographs of portrait or genre subjects—largely British imports—were not uncommon. Beginning in the first decades of the nineteenth century, art began to take a place in American public life. John Vanderlyn exhibited his panorama of Versailles—a great circular canvas—in a specially designed rotunda in New York in 1819. Such institutions as the Boston Anthenaeum (founded in 1807), the Pennsylvania Academy of the Fine Arts in Philadelphia, and the short-lived New York Gallery of Fine Arts commenced to hold periodic exhibitions of painting and sculpture, and two of these institutions were beginning to develop permanent collections. But these organizations afforded the only regular exposure of professional art of any kind to the citizens of the early Republic. Considering the country as a whole and the difficulties involved in travel, the audience was perforce a very limited one. No doubt bigger ideas of the public role of art were already beginning to percolate in fertile minds. It can be said that Samuel F. B. Morse's *Grand Gallerie of the Louvre*, painted in about 1832, though it is indeed a faithful rendering of the subject, embodies also a wish-fulfilling dream of an American museum, even to the detail of young artists seen copying the works of the masters.

VISITS TO EUROPEAN MUSEUMS

The surge of technology in the nineteenth century brought two inventions that can be said to have contributed to the founding and development of the American art museum: the steamboat and the steel engraving. They enabled Americans in large numbers to experience art as never before. The packet steamer before the middle of the century made ocean travel not only relatively comfortable but of reasonable duration; a matter of days at sea instead of weeks. European museums—the obvious model for our first museums—at last became available to the eyes of the educated American. In the vanguard of European travel, to be sure, had been the artists, amateurs of art, and art collectors of the early

Republic, some of whom had made their pilgrimage before the advent of steam, among them even certain citizens who became founding museum trustees.

THE CIRCULATION OF ENGRAVINGS

The Art Union movement which began in 1839 capitalized on the newly developed steel engraving to promote art in American life and to patronize native artists in a systematic way. The central feature of the enterprise was an annual exhibition of paintings to be distributed by lottery to the subscribers of the Union. Of wider influence, however, was the promotional practice of the annual distribution of the steel engravings of the year, taken from works included in the exhibition. In the reproductive process the newly introduced steel plate had a unique advantage; it was capable of infinite impressions of a faithful and highly refined image of the original painting. Such classic American genre paintings as George Caleb Bingham's *The Jolly Flatboatmen* and William Sidney Mount's *Farmer's Nooning* were among the most popular works distributed. By 1851, the ultimate of three such art subscription organizations, the American Art Union, had enrolled nearly 19,000 members, some of them as far away as the then western borders, all of them recipients of the steel engravings of the year. For Americans in increasing numbers, apart from family portraits, these reproductions constituted their first exposure to serious art. The grass roots of private museum patronage were planted in soil thus cultivated.

CULTIVATING THE PRIVATE COLLECTOR

In the first museum course offered in the United States, the famous graduate seminar known as "Museum Problems and Administration" conducted by the late Paul J. Sachs, heavy emphasis was placed on the importance of the private collector in respect to the development of museums. Sachs exhorted his students to cultivate collectors as potential donors in whatever museum community they were to serve. Sachs himself set a brilliant example; over a long life he had created one of the finest collections of old master drawings in the nation. The entire collection of over 500 drawings is today a priceless treasure of Harvard's Fogg

Museum, as his bequest. Each Christmas vacation it was Sachs's happy practice to take his students on an inspirational tour of private collections in New York and Philadelphia. I was fortunate in 1933 to be among his students in this annual ritual. In New York we visited the stunning collections of Adolph Lewissohn and his son Samuel Lewissohn, those of Grenville Winthrop, of John D. Rockefeller, Jr., of Jules Bache, and the library of J. Pierpont Morgan. In Philadelphia we explored the magnificent collection of Joseph Widener at his great country house, Lynnewood Hall, and the collection of Mrs. John McIlhenny in Germantown. One's awe at seeing for the first time these fabulous assemblages of art in private homes will not be forgotten. The subsequent history of all this privately owned art has proven a perfect example of Sachs's precept. Every one of these collections valued in untold millions of dollars is now in the public domain as a gift or bequest of the collector; the entire Widener collection is one of the principal enrichments of the National Gallery in Washington; one of the most notable creations of John D. Rockefeller, Jr.'s manysided collection, the complete French medieval cycle of the unicorn tapestries, is today a display of inexpressible beauty at the Cloisters, the Metropolitan Museum's branch in Fort Washington Heights which itself was a gift of Rockefeller. Given as he was to aphoristic teaching, Professor Sachs could well pronounce to his students that no well-heeled and cultivated New Yorker could die a respectable death without remembering in his will the Metropolitan Museum of Art.

THE PRIVATE ART COLLECTOR AS A SPECIES

Indeed, it would be hard to overestimate the importance of the private collector in the life of the American art museum. In our society this role has proven to be nothing short of vital whether under the laissez-faire dispensation of the nineteenth century or under our present income tax laws. Let us recognize the material significance of private collectors in their role as museum benefactors; let us admit that the totality of their gifts and bequests to the public sector amounts to untold millions, even billions, of dollars. What these gifts have totaled in their spiritual radiance for all to behold over the past 100 years is, of course, incalculable.

It is a commonplace today to denigrate museum gifts of art as merely a tax-avoiding practice. While this impulse certainly colors many such donations, under present tax laws indifference to legitimate deductibility would be folly if not unaffordable.

PRIOR TO TAX EXEMPTION

Moreover, in defense of American generosity for the public benefit, it is well to remind the cynic of the lavish gifts to American museums of art *and* money before the introduction of the personal income tax. No such tax consideration conditioned the gifts in 1896 of Dr. Charles G. Weld, who made the Boston Museum first in the world after Japan for its Japanese collections, or the 50,000 items given by Dr. Denman W. Ross from 1899 to 1934 to the same Museum which made its Chinese collections unequaled in America save possibly by the Freer Collection in Washington. In varying degrees the performance of the collector-benefactor has been repeated all over America. And older museums offer in a sense what amounts to a mosaic of private collections: the Art Institute of Chicago is synonymous with the collections of Martin Ryerson, Potter Palmer, Birch-Bartlett, Maude Buckingham, to name a few; the Metropolitan immediately recalls the Altman, Havemeyer, Marquand, Thornton Wilson, Morgan, and Lehman collections. Some collectors have made whole museums of their collections and endowed them to be operated for the benefit of the public; the Isabella Stewart Gardner Museum in Boston and the Frick Collection in New York are two famous examples.

THE MELLON GIFT

By far the most splendid example of private art museum patronage in America waited upon the inspiration and munificence of Andrew W. Mellon. In 1937 he presented the nation with the $14 million needed to build the National Gallery of Art, an endowment for its maintenance, as well as his own private collection of old masters which included renowned works acquired from the Hermitage Museum in Leningrad. Mellon provided an art museum worthy of the capital of the United States of America. This unparalleled benefaction very promptly influenced public

policy. From the time of the Gallery's opening in 1941 its activities and operating funds have been provided by an annual appropriation from Congress.

VALUATIONS AS GIFTS

Such a prodigality of works of art—irreplaceable assets to any community—could not fail to influence policy, and legislators have exempted such gifts from transfer tax, and the privately funded one-collector museums from real estate tax. However, these laws may not be assumed to remain unchanging; and official indifference just short of hostility to the values of art as a cultural factor continues to lurk in the corridors of officialdom. In 1966 the Congress requested the Internal Revenue Service for a revision of the income tax statutes. Among the changes, some lawmakers urged that gifts of works of art to qualified institutions be admitted for deductibility only at the taxpayer's original purchase price. For example, if a Winslow Homer had been bought in 1920 for $10,000 but had a market value in 1960 of $210,000, it would qualify in 1960 as a deductible gift to a museum at only the original price of $10,000 (and even without any regard for the inflation of the dollar!) This would obviously deliver a devastating blow to museums, and gifts of works of art to museums would be a thing of the past. In my capacity at the time as president of the Association of Art Museum Directors, I was called upon to testify before the Finance Committee of the Senate regarding this revision. Thanks to the sympathy and cooperation of Senator Wallace Bennett of Utah, a member of the committee who warmly favored encouraging tax benefits in charitable giving, our position won the day. The senator agreed to ask me certain crucial questions; one was what would be the fate of works that normally would be gifts? My answer was simple: they would go back into the market, or in the case of European works they would return to Europe as the European market had become as active as the American. How could such a change in the law be of benefit to Americans? To this day the tax law remains unchanged in this important respect. But another disadvantageous new regulation in the 1969 tax law required a private foundation supporting an art museum—even though its only purpose was service to the public—to pay a federal tax of up to 4 percent of income annually.

MUSEUM MEMBERSHIP AS PRIVATE PATRONAGE

It has been my privilege to establish the membership system in two leading American museums, the St. Louis Museum of Art and the Museum of Fine Arts, Boston. The result led to the revitalizing of both institutions. The museums in our society need a substitute for the stabilizing force which in other countries, influenced by very different traditions, is provided as a matter of course by the government. Both of my institutions needed more money for every purpose, and the public sector provided little or no encouragement. Both museums deserved greater usage, wider participation from the public, and the experience of other museums had proven that membership could produce and multiply participation.

Museum membership has many advantages. Through payment of annual dues a personal commitment to the institution is generated. Membership draws the individual and the family into a closer relationship with what the museum offers—exhibitions, publications, lectures, films, art-centered social events. A museum member automatically becomes a part of the art constituency of a community whose value and influence can be manifested in the political arena of city, state, or federal government, such as appropriations by Congress for the NEA or NEH; in other words, for bringing influence to bear on the public sector. Membership provides an avenue for gifts of money and art, and it also discovers and aligns talent for programs conducted by volunteers in the museum.

During my directorship in Boston in the 1960s I was called upon by the Soviet minister of culture. During a walk through the early American galleries he was puzzled by the framed embroidered hatchments on one wall. I explained that they were the family arms of early colonists that were worked in yarn by the ladies of the day. "What do they do now?" he asked. I explained that on a voluntary basis they conducted teaching tours of the Museum for adults and school children. "That's progress!" he allowed. Then I explained to him that the entire Museum, every brick and every work of art, was given by private citizens with no help from the government. The minister obviously didn't believe a word of it, and I thought it useless to explain membership to him.

Members of the Boston Museum have also been invaluable in influencing public policy by making appeals to the State Council on the Arts for funding certain programs. They were a vital element in raising money for the Museum's centennial in 1970 and in raising matching funds to satisfy an NEH grant for climate control. But the success of membership is most strikingly measured in the actual dollar revenues. On my arrival at the Museum in 1955, there were 2,200 "subscribers" on the rolls, most of them contributing $10 per annum; 500 of them, I discovered, were contributing $5 per annum. There was no annual fund-raising effort. Upon my retirement in 1972 there were over 14,000 members contributing about $650,000 per year. In 1983 the membership had grown to about 30,000 contributing in that year $2 million.

Membership in the St. Louis Museum, which was inaugurated in 1950, had grown sufficiently in numbers and prestige by the seventies to play a vital role in dealing with the Missouri legislature and with Governor Christopher Bond in preserving for the state the 109 superb drawings by George Caleb Bingham belonging to the old private Mercantile Library. These were about to be sold into the New York market. The St. Louis Museum with the help of its membership pledged to match the $500,000 guaranteed by the state for a total of $1 million. With the successful conclusion of the campaign in 1975 the drawings by Missouri's "artist laureate" were permanently secured.

Conclusion

A recent official count brings the number of American art museums to about 300, a prodigious growth considering that 100 years ago there were fewer than 10. Not only the spread of education and specifically art education, and not only the prodigious expansion of amateur art collecting are responsible for this development. It has also been inspired by local pride and rivalry. Even in our own times a few of the most distinctive museums have been established by a single donor. One of these is the William Rockhill Nelson Gallery in Kansas City, Missouri. Today, only fifty years since opening its doors, the Nelson Gallery is one of the leading museums in the country. More recently the Kimbell Art Museum of Fort Worth, Texas, was established by the

Kimbell Foundation with an endowment exceeding that of the oldest and largest museums in the country. It would seem as if Americans had accepted the idea, consciously or not, that a city's distinction could be gauged by the distinction of its art museum.

Paul J. DiMaggio

4

The Nonprofit Instrument and the Influence of the Marketplace on Policies in the Arts

Americans experience the live performing arts and the visual arts predominantly through the good offices of nonprofit organizations. Nearly all symphony orchestras, resident theatres, dance and opera companies, and approximately two-thirds of our art museums are private not-for-profit organizations. Such organizations, forbidden by law from distributing income as dividends to owners, members, or staff, are insulated from the pressures that profit-seeking enterprises face from shareholders eager to optimize returns on their investments. Because nonprofit organizations need not maximize net income, public policy assumes that they will maximize something else—in the case of artistic institutions, a combination of services and aesthetic quality. To increase the chances that this will occur, public policy makers provide additional incentives to arts organizations that adopt a nonprofit form: exemption from certain taxes, the right of donors to deduct

PAUL J. DiMAGGIO *is associate professor at Yale University's Institution for Social and Policy Studies and in the Sociology Department and the School of Organization and Management, and he is the executive director of the Program on Non-Profit Organizations. Dr. DiMaggio is a member of many national and regional advisory committees, including the Connecticut State Commission on the Arts, where he serves as second vice chairman. He has also written numerous articles and essays for national publications.*

contributions from individual and corporate incomes for tax purposes, and eligibility for grant-making programs that exclude profit-making firms.

Although most arts organizations are nonprofit institutions, they are not nonmarket institutions. American museums and performing arts organizations exist in a market economy, and they need resources to survive and perform the functions for which they were created. With very few exceptions, nonprofit arts organizations are buffered from the marketplace, but are not exempt from its demands.

The purpose of this chapter, then, is to assess the influence of the marketplace on policy in the arts. "Policy" refers not only to the programs or objectives of public agencies or large institutional donors, but also to the strategies that arts organizations themselves pursue. The marketplace affects both the aesthetic policies of arts organizations and their organizational structures, which invariably influence aesthetic decision making.

The ubiquity of the marketplace, in reality and rhetoric, places demands of an exceptional kind on the arts in the United States, and makes our cultural policy unique. To gain some perspective on this uniqueness, consider the following statistics, all from the early 1970s and all reported in a study by Yale economist J. Michael Montias in *Comparative Development Perspectives,* edited by M. Leiserson et al. Earned income represented 23.2 percent of all revenue for a sample of Austrian nonprofit performing arts organizations; 31.9 percent of the income of a French sample; 17.8 percent in Germany; 20.8 percent of the revenues of Dutch nonprofit theatres; 13 percent of the income of other nonprofit performing arts organizations in the Netherlands; and just 10.5 percent of the revenues in Sweden. In the United States the total contribution of earned income was 54 percent, a figure that is even more striking because unearned income from private sources—individuals, foundations, and corporations—is also dramatically greater than in Western Europe. The cause of the greater reliance of U.S. organizations on earned income lies in the smaller proportion of government subsidy, an area where European nations dramatically outstrip the United States. For this reason, the extent to which American artists and artistic institutions are subject to the influence of the marketplace is virtually unparalleled in the developed world.

Economic Theories of the Marketplace for the Arts

When economists speak of "the market" they have in mind a very simple and efficient mechanism for allocating resources and satisfying desires. An economic market, in its most perfect form, is simply a mass of consumers making individual decisions on the basis of perfect information among profit-maximizing firms with substitutable products. The word "marketplace" connotes something quite different—a place where many sellers peddle a diversity of wares to a varied group of buyers who make comparisons and trade rumors about the quality of goods available in the different stalls. Such a marketplace has everything, perhaps, except the staples of the economists' market—perfect information, similar but isolated consumers, and substitutable products.

The arts marketplace, in economic terms, is an imperfect one. Products could hardly be less standard. Not only do individual producers design their offerings in characteristic ways (one is unlikely to buy a ticket to *Othello* unless one knows something about the company mounting the performance), but each supplier offers an unending cascade of new productions, performances, or exhibitions. Consumers' information is far from perfect. Except for aficionados, most audiences cannot predict a given performance's quality or their own reaction to it. Nor do buyers make their choices *in vacuo*. Market research has shown that word of mouth is the most potent form of advertising for the performing arts.

WHAT IS MAXIMIZED?

Most importantly, the arts marketplace consists of firms that, unlike those in the economists' perfect market, steadfastly refuse to maximize profits. In order to assess the influence of the marketplace on the arts, economists have had to revise their theories to take account of the goals of arts managers and trustees. If artistic firms do not maximize profits, then what they do maximize needs to be discovered in order to anticipate the effects of market forces on their behavior.

The list of candidates is enormous, and each participant group is likely to have its own objectives. Artists or artistic directors may wish to maximize the challenge of their work or their opportunities for innovation or virtuoso performance, their job security or

income, or the flexibility of their schedules. Administrators may hope to increase their professional stature by maximizing the number of critical successes, revenues by boosting attendance, or their own salaries by inflating the operating budget (the best predictor of top administrators' compensation in the performing arts). Trustees may hope to maximize prestige by making their institutions grow or to maximize their feeling of ownership and exclusivity by keeping them small. With objectives so numerous and variable, it is indeed difficult to assess the manner in which museums and performing organizations respond to the market.

In an effort to explain the prevalence of the nonprofit form in the performing arts and the low ticket prices (relative to fixed costs) charged by nonprofit performing arts organizations, Henry Hansmann of the Yale Law School has argued that theatres, orchestras, operas, and dance companies are unable to recoup the real costs of their productions and, consequently, charge prices that will optimize not earned income but the sum of earned and contributed revenues. In the autumn 1981 *Bell Journal of Economics* Hansmann asserts that donations represent a form of "voluntary price discrimination" whereby persons who place a high value on artistic performances subsidize low ticket prices for the rest of the audience. At a price level sufficiently modest to arouse the contributor's sympathies, a nonprofit performing arts organization can attain revenues greater than those available from admissions income alone.

The effects of such market calculations on the behavior of the nonprofit performing arts organization will depend, writes Hansmann, on the goals of the organization's artistic director, managers, and trustees. Management may choose to maximize quality and thereby limit the size of its audience or to maximize audience size but limit the quality of its productions. (The assumption is not that the audience is perverse, but rather that high-quality performances, however defined, bear higher fixed costs than low-quality ones. Consequently, expanding the audience is, under most conditions, a more effective economic strategy for the low-quality producer for whom a larger audience can better offset the costs of production.) One implication of Hansmann's argument is that nonprofit performing arts organizations can survive in the marketplace in at least two different ways—stay small and

concentrate on a select group of consumers and patrons or grow larger and make a greater number of artistic compromises.

THE EARNINGS GAP

Other economists (led by William Baumol and William Bowen in their 1966 work, *Performing Arts: The Economic Dilemma*) have demonstrated that arts institutions face a gap between earned income and operating expenses that is likely to grow for reasons beyond their control. In the manufacturing sector, steady increases in productivity fuel higher salaries. The performing arts and, beyond a certain level of attendance, museums are unable to share in this expanded productivity because their technologies are fixed and their sales limited by the size of their physical plants. The price of attendance can be increased but only modestly, lest consumers choose less expensive forms of entertainment. Consequently, arts organizations face steadily rising costs with no way to pay for them except higher levels of subsidy.

In its broad outlines, the Baumol and Bowen argument is almost certainly correct. Without reducing their quality dramatically, performing arts organizations can rarely pay their way on earned income alone. Indeed, one reason some arts organizations survived before the growth of large-scale foundation, corporate, and government subsidy was that they were subsidized massively by participating artists who worked—as they still do—for pay markedly below that of comparably educated labor in other fields.

With the advantage of hindsight, however, one can question the Baumol and Bowen thesis on several grounds. First, an orchestra can increase its productivity without (to cite their famous example) instructing the musicians to play twice as quickly. Some of the methods for doing so—reducing rehearsal time, cutting orchestra size, or reducing wages—are undeniably controversial. (Orchestras could, for example, follow the lead of the commercial recording industry by substituting synthesizers for the back chairs of their string sections.) I mention these possibilities not as recommendations, but to underscore the fact that the rationale for subsidy is less implicit in the logic of the market than in the valuation of such noneconomic criteria as performance quality.

Second, there are avenues toward increased productivity that

may not have a deleterious effect on artistic standing. The constraint of house capacity can be reduced, for a time at least, by moving into larger quarters. Economies of scale in rehearsal time can be attained by offering orchestra subscription series on an extra night or longer runs for theatrical productions. In some cases, new marketing approaches can produce audiences sufficiently large to capitalize on these strategies.

Third, Baumol and Bowen may have been too optimistic in their predictions of productivity growth in the economy as a whole. As industrial-policy analysts have noted, a major change in American economic structure has been the shift from manufacturing to service industries, which share the "cost disease" that Baumol and Bowen identified. In the years ahead the arts may be much less atypical in their pattern of productivity growth than they have been in the past.

THE DYNAMICS OF GROWTH

It is worth noting that the existence of a budget gap is not proof of its economic inevitability. Most arts organizations have expanded in recent years, and expansion incurs costs that increase demand for both earned income and subsidy. Indeed, a dynamic of growth may be inherent in the combined system of private and public support in the United States. In most arts organizations a manager must avoid incurring deficits so large that he or she appears inept or irresponsible and the fate of the organizations seems clouded. Yet managers must also avoid large surpluses of revenues over operating expenses (unless such a surplus can be allocated to matching a challenge grant). Net income is apt to make potential patrons—private and public—question the depth of an organization's need relative to that of other petitioners. Consequently, rational arts managers will be not profit maximizers but *deficit optimizers,* ensuring deficits sufficiently large to attract grants and donors but not so great as to call into question their competence or the organization's survival. Nonprofit managers must always be ready with a list of new programs should potential surpluses appear on the horizon, and it is easier to add programs than to eliminate them, particularly if they involve a commitment to staff or capital plant. Thus, the logic of management bears an intrinsic expansionary dynamic. If the budget gap did not exist, arts organizations would have to invent it.

How Much Income Do Nonprofit Arts Organizations Earn?

The influence of the marketplace appears on an arts organization's balance sheet as earned income, and the best single measure of the marketplace's impact on an arts organization's policies is the percentage of its income that is earned.

Unfortunately, available information is less than adequate to the task of reaching confident and comprehensive conclusions. The most reliable data come from the Ford Foundation's 1974 report on *The Finances of the Performing Arts*. But that information was collected over a decade ago and is limited to large organizations in the performing arts. The data on resident theatres and symphony orchestras have been updated by the Theatre Communications Group (TCG) and the American Symphony Orchestra League, but data on opera, ballet, and dance have not. There is no reliable longitudinal data on art museums' income patterns, and only the sketchiest information of any kind is available regarding earned income in presenting organizations, very small performing arts organizations, neighborhood arts organizations, local arts agencies, and visual arts organizations. Matters are complicated further because extant sources are inconsistent both in the samples upon which their findings are based and in the way earned income is defined. Combing the available data in a scientific manner is beyond the scope of this chapter; consequently, only a few broad generalizations consistent with the array of available information follow.

The performing arts are dependent upon the marketplace for survival. On average, large resident theatres earn 65 to 70 percent of their operating incomes; orchestras, 45 to 60 percent; dance companies, 55 to 65 percent; and opera companies, 45 to 55 percent.

To varying degrees, other arts organizations also depend upon the market. On the average, art museums earn about one-third of their operating income; presenting organizations, two-thirds; local arts agencies and service organizations, 30 to 40 percent; and, to make a rough estimate, smaller minority arts organizations, approximately 20 percent.

With the exception of professional resident theatres, dependence upon earned income does not vary sharply with size. Larger

institutional theatres earn about two-thirds of their operating income, while smaller, more "developmental" theatres earn between 35 and 45 percent.

TICKET SALES

Most of the income earned by orchestras and resident theatres comes from tickets sold either singly or by subscription. Large orchestras can supplement this amount through recording contracts. Dance companies, by contrast, have been dependent upon touring contracts for their earnings. Due largely to change in National Endowment for the Arts (NEA) policies, this proportion is changing, but it is too early to estimate this transformation's precise effects. Art museums depend less than performing arts organizations on admissions and membership income for a share of their earned income, and they vary widely in their interest and success in capitalizing on such ancillary sources as gift shops and restaurants. Less traditional arts organizations differ so dramatically in their earned-income patterns as to defy generalization. Some neighborhood performing arts organizations have earned much of their income from service contracts with city agencies. Some crafts organizations earn significant portions of their funds from members' fees, sale of goods, or course tuitions.

CONTRIBUTED INCOME

Have arts organizations become more dependent upon contributed income, as the Baumol and Bowen thesis suggests they should? The answer depends upon the time span one inspects. During the period of the Ford Foundation study (1965–71), earned income as a percentage of operating income declined for theatres, orchestras, and opera companies, but not ballet and dance groups.

But this was an era during which private foundations, government, and, to some extent, corporations began to fund the arts in significant amounts. Data from the more distant past are restricted to eleven orchestras that Baumol and Bowen followed for almost thirty years. Earned income for these rose sharply in the postwar period, but by 1963–64 had declined to prewar levels. Earned income as a percentage of operating income appears to have stabilized between 1970 and 1980, with some annual

fluctuations but no apparent long-term trend. In the December 1980 *Journal of Cultural Economics,* Hilda and William Baumol report that, contrary to Baumol and Bowen's earlier predictions, orchestras avoided soaring deficits during the 1970s. They attribute this finding, however, to the imposition of ultimately undesirable economies (for example, reductions in musicians' real salaries and cuts in rehearsal time) and to the unusually sluggish growth of productivity in manufacturing during that decade. The TCG data indicate that within the earned-income category for resident theatres, the distribution has remained roughly constant, but for an increase in subscription income at the expense of single-ticket revenue. The available data, then, are as consistent with the "expansion" model described above as with Baumol and Bowen's diagnosis of the "cost disease." Some economists have suggested that these trends represent short-term gains in nonartistic productivity that, in the long run, cannot keep up with costs; this remains to be seen.

THE IMPLICATIONS

Figures representing earned income can be evaluated in one of two ways. The percentage of an organization's income that it earns in the marketplace may be regarded as a sign of health, and contributed income may be seen as evidence of market failure and fiscal constraint. By contrast, we may view unearned income as a source of entrepreneurial and creative expansion, and treat earned income as evidence of the extent to which the arts are indentured to the tyranny of the marketplace. Which perception is correct varies, of course, from case to case, depending upon whether the organization has expanded its activities; kept prices down; taken more artistic chances; or, by contrast, is simply straining to maintain its current level of operations. Available data do not permit us to assess which pattern is most common. Echoing the frustration felt by many participants in the resident stage, Edward Martenson, director of the Arts Endowment Theatre Program, wrote in the Fall 1983 *Arts Review:*

> Artistic progress is . . . limited by the expectation of a high proportion of earned income compared to total expenses—a low earnings gap—which in turn generates a low expectation of the need for contributions. This expectation is generated by a misunderstanding, shared by many

professionals, trustees, and funding sources, that a low earnings gap is evidence of good management. In turn, this misunderstanding of the nature of the earnings gap has tended to undermine the artistic strength of theatres by forcing them to rely too heavily on ticket sales. Too heavy reliance on audience popularity tends to discourage artistic risk taking, to the disadvantage of long-term artistic vitality.

The Changing Marketplace for the Arts

Before addressing the influence of the marketplace on the arts, let us consider four ways in which that marketplace has been changing. First, the American population has been transformed. Not only are there more of us than ever, but, for most of our recent history, we have become wealthier, better educated, and more likely to pursue white-collar occupations. (In recent years, these trends have begun to slow or, in some cases, to be reversed.) Second, the arts marketplace was affected by the entry of three important new actors between 1955 and 1970—private foundations, government, and corporations. These new players altered the rules that the marketplace once followed.

Third, and partly as a result of the first two factors, the marketplace for the arts is overflowing with providers, both new organizations in traditional industries and new kinds of arts organizations. This expansion of arts activity has created both unprecedented competition and critical masses that have made even higher levels of production possible. Finally, arts organizations have become unprecedentedly attentive to the marketplace, internalizing it by creating new staff positions responsible for marketing and audience development. The combination of these developments has created a marketplace for the arts that is sizable, complex, and strategically demanding to an extent unimaginable thirty years ago.

DEMOGRAPHIC CHANGE

Has the market for the arts, as measured by the amount that individuals are willing to spend in nonprofit arts organizations, expanded? At one level, it has. Attendance at arts events has increased steadily over the past twenty years, more quickly than the rate of population growth. As William and Hilda Baumol

note, however, there is no evidence that individuals are willing to spend an increased percentage of their real disposable incomes on the live performing arts. (Comparable data for museums and other arts organizations are not available.)

The principal reason for this finding is that real income rose substantially between 1929 and 1978, and Americans spent only a small proportion of this increase on the arts. Per capita real expenditures on the arts rose 12 percent during this period, however. Between 1945 and 1978, there was an increase in real expenditures per capita of approximately 25 percent; and, from the early 1950s, per capita real expenditures have increased even more dramatically. Thus, although the Baumols observe correctly that advocates of the arts have made exaggerated claims about the extent of the "culture boom," spending on the arts increased noticeably during the past three decades. As they indicate, part of this increase is the result of the geographic expansion of the arts beyond a few large cities, aided by foundation and government grants. Yet the new institutions of the hinterlands found audiences, and the old ones enlarged theirs. Part of the reason for increased attendance and per capita spending can be found in the demographic change that occurred over the past two decades.

To understand this, we must first understand what kinds of people traditionally have constituted the market for the nonprofit arts in the United States. Arts consumers are more affluent, better educated, and more likely to work in managerial or, especially, professional occupations than individuals who do not visit art museums or attend live performances. A review of more than 250 audience and visitor studies by Paul DiMaggio, Michael Useem, and Paul Brown (*Audience Studies of the Performing Arts and Museums*) in 1978 reported that almost 60 percent of employed persons in the typical arts audience worked in professional or technical occupations, compared to 15 percent of the adult population at large. And only 3 percent were blue-collar workers (compared to 33 percent of the labor force in 1975). Approximately 80 percent had at least some college education, compared to just over one quarter of adult Americans. When the effects of income, occupation, and education are considered simultaneously, education emerges as the most potent predictor of attendance.

There is little evidence in support of the contention that the composition of the arts audience changed between the early 1960s and the late 1970s.

What changed between 1950 and 1980 was the nature of the American population. First, the baby boom increased its size. Second, a massive growth in higher education increased the percentage of young people in college to half of the eligible population in 1965, producing a bumper crop of college graduates. Finally, real income continued to rise, and the long trend of erosion of blue-collar jobs and the increase in professional and managerial positions continued. During the 1960s and 1970s, demographic and social forces increased the market for the arts, enlarging the number of Americans who fit the arts consumer profile (affluent, educated, and white-collar workers) and decreasing the proportion of those who did not.

If the impact of demographic forces on the robustness of the arts is little understood, then the threat that these same forces pose in the years to come is even more poorly fathomed. The baby boom will continue to yield a rich harvest for a few more years. But already the children of the boom—or the "rat in the python" as demographers call them—have begun to establish homes and families, an activity that takes its toll on the consumption of entertainment outside the home. The replacement of blue-collar with white-collar jobs continues, but will proceed at a slower pace than in the past, with more of it occurring toward the less prosperous end of the white-collar scale. Growth in real income has lessened as the shift from a manufacturing to a service economy has curbed rises in productivity. Most significantly for the arts, the increase in the proportion of young people seeking higher education slowed by the end of the 1960s, and the number of graduates peaked in 1974. Of equal importance, more students are attending community colleges and pursuing vocational curricula. Fewer students are having the kind of college experience— liberal arts curriculum at a residential college—most likely to produce arts consumers. The long-term effect of these developments on the market for the nonprofit arts is difficult to assess, but it should be clear that today's arts organizations face the future without the prospect of the demographic boost they received during the 1960s and 1970s.

THE RISE OF THE GRANTS ECONOMY

A second change in the marketplace of the arts during the past thirty years has been the entry of large institutional donors, specifically private foundations, government, and corporations. Each of these sets of actors came into its own during the 1960s and together they substantially altered the arts marketplace.

The Ford Foundation's active involvement in arts support from 1957, and especially after 1962, was by far the major private effort. It laid the institutional groundwork for the expansion of professional artistic activity in the United States during the 1960s and 1970s. The 1950s and 1960s witnessed, in addition to Ford's effort, a significant increase in both the number and the assets of private foundations; in the 1960s, these institutions as a group increased their commitments to the arts. Baumol and Bowen estimate that in the early 1960s 4 to 7 percent of foundation gifts accrued to the arts and humanities. By contrast, in the late 1970s private foundations were devoting more than 15 percent of their outlays to cultural activities.

Similarly, corporations increased both the amount and the extent of their support for the arts during the 1960s and 1970s. Baumol and Bowen report that business gave 5.3 percent of its donations to "civic and cultural" organizations in 1962. But the Conference Board, using a very broad definition, reports that by 1980 this share rose to 11.4 percent of company gifts.

Finally, government became a significant supporter of the arts with the creation of the National Endowment for the Arts in 1965 and the proliferation of state arts agencies during the 1960s. The Arts Endowment's budget rose from $2.5 million during the first year to over $150 million by the 1980s, and states' support for the arts increased from under $3 million in 1968 to over $135 million in 1984.

By the 1980s, arts organizations that had relied on a combination of ticket sales and private patrons twenty-five years before were receiving as much as 25 percent of their incomes from institutional donors. Three consequences of this development are germane to the current structure of the arts marketplace. First, institutional support has been associated with a massive diffusion of traditional artistic activity beyond the major cities and with a significant

differentiation of cultural work—including the rise of new kinds of arts organizations—in the principal artistic centers.

Second, institutional arts support—particularly programs like the Ford Foundation effort and the NEA challenge and institutional advancement grants—encouraged capital expansion by arts organizations that yielded increases in both capacity and scale of activity. The cost of expanded facilities has added to the pressures on arts organizations to increase earned income and, in some cases, has brought them more actively into the marketplace.

Finally, the increase in assistance from foundations, corporations, and government (much of it in the form of grants-in-aid of new programs) has increased dramatically the complexity of arts institutions' administrative components. In the aggregate, the availability of project support has led many arts organizations to develop a broader range of programs that require more administrative staff and greater attention to coordination. The "grants economy" also provides incentive to arts organizations to hire staff equipped to write convincing grant applications and to back them up with the appropriate financial data. In turn, better financial data and more administrators increase the likelihood that arts organizations will pay attention to market information, if only by making such data readily available.

CRITICAL MASS

A third important change in the arts marketplace has been the appearance of critical masses of resources, organizations, and artists in places that had little organized cultural activity before the 1960s. The growing density of the marketplace in the arts can be demonstrated by a few statistics. Of the 165 resident theatres listed in the TCG's *Theatre Profiles IV*, 87 percent were founded after 1960 and 41 percent since 1970. Sociologist Leila Sussman reports that of the companies listed in the 1979 *Dance Magazine Annual* (not including soloists), 89 percent had been formed in the preceding ten years and most during the previous five. Of respondents to a 1975 sample survey of New York State arts organizations by the National Research Center of the Arts, 54 percent of the theatres, 58 percent of the musical groups, 91 percent of the dance companies, 90 percent of visual arts organizations (excluding museums), and 84 percent of the state's local arts agencies had been founded during the 1960s and 1970s.

Even the most staid and traditional of the arts yielded new nonprofit enterprises during this period. More than a third of a national sample of art museums did not exist before 1960.

The growth of critical masses or artistic resources has been perhaps the most significant development in the cultural marketplace during the past twenty years, for it has created local markets —creative, managerial, and fiscal—where only national markets had existed. Performing artists, and to some extent visual artists, no longer gravitate to New York, despite its magnetic appeal, as if no other venue existed. Aspiring musicians in Minneapolis or Hartford or San Francisco need no longer choose among episodic employment in orchestras, wedding combos, and teaching to make a living. In Hartford, for example, a seat in the orchestra will provide many more services than it did in the 1950s. To supplement orchestral income, there are three chamber orchestras and over fifty smaller orchestras to choose among in Connecticut alone. In many cities around the country, the emergence of opera and ballet companies, chamber ensembles, and civic orchestras has expanded opportunities for musical work and rendered geographic immobility less destructive of career advancement.

Actors may benefit less than musicians from this proliferation of nonprofit arts organizations, but even in theatre a dense underbrush of episodic, semiprofessional—but artistically vital—theatres provide a training ground where more established resident theatres may take root. For example, in Pittsburgh, which has one nationally visible resident theatre, sociologist Mary Garty found no fewer than twenty smaller ensembles, eight of which had their own facilities and fourteen of which mounted three or more productions during the 1981–82 season alone.

Critical mass also enables administrators and, less obviously, trustees to gain experience in nonprofit arts organizations. It makes it possible for state and local arts agencies to mount technical assistance workshops and cost-sharing efforts aimed at creating economies of scale in purchasing, publicity, fund raising, and house management. And although this hypothesis has not been tested rigorously, it seems likely that the availability of artistic opportunities increases the size of the local arts market.

At some point, however, critical mass becomes market saturation and synergy yields to competition for audiences, donations, board members, artists, and performance space. Nationally, the

proliferation of opera companies has increased soloists' fees sharply, even among smaller companies. At the local level, competition for trustees is so intense that small, new organizations often find it difficult to assemble competent boards. In San Francisco during the 1970s a battery of concurrent challenge grants nearly exhausted the resources of the city's major donors. And the growth of touring companies at the state and regional levels has brought organizations with established reputations into unequal competition with struggling local companies.

One could cite many additional examples. The point, however, is that the marketplace, especially outside of New York, Chicago, and Los Angeles, has changed dramatically, increasing the stakes as well as the challenges. Organizations that held virtually worthless local cultural monopolies in the 1950s find themselves in a far wealthier—but more competitive—industry in the 1980s.

THE INTERNALIZATION OF THE MARKET

The cultural marketplace sends signals to nonprofit arts organizations, but to artists, managers, and trustees unaccustomed to recognizing them, such signals may be ambiguous. Managers and trustees in all sectors tend to apply a standard package of solutions to a wide range of problems. If that package includes redoubling marketing efforts, empty seats will trigger an intensification of marketing activity. If not, empty seats may activate premises about the unpalatability of demanding repertoire, and the presentation of more popular plays may be the favored solution. Danny Newman, in *Subscribe Now!* (published by the TCG), notes that performing arts trustees and many managers are more likely to respond to fiscal adversity by attending to fund raising than by trying to increase subscription sales.

The impact of the market on nonprofit arts organizations, then, depends on the extent to which their leadership is prepared to read its signals. In the last twenty years, the larger and more institutionalized nonprofit arts organizations have begun to internalize the market by bringing into their administrative structures staff whose primary responsibilities are marketing and earned income. The creation of these positions, often spurred by fiscal calamity, is itself a policy response to the marketplace. And the market, once internalized with its own organizational advocates, is likely to exert an ever greater impact on organizational strategy.

To what extent have managers of nonprofit arts organizations become more aware of the market in recent years? Some data bearing on this question are available from my own surveys, undertaken at Yale in 1981, of the top administrators of 165 TCG theatres; 155 U.S. major, regional, and metropolitan orchestras; and the 194 largest U.S. art museums. Few of the respondents to these surveys had academic training in management (art or general), a field that trains individuals to think in terms of the market. Nor had many administrators had direct experience in marketing or public information, two staff functions for which the marketplace is most salient. (The one exception to this was among the resident theatres where more than one in four of those managing directors who had entered the field since 1974 had worked in public information and one in six had served on a resident theatre marketing staff.)

As a group, the managers rated their preparation for responsibilities in the areas of marketing and public relations as only fair, or, in the case of substantial minorities, poor. The more recent entrants among the theatre administrators were considerably more buoyant about their expertise than their predecessors. By contrast, change was less evident in the museum and orchestra worlds.

Whatever their levels of preparation, top administrators in these fields reported a substantial amount of in-service education in the areas of marketing and development, largely through workshops, but, increasingly through participation in arts management and general management courses, as well. In all three fields, top administrators' assessments of the relative importance of management versus artistic preparation appear to be changing. Just 27 and 13 percent of the least experienced orchestra and theatre administrators, respectively, maintained that artistic experience was more important than managerial experience for an administrator in a position such as theirs. By contrast, of the most senior cohort, 41 and 30 percent, respectively, adhered to this position. And although more than 90 percent of the most senior group of art museum directors chose artistic over managerial preparation, only 66 percent of the most recent entrants to the field agreed.

A related development is the extent to which arts organizations now employ staff primarily responsible for marketing and audience development. An informal telephone inquiry revealed that

approximately 40 percent of the major, regional, and metropolitan orchestras and 60 percent of the resident theatres listed in TCG's *Theatre Profiles IV* had a regular staff member (other than the top manager) with such responsibilities. A survey of these individuals indicated that marketing staff in both resident theatres and orchestras were young (in their thirties) and college educated, and that about half were women. Theatre marketing staff were more likely to have artistic backgrounds than were those in orchestras. Few in either field majored in administration, although substantial minorities had some graduate training in arts administration or general management programs. The orchestra marketing staff were more than twice as likely as their theatre counterparts to report administrative or staff experience outside the arts. About 20 percent of each group had professional backgrounds in the media or press.

In order to read the signals of the marketplace, an arts organization must have someone—an administrator, a staff member, or trustee—capable of doing so. But the mere presence of someone in charge of marketing or audience development does not guarantee that the market will weigh more heavily in an organization's deliberations. As University of Chicago management professors Paul Hirsch and Harry Davis note, some marketing staff face opposition from artists, and even from managers, who identify marketing with commercialism. Their experience consulting with Chicago arts organizations led them to pose the question "are arts managers really serious about marketing?" Their answer is a qualified yes, once financial circumstances are so desperate as to force managers beyond their standard package of solutions. The long-run implications of this conclusion depend upon whether attention to marketing ebbs or flows; or whether marketing directors, once placed in influential positions, fully institutionalize their functions. If the latter, it may be just a matter of time, given the natural fluctuation in the fortunes of most nonprofit arts organizations, before a crisis leads even the most skeptical administrators or boards to bring marketing directors into their inner councils.

What role do marketing staff play in decisions about artistic programing? The responses of the orchestra and theatre marketing staff surveyed suggested that, as a group, they do have some opportunity to affect repertoire. Approximately 33 percent of the

respondents in each area reported that they were "usually" consulted about artistic program decisions or, in a few cases, "shared decision-making authority" in this area; 25 percent of the orchestra marketing staff and 40 percent of the theatre marketing staff responded that they were sometimes consulted about such decisions. Thus the oft-stated principle that marketing is purely a "support" function, with the sole duty of maximizing the audience for whatever programing is chosen by the artistic director, may be honored as much in the breach as in the observance.

One general conclusion is that the cultural marketplace is more complex and challenging than in the past, and arts organizations that confront this new marketplace are themselves more complex institutions than they once were. We have also seen, from the figures on earned income, that almost all U.S. nonprofit arts institutions rely on the market for a substantial amount of their sustenance and, consequently, cannot fail to feel its influence.

Direct Influences of the Marketplace on the Arts

The influence of the marketplace is artistically conservative. Nowhere is this better documented than where production costs are highest—the world of opera. Sociologist Rosanne Martorella, in *The Sociology of Opera,* a study of the American opera industry, reports that market forces have encouraged standardization of repertoire and a virtual exclusion of contemporary work, moderated only by private and government subsidies during anniversary or gala years. According to Martorella, market pressures, exacerbated by increasing deficits, "have encouraged longer seasons, increased the total number of performances, lowered the diversity in repertoire, and, at worst, acceded to the demands of commercial interests." Conservatism in repertoire, she adds, is strongest in those companies most dependent upon box office receipts for their financial well-being. In one large opera company, for example, the compositions of just six composers accounted for 32 percent of all performances staged between 1954 and 1980. Contemporary opera is most commonly performed by university companies relatively free from market constraints.

As Martorella points out, opera programing decisions are affected by cost as well as demand factors. In 1972, for example, the Metropolitan Opera lost $29,000 per performance of *Aida*

at 98 percent capacity, compared to just $16,000 per performance of *Rigoletto,* which filled only 90 percent of the seats.

The opera audience responds quickly and negatively to novel or challenging work. In 1972, according to figures provided by Martorella, the Met sold a median 93 percent of available seats to productions of eleven of their fourteen most frequently produced operas. By contrast, only 85 percent of available seats were sold for operas that were not part of the top fourteen. Similarly, a study of the Seattle Opera by Mahmoud Salem reports that the critically successful experimental season of 1969–70, which contained no popular operas, reduced both total admissions and subscription sales by over 20 percent.

The situation in the orchestral world is similar. Although there is no consensus on the degree to which challenging or novel work, which may be included in programs with familiar pieces, actually repels the audience, artistic directors and managers act as if the public prefers more standard fare. Philip Hart, whose book *Orpheus in the New World* is still the best treatment of the American orchestra industry, reports that, while critics call for a serious repertoire,

> there is equally strong pressure on many orchestras, from the conservative side, to lighten programing, to include a larger measure of crowd-appealing music. . . . In the face of the very small proportion of the total population represented in symphony audiences, such enterprises encounter considerable resistance in gaining financial support, and are tempted, within the organization, to modify artistic policy to gain wider audiences.

In *Bach, Beethoven and Bureaucracy,* an illuminating case study of the Philadelphia Orchestra during the 1960s, political scientist Edward Arian contends that the orchestra planned its repertoire in a manner calculated to increase box office receipts, maximize record royalties, and economize on rehearsal time. Arian quotes the orchestra's anniversary statement:

> Whatever a conductor's desire to promote new works and give new talent a hearing, he is invariably governed to some degree by the strictly commercial aspect of his selection, meaning the box office appeal (or lack of it).

Nor is the resident stage immune to the call of the box office,

despite the commitment to artistic innovation and growth that many resident theatres evince. Theatres dependent upon the market can rarely risk a full season of experimental work. Most resident theatres, particularly the larger ones, incorporate in their repertoire a careful mixture of the innovative and the familiar, the difficult and the undemanding. A simple, if imperfect, measure of the extent to which resident theatres are conformist in their programing is the number of times a theatre's typical play is performed by other resident theatres over a given two-year period. Using this measure to investigate the relationship between dependence on earned income and conformity, my colleague Kristen Stenberg and I have uncovered some intriguing, if preliminary, findings based on data from the TCG's biennial survey, *Theatre Profiles IV*. Conformity, it seems, is primarily a product of size. Repertoires of large-budget theatres are far more similar than those of smaller ensembles. Even controlling for size of budget, resident theatres with large-capacity houses produce less distinctive repertoires than those with small ones. Having a large house to maintain and fill seems to discourage taking risks.

Findings are more complex regarding dependence on earned income per se. If we exclude New York theatres, earned income is positively associated with conformity, even controlling for house capacity and budget size. In New York, however, the relationship is not significant. Because the New York market contains sufficient numbers of sophisticated theatregoers and competition with Broadway theatres is so intense, innovation is not a poor market strategy (holding size and house capacity constant). The finding that earned income affects distinctiveness negatively is upheld as well by David Austen-Smith's study of British theatres that finds the percentage of costs covered by subsidy (the complement of the percentage of income that is earned) positively associated with the extent to which theatres produce highbrow fare.

If the market discourages innovativeness in the performing arts, its effect on art museums is less uniform, in part because the level of income derived from admissions and memberships is a smaller portion of their operating budgets. Efforts to increase attendance sometimes have had the effect of making curatorial work less interesting and may have made it more difficult for art museums

to attract and retain talented curatorial staff. But museums may value increased attendance less for its direct effect on the bottom line than for its utility in the pursuit of unearned income, particularly grants from public and private institutional donors.

The market also influences arts organizations to invest less heavily in activities designed to advance educational goals or expand the audience's social base, because such activities are likely to cost more than they earn, for several reasons. First, other things being equal, publicity directed at the wealthy brings better returns than that aimed at the poor or even the lower middle class. Not only is income associated with the ability to pay for entertainment or edification; it also is correlated positively with people's taste for the nonprofit performing arts. Moreover, up to a point that most arts organizations have not yet reached, demand for the arts exhibits little price elasticity; most of the current audience for the arts is willing and able to pay more for performance tickets or museum admissions. Economically rational arts organizations increase their prices, thus reducing the likelihood that they will attract the less well-to-do. Finally, educational activities do not pay their own way without grant or subsidy support, unless the services are purchased by municipal government through contract with the provider. In short, the influence of the marketplace on the social constituency for the arts is profoundly conservative.

These findings should be regarded with some caution for three reasons. First, we do not have the kind or quality of data that we should like. Designers and students of cultural policy are still at a great disadvantage relative to our counterparts in such fields as education or health, where much more research has been undertaken. Second, these conclusions describe tendencies rather than laws. Because arts administrators and trustees have a variety of strategies at their disposal, different organizations respond to market pressures in different ways. Finally, any discussion of the influences of the marketplace must assume that other forms of resource allocation employ different criteria. To the extent, for example, that institutional donors and private patrons choose to reward arts organizations for supplying aesthetic experiences of the variety that upper-middle-class arts audiences prefer, then the influence of the marketplace will differ little from that of private or public subsidy. (There *is* substantial evidence that criteria

used by funders and consumers do diverge, but this cannot be taken for granted.)

Despite these caveats, at least two conclusions are worthy of confidence. First, the logic of the marketplace is in many ways inimical to the efforts of nonprofit arts organizations to present innovative productions and exhibitions of the sort favored by many artists, curators, and critics. Second, the marketplace is unsupportive of policies that expand the social range of the audience for the arts, serve the poor, or pursue the goal of public education. These conclusions should not be surprising. The nonprofit form was introduced into the arts, and nonprofit organizations were given the legal protection they now possess, precisely so that they might pursue those creative and educational purposes that the market could not sustain.

Institutional Policies and the Influence of the Market

If the market influences the policies of arts institutions, the policies of institutional donors—foundations, corporations, and government—have shaped the extent and nature of this influence in recent years. The policies that institutional donors as a group have pursued are paradoxical in effect. In the short run they serve to insulate arts organizations from the marketplace while, in the long run, they may drive the organizations toward greater awareness of and dependence upon the marketplace.

Take, for example, those programs that have enabled organizations to increase the scale of their activities and the scope of their commitments. Grant programs aimed at enhancing the stability of arts institutions—the Ford grants of the 1960s and 1970s, the arts stabilization program of the 1980s, and the NEA Challenge and Institutional Advancement grants of the 1970s and 1980s—enabled organizations to expand in a manner that made the marketplace more salient and its imperatives more pressing. Performing arts organizations with their own houses, for example, found sound management and marketing systems more important than did their counterparts with fewer fixed costs.

Other government and foundation programs have increased the visibility of the marketplace and its salience to organizational policy makers in a variety of ways. Not least in importance was Ford's support for the work of Danny Newman in spreading

the gospel of subscription throughout the performing arts, revolutionizing the manner in which arts organizations sold themselves and inspiring a new self-consciousness about marketing.

Other private foundations and, at times, government played a role in the development and proliferation of university arts administration programs, which provide both graduate and in-service education to large segments of a new generation of performing arts managers and staff. Marketing and subscription development play an important role in the curricula of these programs; and the fact that such programs are, with few exceptions, headquartered in business schools serves to underline the significance of the marketplace for the students they teach.

Government programs have played a particularly important role in encouraging awareness of market factors. NEA matching grants, for example, can and have been matched in part through enhancing earned income. (In the late 1970s, the Metropolitan Museum of Art boosted its suggested admission price from $1.50 to $2.00 as a result of its NEA matching grant.) Throughout the 1970s, the Arts Endowment funded service organizations to provide their members with technical assistance workshops. In several fields, such workshops were a primary vehicle through which managers learned about marketing's importance.

The role of state arts agencies in encouraging awareness of the market and earned income may well have exceeded that of the federal government (partly as a result of the proximity of state agencies to their clients). Most state arts agencies provide technical assistance through grants or staff services to organizations in their states. Many state agencies, especially those without resources to employ professional panels for peer review of applications, evaluate proposals largely on the basis of the applicant's administrative soundness and, at times, the size of the audience.

The use of administrative and quantitative criteria for the evaluation of applications, a phenomenon extending to corporate donors, some private foundations, and government agencies, is less an expression of political will than a reflection of bureaucratic imperatives. Staff of public agencies, even those who are artistically sophisticated, are deeply reluctant to make artistic judgments and find it easier to evaluate organizations on the basis of their ability to complete fiscal reports, the dimensions of their annual attendance, or the extent to which their earned income covers costs.

Such criteria are less ambiguous and more defensible than aesthetic evaluations, even if their relevance to the goals of subsidy is less apparent.

In many cases, these dynamics have had the salutary effect of spurring arts organizations to pursue their missions more effectively. In some cases, however, the impact of the grants economy on the ways in which institutions regard the marketplace is pathogenic, generating mixed signals that lead to ritualism, administrative overload, and goal displacement. By "mixed signals" I refer to the fact that public programs rarely integrate their separate efforts to assist artists, encourage outreach, and educate managers. Indeed, they often fragment these initiatives in ways that send inconsistent messages to arts organizations about the ways they should organize themselves and invest their resources. The same agency that, with one hand, awards grants to produce unknown playwrights, with the other, provides a consultant who emphasizes the importance of increasing earned income and attendance. The same foundation that provides a grant for outreach programs underscores the importance of conventional marketing approaches that target resources at those prospects most similar to the current audience. Such enterprises are not intrinsically inconsistent, and each may be valuable in and of itself. In systems that tend to deny the existence of trade-offs and conflict, however, these aggregate influences may frustrate or confuse administrators and artistic directors and result in cynicism or organizational disarray.

Ritualism is one response to mixed signals of this kind. Arts organizations sometimes respond to the perceived emphasis of arts agencies on administrative competence by creating symbols rather than functions, developing staff positions with names like "audience development director" or "director of special projects," and overloading the incumbents with duties and undersupplying them with resources. Efforts to increase the salience of the market, or evaluations based on administrative, rather than artistic, criteria may also create a state of imbalance in which an arts institution's scarce resources are redistributed from artists and their work to managers and theirs.

Finally, in some instances, public arts agencies, corporations, and private foundations—particularly in their dealings with small and unconventional arts organizations—present a single model of management and participation in the marketplace as ideal. In so

doing, they risk encouraging small organizations to forsake their aesthetic or social goals in favor of short-term administrative objectives.

I do not mean to suggest that institutional funding *must* give rise to these pathologies. In many cases, the fit between the missions of grant applicants and the messages from government, corporate, and foundation donors has been good. Without the entry of institutional funding, the creation of artistically sound and institutionally stable arts organizations in the 1960s and 1970s across the United States would have been unachievable. But if the challenge of the last two decades was the establishment of critical masses of artistic activity, the challenge of the 1980s may be the development of policies to nurture and sustain the underbrush of experimental and innovative cultural enterprises that has emerged, without thrusting upon new organizations market solutions inconsistent with their artistic goals.

Strategies toward the Marketplace

Although the marketplace is a force that arts institutions must confront, it is one that may be confronted in several ways. The choice of strategies with which to face the market is one of the more significant policy decisions that arts organizations must make. They are not mutually exclusive; most institutions usually employ several of them.

None of these strategies is particularly new, nor is any peculiar to the nonprofit arts. In fact, most were familiar to that champion of earned-income enhancement, P. T. Barnum. In deference to his expertise in this area, we shall let Mr. Barnum act as our guide. (Quotations are trom *Selected Letters of P. T. Barnum,* edited by A. H. Saxon.)

THE ENTERTAINMENT STRATEGY: GIVING THE PUBLIC
EXACTLY WHAT IT WANTS

This principle was the secret of P. T. Barnum's success. He wrote of his American Museum:

> I determined to make people talk about my Museum; to exclaim over its wonders. . . . It was the best advertisement I could possibly have, and one for which I could afford to pay. . . . And so, in addition to the

permanent collection and the ordinary attractions of the stage, I labored to keep the museum well supplied with transient novelties; I exhibited such living curiosities as a rhinoceros, giraffes, grizzly bears, orangoutangs, great serpents, and whatever else of the kind money would buy or enterprise secure.

This is the quintessential rule of the entertainment industry—give the public what it wants and change the attractions. The top thirty record charts, the best seller lists, and television's ratings wars testify to the pervasiveness of this approach to programing.

The trouble with this strategy for nonprofit arts organizations is that it is likely to be inefficient. At most feasible scales of operation, physical plants are too small to yield substantial profits. In addition, the sacrifice of artistic discretion is likely to alienate those contributors, individuals and institutional, who might otherwise make up deficits. Such a strategy also brings nonprofit arts organizations into competition with commercial entrepreneurs, who are better at it and can more easily raise capital.

In the performing arts, the road to entrepreneurial riches appears to lie either in electronic economies of scale or, for the purveyor of live entertainment, in dealing with the artist exclusively on a short-term contract basis. In live popular music, for example, acts are rarely booked into a house for longer than a few days. The artist, in effect, subsidizes the operation by accepting substandard wages with the hope of eventually benefiting from the economies of scale of the recording industry.

For administrators or trustees who would opt for total sell outs of their convictions, there are few Faustian bargains to be made in the nonprofit world. If one wishes to be guided solely by the marketplace, the for-profit form is superior.

THE HYPODERMIC STRATEGY—NUTCRACKERS AND BLOCKBUSTERS

As a general thing I have not "duped the world," nor attempted to do so. . . . The Mermaid, Wooly Horse, Ploughing Elephants, &c were merely used by me as skyrockets, or advertisements; to attract attention and give notoriety to the Museum & such other really valuable attractions as I provided for the public.

If few nonprofit arts organizations contemplate utter surrender to the forces of the marketplace, many do beat limited retreats, offering occasional programs of great popular appeal in an effort

to subsidize more challenging productions or exhibitions. The quintessential moneymaker is the *Nutcracker Suite,* a holiday staple virtually guaranteed to fill the house while it sours the dancers' dispositions.

There are other ways to give a nonprofit arts organization a shot of commercial success, however, and some are widely employed. In all of the performing arts, but especially in opera, superstars may be retained for specific productions in order to increase attendance. Resident theatres, in the wake of Joseph Papp's successes, may be tempted to prepare one or two productions a season for transfer to Broadway. (Most transfers, of course, have been far less commercially successful than *A Chorus Line.*)

For most performing arts organizations, the strategy of offering occasional popular works succeeds best in tandem with a strong subscription system, allowing a few less challenging productions to attract commitments for a full season of the company's work. Few works are so popular in and of themselves that, within the constraints of a constant house capacity, they can materially affect an organization's fiscal welfare if the audience does not come back for other productions. Orchestras, which perform many pieces on a program, are advantaged in this strategy, since difficult pieces can be sandwiched between chestnuts. Of course, the trick for an organization that has educational or aesthetic aspirations is not to let the box office's hypodermic jolt become addictive.

For art museums the issue is more complicated. The spread of blockbuster exhibitions during the late 1970s represented an effort to deploy occasional forays into mass entertainment to strengthen the institutions' less commercial activities. In the short term, it is not obvious that blockbusters are sensible commercial propositions; the marginal return in admissions income—after the increase in security, maintenance, and other operating costs are borne—may not equal the cost of mounting such exhibitions. What made blockbusters profitable was the combination of corporate and government subsidy of costs and the ability of museum gift shops to exploit popular interest in the exhibition's subject. (The Metropolitan Museum's King Tut exhibition, for example, was a masterful and profitable example of this strategy, albeit the despair of some curators.) Blockbusters may also pay dividends in increased membership and, more importantly, in increased prestige, a commodity translatable to gifts and grants.

Ultimately, the blockbuster exhibit is more a creature of the grants economy than of the commercial marketplace.

THE AUDIENCE DEVELOPMENT STRATEGY

Writing to a newspaper publisher who had printed a story favorable to his new circus in 1874, Barnum commented:

> I felt a great desire to do a big thing for the public and to make it quite unobjectionable to the most refined & moral. I think I have succeeded. It is my last crowning effort. Three months of the same success which I am now receiving (pecuniarily) will be required in order to reimburse the outlays made since last November. The present excitement must end before that time, I think, but in time I have no doubt of getting my money back. But whether so or not is of less consequence than the fact that I have awakened a public taste which will not henceforth be satisfied with namby-pamby nonsense.

What Barnum proposed is now known as audience development —using publicity to develop a large and dedicated audience that, when exposed to the highest quality programs, will learn to appreciate them and demand more. The modern father of audience development is Danny Newman, of the Chicago Lyric Opera Company, whose work on behalf of subscription marketing was sponsored by the Ford Foundation and spread the philosophy of subscription throughout the performing arts. In his primer, *Subscribe Now!*, Newman writes:

> The subscriber is our ideal. In an act of faith, at the magic moment of writing the check, he commits himself in advance of the season's beginning. . . . By attending all of our productions, season after season, he develops discernment and perspective as a member of the audience. His awareness of everything connected with the art form heightens. He begins to develop and articulate his own opinions about performance values.

By developing a loyal subscription audience, Newman contends, the performing arts organization cannot merely sustain itself financially but in effect can alter the tastes of consumers so that they will support and appreciate ever more challenging repertoire. In so doing, a theatre or orchestra can relieve the constraints the market imposes without depriving itself of the benefits of earned income.

Evidence that the subscription approach yields financial rewards is strong and convincing. Performing arts companies have used Newman's methods to build audiences of subscribers who renew year after year and provide a measure of financial stability and cash-flow relief, without which the expansion of nonprofit enterprise would have been unlikely.

Data on whether or not the subscription approach has yielded more sophisticated audiences and, as a result, more adventuresome artistic programing are, on balance, mixed. Critics differ as to whether our resident theatres and orchestras have become more or less adventuresome following the rise of subscriptions. Ultimately, the question of effects is difficult to answer given the confounding influence of other changes in the arts marketplace during recent years. Theatre repertoires, for example, are no more diverse than in the late 1960s. But subscription has facilitated the evolution of far more resident theatres, and even those that did exist in the 1960s, as a group, now serve a much larger audience. Even if the subscription approach has not changed markedly the tastes of individual theatre's audiences, by providing fiscal stability to organizations that might otherwise have failed, it has contributed to the overall output of innovative work.

There are, however, three caveats that one should bear in mind. The first has to do with the relationship between subscription (and, more generally, marketing) expertise and what sociologists call "goal displacement," the effective substitution of easy short-term goals for difficult long-term ones. As Danny Newman has written, in a paper presented at the 1978 UCLA Conference on Professional Arts Managers:

> The question of whether art is successful is sometimes inconclusive. One critic may hail it, while another one might damn it, and there might be widely differing audience reactions. However, whether or not a subscription campaign is successful is immediately apparent, readily measurable in exactly how many season or series tickets were sold.

Performing arts administrators and trustees must be wary lest concrete marketing objectives conflict with long-term and more elusive aesthetic goals.

The second caveat is that audience development should not be confused with expansion of the audience's social base. In marketing, as in politics, a basic rule is to "go hunting where the ducks

are." In the arts, the ducks are well-educated, upper-income professionals much like the people who already attend. When audience development works, it brings in more of the upper middle class. Extending the audience beyond the middle class requires methods that are economically irrational by the market's standards.

Finally, audience development techniques may not be useful to very small companies presenting experimental or otherwise unpopular work. Phillip Hyde and Christopher Lovelock of the Harvard Graduate School of Business found that such companies are in close touch with their limited audience and can publicize their work effectively through word of mouth and critical reviews. Such organizations are usually "financed," in large part, by income foregone by unpaid or poorly paid actors and musicians. In return for their implicit subsidy, such actors and musicians are rewarded with the opportunity to do the kind of work they prefer. If artistic values are compromised or deferred in the interest of developing a sophisticated subscription audience, experimental organizations may lose their most important contribution resource—the artist.

THE COST-CUTTING STRATEGY

If one approach to the marketplace is increasing earned income, another is cutting costs through administrative coordination and economies of scale. I am concerned with cost-cutting approaches that enable organizations to do more with less, not with those that clearly detract from the organizations' abilities to pursue their missions, such as closed galleries, fewer rehearsals, and smaller cast plays.

Faced with market privation, some arts organizations have attempted to trim staff and, as they usually put it, to "cut the fat" from their budgets. The promise of this strategy is limited for several reasons. First, artistic salaries are already low, and artists are rarely expendable. Second, administrative savings may be illusory; extra hands in the development or marketing department may be expensive but are wasteful only if they cost more than they raise. (The extent to which the proliferation of nonartistic staff may upset the delicate political balance of some organizations is a separate question.) Third, the dynamics of cutting fat are complex. One person's fat is another's bone and marrow. Market

constraints have provided occasions for the elimination of ineffective staff in organizations whose managers or trustees were predisposed to purge. In general, however, it is not clear that arts organizations actually cut the fat before they begin carving the muscle. Indeed, in a grants economy there is some incentive to cut muscle first, dramatizing the gravity of a crisis to funding agencies and potential patrons.

The most promising cost-cutting strategies may be those that capitalize on new critical masses of arts activity in order to reduce expenses through cooperation and economies of scale in such areas as purchase of supplies, financial administration, and even marketing and fund raising. Joint purchase plans, time sharing in computer systems, united funds for the arts, and other forms of cooperation have all proliferated in recent years, often under the aegis of arts centers spurred by corporate pressure for greater efficiency.

Although the current drive toward cooperation among arts organizations is largely a product of the 1960s, the virtues of joint action were not unknown in Barnum's day. Indeed, Barnum himself engaged in an active trade with the young Smithsonian Institution in Washington, D.C., exchanging animal corpses suitable for stuffing for objects worthy of exhibition.

Inevitably, coordination is a political as well as an economic phenomenon. Marc Friedman, a graduate of the Yale School of Organization and Management, surveyed the efforts of arts centers to mount cooperative programs among their participants. While such programs have sometimes been effective, in most instances they have succumbed to political disputes over allocation of staff time, expenses, and space. In particular, joint fund raising and joint occupancy of a single house may become a means for the most powerful organizations to solidify their positions and turn an arts cooperative into a cartel. As Friedman notes, ". . . the banner of cooperation, if waved at a sufficiently high altitude, will elicit universal applause. As specific plans come into focus, however, a bewildering set of complications are revealed."

THE CONGLOMERATE STRATEGY

Product differentiation and market segmentation—expanding the number and kinds of services organized under one administrative roof and offering different kinds of services to dif-

ferent segments of the total market—represent another way to take advantage of economies of scale. Barnum understood this well when he hatched a scheme to endow and manage a magnificent new free museum for the amusement "and edification of the Youth of America." His generous offer had one catch:

> Now alongside of Barnum's Free National (something) [sic] I propose to erect Barnum's American Museum with its giants, dwarfs, fat women, bearded ladies, baby shows, dog shows, wax figures, theatrical . . . Lecture Room . . . To this museum I charge an Admission fee of 25 or 30 cts., children half price.

The free public gallery, as dignified as the British Museum, would draw the public toward Barnum's more spectacular enterprise and ensure the latter's profits.

The closest thing we have to conglomerate enterprise in the arts are arts centers, and, for the most part, organizations participating in these are still legally autonomous enterprises. Yet there has been some movement in the direction of product differentiation, market segmentation, and the development of multidivisional firms in the nonprofit arts in recent years. The emergence of second stages in a few theatres, for example, permits the coexistence of performances for both conventional and avant-garde tastes. Orchestras have formed small ensembles to take advantage of touring opportunities and new markets for chamber music. As musical training increasingly includes some formal or informal experience in jazz and popular music, is it too far-fetched to imagine that an orchestra might transform itself into a civic music center and sponsor performances, by core musicians, of every genre and variety? This is probably no more unlikely than the prospect that a major art museum would enter the retail or real estate fields or that a major public television station would enter the magazine publishing business. By diversifying, larger arts organizations may find new ways to increase revenue at the same time that they protect the integrity of their principal artistic missions.

THE COASTAL ENCLAVE STRATEGY

Management theorists exhort profit-seeking firms to identify their central means of production (the "technical core") and to elaborate their administrative structures to insulate that core from

the contingencies posed by an unruly environment. By the same token, nonprofit arts organizations can identify their central mission and protect it with subsidies from nonartistic enterprises. Rather than compromising artistically to produce crowd-pleasing programs, an arts organization may establish coastal enclaves of market enterprise that do not involve or, in theory at least, affect artistic decisions.

Barnum did not adopt the coastal enclave strategy; in effect, he could not, since the core of his mission was commercial and profitable. Henry Lee Higginson, one of Barnum's illustrious contemporaries, pioneered this approach in his stewardship of the Boston Symphony Orchestra, which he founded and financed. In the orchestra's first years, serious music existed side by side with lighter material on the orchestra's programs. Faced by the need to extend his musicians' employment opportunities lest they fail to renew their contracts, Higginson started the Pops Concerts in 1885 as a summer series for the general public. Popular material was banished from the programs of the regular symphony concerts, which hewed closer to Higginson's definition of the "better kind of music," as the Pops series enabled Higginson to better protect his winter concerts from the demands of the market.

The creation of profit centers segregated from core artistic missions has become more popular in recent years. Where this strategy has been successful, it has transformed organizations that have attempted it. By 1979, for example, the Metropolitan Museum of Art earned over half of its $45 million operating income from "auxiliary activities," especially its retailing operations, which netted profits, conservatively estimated, of over $500,000.

The Metropolitan may be a poor model for smaller organizations lacking its scale and administrative resources. Nonetheless, opportunities for both related and unrelated business income exist in merchandising, real estate media, and restaurants. For the organization with the administrative competence to avoid being overwhelmed by such enterprises, opportunities to subsidize core artistic missions are abundant.

Not all these opportunities, however, can be readily exploited. In *Self Help* Edward Skloot, president of New Ventures, a nonprofit management consulting firm specializing in earned-income

enhancement, estimated in 1982 that only 15 percent of the nonprofit organizations that he encounters have the capacity to develop new, profit-making lines of revenue. Dangers abound: poorly planned activities may distract top administrators and trustees from the organization's artistic work, run up fantastic deficits, eventuate in unwelcome encounters with the Internal Revenue Service, or affect artistic work in unexpected ways.

THE "SMALL IS BEAUTIFUL" STRATEGY

The strategies I have described are available, for the most part, only to organizations of substantial size with full-time staff and substantial fixed costs. Many artists avoid the effects of the marketplace by foregoing the stability and financial rewards that institutionalization can bring. If a theatre or dance ensemble, for example, is prepared to stay small, it can maintain a substantial amount of artistic freedom, playing in makeshift houses, requiring artists to subsidize labor costs by taking day jobs, or affiliating with a university that will make production space available. Indeed, much of the growth in the arts over the past twenty years has occurred among institutionally invisible organizations following exactly this strategy.

In the case of experimental performance groups, market avoidance is a matter of convenience and conviction. Entering the marketplace requires unacceptable compromises and distractions. For some neighborhood arts organizations, market avoidance is a matter of programmatic necessity. When the purpose is to engage the interest and participation of audiences that have not been involved in the arts or that have no money to pay for them, a market, in economic terms, simply does not exist. The noninstitutional or anti-institutional arts are invisible, almost by definition. Many experimental or neighborhood groups have no trade associations, no press agents, and, in some cases, no official corporate charter. The low profiles of such organizations should not trick us into underestimating their importance to the vitality of American culture as trainers of artists and as sources of innovation. Nor should disengagement from the market be confused with failure when such disengagement follows logically from the goals that artists hope to achieve.

The Influence of Commercial Culture Industries on the Nonprofit Arts

Thus far I have discussed only the marketplace for the productions and exhibitions of nonprofit arts organizations. But we must not forget that the nonprofit arts (whose boundaries in this country are roughly coterminous with the more ambiguous and fiercely contested borders of "high" or "serious" art) coexist with a massive for-profit cultural apparatus. Indeed, the for-profit cultural industries—film, television, the recording industry, publishing—dwarf the nonprofit arts both in the size of their publics and the scale of their revenues. Two statistics illustrate this difference in dimension. The first is that twice as many people watched a single television broadcast, "The Day After," as attended all U.S. art museums in 1979 (according to a report of the National Center for Educational Statistics). The second is that in 1983 the sales of a single pop record album, Michael Jackson's "Thriller," exceeded the total budget of the National Endowment for the Arts. What these facts suggest is that the nonprofit arts make a contribution to our culture that is quite out of proportion to the amount of money spent on them, and, to the extent that nonprofit and for-profit culture compete, the competition is very uneven.

COMMERCIAL ACTIVITY IN NONPROFIT ART FORMS

Several kinds of commercial activity directly impinge on the nonprofit arts, either by competing with them or by providing raw materials or technical, human, or artistic inputs to nonprofit production. These activities, smaller in scale but more intimately connected to the nonprofit arts than are the commercial media, include commercial art galleries, for-profit theatre, and the production of materials and services that artists use.

The significance of the commercial art gallery for the modern art museum with contemporary collections is overlooked with astonishing frequency. (The most comprehensive recent book on the institutional aspects of the art museum devotes fewer than two pages to the gallery system.) When galleries do receive attention, it is usually with regard to allegations of conflicts of interest or "cronyism" between gallery owners and curators. The more important role of the gallery system, however, is in shaping

the careers of living artists who do sell their works to museums and in winnowing out the ones who do not. Commercial galleries exist to net profits for their owners, and the artists who succeed through the gallery system are those whose works will sell. At the input side, ironically, the nonprofit art museum relies on a for-profit screening system with commercial selection criteria to narrow the range of work that it will consider for inclusion in its collections. Artists, of course, are painfully aware of this, and many resist the gallery system, claiming that it encourages trendiness, "pack" criticism, and the transformation of the visual artist into a celebrity. Artists have responded by establishing nonprofit or cooperative galleries and exhibition spaces to provide opportunities for those the gallery system rejects. In some states, particularly New York, public agencies have eased the pressures of the art market by assisting artists in creating nonprofit alternatives to the commercial gallery system.

In the world of drama, the resident theatre coexists with Broadway in New York and with dinner theatres and other commercial houses in the rest of the country. The effects of this competition may, in fact, be largely salutary, for by preempting the commercial field the for-profit enterprises create a niche for more artistically ambitious institutions. Broadway also provides a market for the production of the resident stage and a source of occasional employment for many actors and directors.

Finally and least visibly, the nonprofit arts are surrounded by for-profit enterprises on which they depend, firms that manufacture paint, sheet music, photographic supplies, and musical instruments. Such firms need profits to survive, and this imperative influences their decisions about products to manufacture and services to offer. In turn, these decisions determine the raw materials with which artists work and constrain the scope of their artistic expression. Sociologist Howard S. Becker has noted the extent to which artistic "conventions"—the DNA particles of art—are embedded in the products and processes that the market makes available to the artist. "Manufacturers, suppliers, and repair people," writes Becker in *Art Worlds,* "constitute a stable and quite conservative segment of any art world. . . ." What manufacturers make

> typically fails to meet the needs of people who are trying to create something new (or, for that matter, something old) in a medium. . . . If

you construct a musical instrument like a saxophone to play the tones of the chromatic scale, it is ill-adapted to playing quarter tones or microtones; for that purpose, you must design and build entirely new instruments. Some artists, similarly, have found that the suppliers of papers do not make what they want for their work, so they have taken up the craft of paper making. In the process, they have learned to exploit the artistic possibilities of paper in new ways, incorporating into the body of the paper itself some of what they might otherwise have applied to its surface.

Avoiding the constraints of commercial materials production is expensive. It requires that either artists or the institutions that employ them invest in learning how to create and work with unconventional media. The cost of this learning is incurred not only by the creator, but also by the performers and technical support staff. One contribution of public policy can be in helping innovative artists transcend material-based constraints, as when institutional grants enable orchestras to perform new works that require players to master unconventional instruments or use old instruments in unconventional ways.

COMMERCIAL COMPETITION WITH THE NONPROFIT ARTS

The commercial media compete not only for audiences but also for performers. Many actors commute regularly between Broadway, resident stages, and the movie and television industries. Media contracts challenge even the superstellar fees of opera, as the recent defection of Pavarotti to cinema attests. The short-term nature of most media and performing arts contracts softens the impact of competition for artists on the nonprofit performing arts. Nonetheless, many theatrical productions have been thrown into disarray when filmmakers or television producers raided their casts.

COMMERCIAL CONTRIBUTIONS TO THE NONPROFIT ARTS

Although commercial culture industries compete with nonprofit arts, there have been numerous commercial contributions to high culture. At times, for-profit producers provide markets for the work of nonprofit practitioners, from Stravinsky's stint on network television to the transfer of resident stage productions to

Broadway or cable television. Hollywood provided a market for the talents of some of our most serious novelists. And the advertising industry provides important outlets for the energies of modern composers who work in electronic media.

Artists whose work usually appears in nonprofit settings often draw on the world of commercial culture for motifs and themes. The most extravagant example of such borrowing is pop art, but commercial themes are quoted in serious theatre, dance, and poetry as well. Nor should it be forgotten that the production of literary works is largely a for-profit business. Although the relationship between literary artists and publishers has always been a contentious one, it is not notably more so than relationships between living painters and art museums or between living composers and symphony orchestras.

The commercial cultural apparatus makes the greatest contribution to the nonprofit arts when it nurtures forms or genres that the nonprofit system fails to support. Harrison and Cynthia White, in *Canvasses and Careers,* illustrate the manner in which the emergent commercial gallery system in France served to nurture Impressionists whom the traditional academic system was too conservative and too crowded to support. Closer to home, jazz, only of late certified as high art with its own chairs in university music departments and its own programs in public arts agencies, was born and reached maturity in the world of commerce. At times, therefore, when the nonprofit system becomes too conservative, the market sustains serious creative work.

Indeed, the relationship between the nonprofit and the for-profit arts is made more complex by the curious ecology that characterizes the succession of art forms and media. Each new technological advance—film, radio, television—seems to wash away its predecessor as the central purveyor of mass culture; but in the process each new wave leaves tidepools of more specialized markets in the medium it displaced. If movies had not killed live theatre as a viable way of reaching the masses, it is unlikely that resident stages, with their more limited commercial but more ambitious artistic reach, would have emerged. If television had not wounded the film industry, would the art film have found a place in modern movie houses? Radio is another case in point. The advent of television forced radio stations to turn to recorded

music and to aim their programs at narrower demographic targets, thereby increasing airplay for classical music and creating audiences for a broader variety of popular forms.

Given the size of the commercial cultural apparatus and its many points of articulation with the nonprofit arts industries, it is surprising that arts policy makers have attended almost exclusively to the nonprofit enterprise. Certainly legal, managerial, and political obstacles stand in the way of public subsidies for profit-seeking artistic firms, although contracts with for-profit producers are used widely in other policy arenas. There may be ways in which policy makers can intervene in the for-profit culture industries to maximize diversity and opportunities for creative ferment and artistic freedom. Indeed, many European countries use the tax system to make industrial policy for commercial culture, for example by varying value-added tax rates to favor products that the market might otherwise slight.

Conclusion: The Arts in a Market Society

I have, until now, described the influence of the marketplace on the arts in rather concrete and pragmatic terms. But the market exerts another, broader influence on cultural policy, less through its effects on the exigencies of daily operations than through its impact on the ways in which problems are posed and solutions evaluated.

The United States is a market society in the sense that the values of the market form the ideological backdrop for policy discourse. The mechanisms of the market—competition for gain, precise calculation of benefits and losses, survival of the economically fit, and expiration of organizations that fail on the bottom line—tend to be seen as natural, rather than human, creations. No one recognized this better than Karl Polanyi, the great economic historian, who, in *The Great Transformation,* wrote of the origins of market society:

> Nineteenth century civilization alone was economic in a different and distinctive sense, for it chose to base itself on a motive only rarely acknowledged as valid in the history of human societies, and certainly never before raised to the level of a justification of action and behavior in everyday life, namely, gain. The self-regulating market system was uniquely derived from this principle.

As an economist, Polanyi respected the effectiveness of markets as tools for the allocation of scarce resources. But, as a student of economic and political thought, he found the ideology of the market—the view, formalized in economic theorems, that the market by itself could best satisfy the full range of human needs —a radical and utopian one.

Today the ideology of the self-regulating market, as much as the vicissitudes of real market institutions, shapes, and I would suggest distorts, much of our discourse about public policy toward the arts. Just as economic behavior requires the precise calculation of cost and gain, so also does the market society impose a rhetoric of means and of quantification on dialogue about political goals.

In discussion of cultural policy, this rhetoric of means and numbers is reflected in the tendency of advocates of the arts to pose their justifications for public and, increasingly, corporate involvement in terms of such fiscal rationales as economic impact, urban development, or encouragement of tourism. We are asked to support the arts because they are means to other, more measurable ends—because they draw consumers who spend money on shelter and meals, attract businesses that employ local workers, and increase the value of real estate in the inner city. As W. McNeil Lowry put it:

> Our fascination with numbers in the United States is too obvious for comment, except to note that it becomes a universal game when Americans are prompting government expenditures for any activity or justifying the expenditures that government has already laid out. How ever unclear in its total spectrum may be our government's policy in the arts, it is clear that numbers form its core.

In the long run, concentrating on economic effects is neither good advocacy nor good policy. It is not good advocacy because, on close inspection, the arguments are too weak. In some cases, as in the assertion that businesses relocate to be near culture, the evidence is simply too thin. In other cases, as in the argument from economic impact, the claims can be too easily turned against the arts—for example, by those who would cut arts funds in favor of other expenditures with even greater economic impacts.

If economic arguments are poor advocacy, they suggest even

poorer policy. In the unlikely event that anyone other than a few economists should take them seriously, they would require a reallocation of arts funds to those uses that would achieve the promised ends. Would anyone seriously propose that the NEA, for example, only fund those organizations whose revenues bear the largest economic multipliers, whose programs attract the largest number of tourists, or whose productions are most cherished by the executives of peripatetic or expanding corporations? Aside from the fact that the federal government has no interest in boosting any one region's, state's, or community's ability to draw dollars or jobs away from another, the consequences of such a policy in artistic terms surely would be absurd.

Yet it is easy to see why advocates of the arts cling to such slender reeds when they might be speaking of such things as beauty, truth, creative spirit, empowerment, or self-awareness. The habits of thought that a market society propagates cannot easily accept such diffuse and elusive goals as valid reasons for public action. It is easier to count the things that can be counted, even if their relevance to policy objectives remains obscure. Policy discourse in a market society tends to become the domain of engineers who calculate means to familiar ends, not an arena for discussion of the ends themselves.

Policy makers in a market society may also be too quick to pose standards that are analogous to economic rationales for the evaluation of artistic genres or institutions, and too slow to consider differences in the goals that different kinds of arts organizations pursue. Too many foundations, corporations, and public arts agencies have created quasi markets—nonmarket quantitative standards such as the number of attenders an organization draws or the quantity of private contributions it attracts—as measures of an organization's success. Too often arts institutions are tempted to take part in quasi-market competition of this kind despite the fact that their own missions lead them to produce programs with little appeal to the general public or the wealthy.

In short, policy makers and analysts must resist the natural temptation for participants in a market society to believe, or act as if they believe, in the "survival of the fittest" in the nonprofit sphere. Fitness can only be estimated in terms of goals. Nonprofit arts organizations that pursue many of the goals to which cultural policy addresses itself will not be fit to compete in the economic

marketplace, and many may not be fit to attract private contributions or large audiences either.

According to Polanyi, the ideal of the self-regulating market requires that all human activity be evaluated solely according to economic criteria. This, he maintains, would be unacceptable in any human society. Consequently, for the market system to function in a manner compatible with human values, societies have developed mechanisms of self-protection that coexist with the market. The nonprofit organization is one of these self-protective devices, employed to buffer certain areas of human activity from the discipline of the marketplace. Recognizing this, cultural policy must regard the market as a tool rather than a standard. Policy toward the arts should use the market when it serves its purposes, but insulate and protect those goals—and the organizations that implement them—that the marketplace will not support.

5

Issues in the Emergence
of Public Policy

Format

PARTICIPANTS

This chapter was edited by W. McNeil Lowry from the transcript of a symposium held in New York City on December 15, 1983. The participants included:

Donald Erb, a composer and conductor, has been professor of composition and composer-in-residence at Indiana University, The Cleveland Institute of Music, Southern Methodist University, and elsewhere. Mr. Erb's works have given him a major concert career and garnered many prizes.

Howard W. Johnson, president and chairman emeritus of the Massachusetts Institute of Technology, is a director of many corporations and a trustee of several distinguished institutions in the arts, education, and the sciences.

Thomas W. Leavitt is director of the Johnson Museum of Art and professor of art history at Cornell University. He has been active in the national councils and associations of museums; for two years he directed the museum program of the National Endowment for the Arts (NEA).

Perry T. Rathbone is director emeritus of the Museum of Fine Arts, Boston, and senior vice president and director of Christie's International.

Samuel Sachs II is director of the Minneapolis Institute of

Arts. He was educated at Harvard and at the Graduate Institute of Fine Arts at New York University.

Alan Schneider was a director in every segment of the theatre in the United States and Europe and was active in the professional training of theatre artists, most recently at the Juilliard Theater Center and the University of California at San Diego. The first volume of his autobiography is now being published. (On May 3, 1984, Mr. Schneider met an untimely end from injuries on a London street near the Hampstead Theatre.)

Barbara Weisberger is the founder and, until 1982, was the artistic director of the Pennsylvania Ballet. In the historical development of teachers of ballet trained only in America, she follows the Christensens in the West and the Littlefields in the East.

Peter Zeisler converted long experience in theatre production and administration into an extended career as director of the Theatre Communications Group. He was the first president of the League of Resident Theatres and was once chairman of the NEA's theatre panel.

QUESTIONS

Six sets of questions were posed to the symposium members.

1. Agreement upon priorities: the intrinsic values in the arts rather than social, political, or economic ends? Public understanding of the role of the arts in a healthy society versus an official state policy on the arts? Dualism in public policy influences?

2. Are a society's values reflected in the priorities it assigns through government programs? What share of the financial support of the arts do these programs bear? Is this money less critical than its reflection of public policy?

3. What are the implications of these issues for the private sources of policy about the arts—private patrons? Trustees? Foundations? Corporations? For the educational system?

4. What is the responsibility—and the opportunity—of the artist to share in the development of policies? Is his or her part in decision making equal to that of scientists, industrial engineers, and others required in a democracy? In the public sector? In the private?

5. What is the influence of the nonprofit charter on the governance of artistic groups? The roles of the artistic director or

producer, the manager, and the trustee? The influences upon governance from the separate sources of public policy in the arts? Shifting cycles in the influences of voluntarism?

6. What are the most urgent remaining tasks to ensure a public policy for the arts which comprehends them as a fundamental national interest?

PROCEDURE

Mr. Lowry, who chaired the discussion, asked the members to begin with individual statements from their own experience. He then invited comments on these statements from the other participants before proceeding more systematically with the agenda.

Mr. Lowry: Mr. Leavitt, from the vantage point of your own experience, how would you weigh the priorities in the values of the arts to society?

The Intrinsic Values

Mr. Leavitt: In one sense, I would certainly agree that the intrinsic value of the experience of the arts and their creation is central and should not be undermined by applying social, political, or economic ends. The experience itself is valued, I think, and by broad groups of the public. However, that doesn't mean that any work of art contains only intrinsic values. There's no such thing as a work of art that doesn't refer outside itself. And so the arts and the presentation of the arts are in themselves political and social. Why one play is produced rather than another. Why a museum puts on one exhibition rather than another. What dance companies get support. And so on. All of this is enveloped in a political and social context.

Still, if you subvert the free expression, no matter how free or unfree that really is, to specific social, political, or economic ends, I think you are quickly heading downhill toward the kind of art that exists in a totalitarian state.

As to the public's understanding of the role of the arts in society, I think we do fairly well. But I think we have to recognize that as far as most people in our society are concerned, including many politicians, the artist today really is taking the place of the court jester in earlier societies. He can get away with a lot, say lots of things that are disturbing, prick the conscience of the public, and so forth, and thus challenge any ordinary under-

standing of art and of society. I think the general public's attitude towards the arts is that one doesn't take them too seriously, that they are to be tolerated and even encouraged but at an appropriate level, below the level of education and other activities in our society.

So while I would deplore, I think, an official state policy on the arts, I can't be entirely sanguine about the importance of the arts as seen by members of our society.

"Policy" or "Influences"?

Mr. Schneider: Well, although I occasionally look at a painting or listen to some music, the only thing I can speak with even relative authority or clarity about is something related to the theatre. I'm not quite sure how valuable what I'm going to say might be here. I get very mixed up with the word "public" and with the word "policy."

Theatre, even today, is constantly defending itself, it seems to me, in having to assert its social utility. Theatre in New York is said to be valuable because it serves the restaurant business, or the hotel business, or the tourist business, the taxi industry, and so on, and incidentally, maybe the arts. In a way, for the word "policy" I keep substituting in my mind "attitude." Policy is the result of attitude. I mean, do we have a national policy or governmental policy? We sometimes differentiate between public and federal, or national and federal. I'm not quite sure.

Our attitude toward the theatre as one of the arts is either that it's some kind of peripheral entertainment or it's some kind of high fallutin' elitist private industry, or private experience of some kind. I've been fighting to land somewhere in between all my life, and not always succeeding. When I want to buy life insurance, I have to tell people I rob banks rather than that I'm a thearte director. Or if I'm looking for an apartment, I have to pretend that I'm not an artist. That bothers me. I'm opening up just a couple of questions in my own mind. How we avoid this or oppose this as a society is not clear to me except by encouraging more people to experience art on a higher level, which indeed in the theatre has been happening. In my lifetime in the theatre, which is now getting to be maybe thirty-six years, I have seen a shift from the theatre as a kind of private fiefdom, operating to make money for investors, to a kind of public na-

tional activity to which a considerable or sizable minority of the nation's population contributes as an audience.

I don't think there are necessarily more artists in the theatre, but there are certainly more people and a more spread out audience going to the theatre. And I think that's a great step forward. Whether that's the result of public policy or the result of anybody's policy other than the Ford Foundation's or a few individuals who felt keenly about what was happening in the theatre nationally, I don't know. I'm a little nervous about the word "policy." There's a word you used, "influences," which seems to me to be perhaps closer to what I sense. If there's a policy, there's going to be a consequence. Or if it's a stated or categorized policy, the consequences are going to be even more serious. And I'm not sure how I feel about the word "policy."

Intrinsic Value Is the Key

Mr. Rathbone: I take the position that Tom Leavitt has already expressed. The intrinsic value of the arts, rather than any other consideration which concerns them—social, political, or economic—is the one on which we should predicate our own attitude toward the public's attitudes.

Those who have been involved publicly with art for a long time have all studied art from that point of view, the intrinsic, never from the point of view of the social benefits or the political power or any other consideration. And I think it's upon that belief that these things were founded and have been developed from the beginning. And I should be very skeptical about—well, to go back to this word "policy"—about the development of any policy on the political side of American life that would in any way seek to dictate any contrary attitude. Fortunately, I've never had to deal with any issues where that would be affected by political attitudes.

Like Mr. Schneider, I've seen an immense change in the attitude toward art in this country, as a commonplace. The American museums, thanks to the leadership provided by widespread art education in our country, have seen the whole perspective about museums change. You don't have to make the excuses for the programs that afflicted art museum directors of a previous generation.

I'd be very wary of developing a policy or an official attitude

that would, in some way, take priority over a recognition of the intrinsic value of the arts.

The Loss of Standards

Mr. Zeisler: We're in mid-December, and the artistic institutions in this country ground to a halt about three weeks ago because now the theatres are doing *The Christmas Carol,* the ballet companies are doing *Nutcracker Suite,* and in every museum the gift shops make Bloomingdale's look like Korvette's. I can't believe this would happen at the Rijksmuseum. I can't believe this would happen in the National Theatre in England. I can't believe this would happen at the ballet company in Copenhagen. I think it says a great deal about the role the arts play in this country.

I have felt for a long time now that we are doing to the arts in this country exactly what we've done to the educational system. We're watering it down, because we confuse access with right. We now have an educational system in which B.A. programs are doing what junior high schools ought to do. We have junior colleges doing what, I guess, grade schools ought to be doing. And we just keep watering down the process. We're doing the same thing with the arts, and I find it terrifying.

As far as public understanding is concerned, like Alan I can only talk about the theatre. I don't think yet that we understand in this country the theatre as an art form, as opposed to the theatre as a way of making a buck. I think there's a constant dilemma, a constant confusion, only because we've come out of this boring Anglo-Saxon society that banned the theatre 300 years ago. Remember it's less than fifty years that the English have had any kind of federal subvention of the theatre. The theatre had to be a commercial entity because that's the way that society dealt with it, and we copied from them.

And in Education

Mr. Erb: A year ago I was coming up from Dallas on the airplane, and they put a little nine-year-old girl next to me. And she was a very talkative one, very bright, very talkative. After a few minutes in the flight, she said, "Are you a lawyer like my daddy?" I said, "No." She said, "What do you do?"

You know, you get a little paranoid about those questions, I

find. I said, "Well, I'm a musician." I knew it wouldn't end there. She said, "What kind of a musician are you?" I said, "Well, I'm a composer." She turned around in the seat and looked me over very carefully. When she was all through looking, she said, "Well, if you were famous, I'd ask for your autograph."

I think one of the big problems in public understanding has to be with taking off from this question of watering everything down, what I call a Conway Twitty Syndrome. We have a very genuine confusion in this country about the difference between art and entertainment, and I think that really spins right off what Zeisler said. Somehow music seems to be living this battle, too, which concerns me. I think it's gotten worse. It's created by a lousy public education. It's created by the media, the major networks, which present entertainment to the public every morning between the hours of seven and nine as genuine things to be taken as serious statements about life, which they're not. I don't particularly care what Carly Simon thinks about life. I don't think she's really very good at it. We are possibly on a very serious slide downhill in understanding what the role of the artist is in our society.

The More Positive Signs

Mr. Johnson: I agree with the last couple of skyrockets, at least in the first part, that we've got a serious situation. I don't agree that it's getting worse. And I don't think that it was all that great twenty-five years ago, as I remember it. I think I would side with Perry Rathbone's comment, and the earlier set of comments. We have seen improvements in attitudes, in views, toward what might be called artistic expression, and you have to separate that from this awful character of American life, a very heavy overlay of commercialism, which largely because of TV invades almost everything. I don't know what we do about that. But despite that, my own view would be that in Boston, where I live and spend most of my life, I see certainly no decline, and I think I would see some improvement in the attitude of people toward the arts. I'm not talking about the commercialization of the arts, but attitudes toward the arts.

But let's go back to some other points. I think certainly the people at this table agree, and we must agree, that the basic pur-

poses of the arts are their intrinsic purposes, the sense that the creative individual has in artistic endeavors. That's the purpose of the artist, the composer. I used to think I saw something else, but my exposure in the last twenty-five years tells me that is the only way one can talk of art. I suppose, if we were talking about a different society, a more simple or less complicated society, that would be enough. But then how does public policy relate to the first proposition which you stated, that it's the intrinsic character of the arts that makes them happen? You can't direct them, you can't push them. It somehow comes out of the individual. It emerges. I don't have it, but I've seen it in others, and I know it emerges. Why? How? I suspect we still don't know.

Policy Is Crucial

But I don't think we should shrink from the politics of it. That's the main point on which I disagree with Rathbone. I was prepared, as a number of people around this table were, to oppose the administration on the question of cuts in the Endowment's budget because I think we have to encourage an environment in which the arts are nourished. And that takes money and it takes local policies and federal policies that make it possible. Inevitably we can't hold ourselves apart from the political and economic side of the arts, because it does take money, it does take an atmosphere in which the artist doesn't have to defend himself. I think there are these two faces of our problem. There wouldn't be the second unless there were a fundamental creative urge in the arts present in every society and at every time. In our kind of complex urban society there have to be public policies, and that means politicking to get them. So that monies, support, and encouragement are there. I think I'll stop there, much as I'd like to get into that debate on education.

Institutional Problems Are Paramount

Ms. Weisberger: I must say I thought I was entering this symposium with the fear that I was going to be the most pessimistic. Then I realized that Peter Zeisler was going to be here, and I lost the fear. Also, I stayed with a friend last night who is into runes, and I picked one that said, "be moderate." That ad-

vice seemed to warn me that it can be more effective to listen
and see both sides of the story. But I have been thinking about
both sides of the story for a while now, and when I can muster
moderation, I realize that I can almost turn into a devil's advo-
cate today, and I'm not sure I want to do that.

I don't feel the questions we are addressing have to do with
aesthetics or the necessity of the artist; basically they have every-
thing to do with that, but that is not where deep problems lie.
The artist will exist and will persist and will work. The problems
arise when the artist is part of, or responsible to, an organization
or an institution on which his or her professional life depends.
And the problems for policy then become extremely complex,
because it is at this point one recognizes the dichotomy—how do
these two live together?

I think that we who are practitioners, either as artists or
artistic directors or curators or whatever, have spent years talking
to each other and commiserating. We pick out those we know
agree with us. There are no questions about the first statement
on Mr. Lowry's agenda, at least in my mind, and certainly among
all practitioners and among the most enlightened of those around
us, no question about the intrinsic value of the arts. But that
doesn't make it so to the rest of the world, and how do we live
in that world and take that responsibility and that opportunity
to shape our lives within the concentric circles that are around
us?

The Overall Cultural Slide?

Mr. Zeisler: I get nervous when we isolate the problem of
the arts. It seems to me that the arts are really just part of the
problem. The major problem, it seems to me, is the continuing
diminishing of intellectual vigor. Look what has happened to the
media in this country. Look what has happened to our means of
communication, where we've turned major journals into life
style magazines.

Our newspapers keep getting worse. Our critical magazines
disappear, because they can't play the numbers game. Our elected
leadership—this becomes more dismal from one administration
to the next. It's saying something about a society, and until we
find a way of revitalizing the leadership or at least the communica-
tions system within this country, how are we going to have any-

thing else flourish, of which the arts are one manifestation? The problem is not the arts: the problem is much more fundamental, I think.

The Level of Understanding

Mr. Johnson: May I ask a question on that? There's no question on the media, in general. There's a kind of a watering down of a sharpness of criticism, of thinking, as presented in the newspapers or the journals. But do you think that is the litmus of the whole society? Do you see signs of that in the professions or the university or the arts?

Mr. Zeisler: I certainly see it in the university. It's all part of a piece. We've lost the hard edge of excellence in this country. I used to teach in the graduate school at Yale, and I couldn't find kids that could write a simple declarative statement. They're getting into graduate school when they shouldn't have been in college.

Mr. Erb: It's very hard to teach grammar when on television they're trying to destroy the difference between adjectives and adverbs, you know. I sat on the Planning Section of the Endowment for a number of years with a man whom I saw on television the other day. He was head of the Country Music Foundation International. And he would simply sit on the NEA panel and call us a bunch of elitists. He said to me, "You're an elitist. What you do doesn't matter. Leave that up to me."

Mr. Lowry: But there's a possible continuation of that argument, even on the panels in the Endowment, isn't there? So does it really matter that there is a distinction drawn between popular and elite, if the Endowment is subject to the influence of people like yourself, as well as of the other man?

Mr. Erb: I was addressing Mr. Zeisler's comment about the level of literacy, about the level of intellectual understanding around today. And I think, if they heard me talk as I'm talking now, many would say that just wasn't relevant.

Is This Analysis Helpful?

Mr. Schneider: I want to say something to Peter and to Howard, if I may. Gresham's law operates in the arts as well as everywhere else. And I don't think there's any way of avoiding it. I don't think we can really devote either this symposium or

the American Assembly to reforming American society. You and I know what we want to do.

Mr. Zeisler: With respect to the arts, that's all I want to do.

Mr. Schneider: On the other hand, I don't think there's any one answer here. A good thing always has bad consequences, and bad things sometimes have good consequences. I do think I want to answer Mr. Johnson. I didn't want to interrupt you when you were saying you can't create or shape the environment in which art happens. I think you can, and we do. Art doesn't just happen in a garret, or whatever. Henry Miller went out and robbed the overcoats of the patrons of the cafe in Paris that he went to, in order to continue to live and write in Paris. I'm sure you agree with that.

The only thing is, I think we're a little simplistic, including me, in saying that media are this and media are that. Television is terrible, and I don't watch it, but it's also occasionally, if you watch it selectively, pretty good. I watched the Maria Callas show the other night. Whether you want to watch Leonard Bernstein or you want to watch Kenneth Clark, or X or Y or Z, art is never going to be other than elitist, in my opinion, and then it spreads out and becomes populist.

Mr. Samuel Beckett was an elitist playwright and still is, and three short pieces have now been running six months in a little ninety-nine-seat theatre, which couldn't have happened twenty-five years ago. It works both ways. It's getting better and it's getting worse, or it's getting worse and it's getting better, both. And I think other forces will shape it. I think what I'm scared about with the whole issue here is that there's so much general diffusion that I have difficulty focusing on where we're going, and somehow the more focused we are, the more we might accomplish something. If we get too spread out about society . . . I don't know what we're going to do about society. I just worry about what I'm going to do about myself and my kids, and maybe society will follow.

How Conscious Is Federal Policy?

Mr. Lowry: I would not take sides on the general application of your point. I do think that so far as the agenda for this discussion is concerned, if we require focus, leaving the same legitimacy to Zeisler's comments as to your own on that subject, it is

my impression, and it's been reinforced in the past half hour, that we can dispose of question number two very quickly: "Are society's values reflected in the priorities it assigns through government programs? What share of the financial support of the arts do these programs bear? Is money less critical than its reflection of public policy?"

What about these points?

Mr. Leavitt: The problem with knowing what government priorities are is in the manner in which they're determined. I don't think that the society's priorities and values are reflected in the federal government programs, particularly now. I think if that were so, the arts would be getting much less than they're getting. But there's been a lot of work done.

If the government were reflecting society's values in its administration of the Arts Endowment and other programs, I think that we'd be getting even a lot less than we're getting now, probably, from the government. I think that the majority of people go along with Mr. Reagan and with his firm belief that the government should not be in the business of supporting the arts, period, at any level. And so I don't know—I think it's the elitist group that has actually got the government to act, to the extent that it has, in support of the arts.

Mr. Lowry: Well, but those musicians Erb was talking about do too, don't they, Tom? The country singers . . .

Mr. Leavitt: Sure. But we've co-opted them, I think, because they tend to be more commercial. In this case, they're less dependent on government than we are, even, because they've got the commercial base.

Mr. Erb: They're not really dependent at all. They take part in Endowment program discussions, but they don't need that money. A case in point was that the city of Dallas just put before the public the question of whether or not they would support a tax to build a concert hall. It passed quite handily. Most of those people will never set foot in that concert hall, but they voted to erect it.

The Question of Motivation

Mr. Johnson: Isn't the main thing, though, that the concert hall gets built, and something, we hope, that's worthwhile, takes place there?

Mr. Erb: I think there's kind of a dichotomy there; on the one hand, they'll pay for it, and on the other, they won't ever go to it.

Mr. Lowry: That's a little bit against your point, Tom.

Mr. Leavitt: Dallas also passed a bond issue to build a museum. So at least in Dallas, one wonders what the values are that are being reflected in such votes. Is it really civic pride and has nothing to do with the arts?

Mr. Lowry: But they were asking the people to do it with taxes, weren't they? So maybe they would think that Mr. (Sidney) Yates (House Appropriations) was on the right track in the Congress, if you put it to a vote, too. I don't know; what do you think?

Mr. Leavitt: Maybe in Dallas, they would think so. But they think he's a liberal. And he's also done a lot of things in Interior that they don't like, on the Interior appropriations. But I guess I was thinking more in terms of the elected politicians. If we didn't have Mr. Yates in the Appropriations subcommittee, we would probably be in very bad shape, in terms of what the federal government does for us, and I don't know who would come to our aid.

Mr. Lowry: I think I do know, in that committee, you mean? But money, itself, Tom, is that less critical than what is reflected by government programs, so far as public policy is concerned? That is how the question is worded.

Mr. Leavitt: I think that it is less critical than its reflection— I'm not sure that it's public policy, but at least it has the appearance of government policy, which is very important, because when we try to raise funds in the private sector, the imprimatur of the federal grant is very important in getting funds. So in that sense the funds that are given by the government, I think—and it's also true at the state level, maybe in the municipal too— carry a value much larger than the actual funds involved, because it enables us to use them as leverage to get more.

Mr. Lowry: I remember when a theatre which had been given $5 million from the Ford Foundation got $25,000 from the federal government; it broke out in a rash on the front pages of the press. Would that be true of Massachusetts as well?

Mr. Johnson: When was that?

Mr. Lowry: It's when the government started to do it after 1966.

Mr. Johnson: Now, it's more accepted.

Ms. Weisberger: The percentages are still close to the same, are they not?

Mr. Lowry: I wonder if it would be still true?

Mr. Leavitt: Almost every major art exhibition that's been held in the last decade has been partially supported by either the Arts or Humanities Endowment. So it's hardly that kind of exciting news, perhaps, but the fact that museums feel that those relatively small amounts of money are worth applying for, at least in that field, to me indicates that they think the value is much greater than the actual money they receive.

The Change in the Sixties

Mr. Rathbone: I don't think things are quite as bleak and black as they sometimes sound from what some of you are saying. There's been such an immense change in the government's attitude toward the arts in our country that the question whether those who vote for concert halls go to concerts or not is not so important. I think the idea has grown in this country so tremendously that the arts are an integral part of our society, and a necessary part of it. And each administration is going to change that complexion to a certain degree, no doubt, but I don't think that because Reagan is artistically illiterate means there's going to be any general change in American policy with respect to the arts.

Mr. Leavitt: As far as Dallas goes, I think it's a little bit of a syndrome of a frontier. Every town that was created had its opera house, and they were very proud of that opera house. Of course, it was actually vaudeville, but it had the name "opera house," and we still see them all around the country.

Mr. Zeisler: A very interesting thing happened in the sixties, due partly to that place on 43rd Street (the Ford Foundation). Half the people that contributed to some of the theatres being built around the country didn't give a good damn about the theatre, but they knew that in order to be a main line city, to be an important city, they had to have cultural amenities. You

know, it really is related to the spread of professional sports in this country. When a city got a major league football team or a major league baseball team, then it had to have a full-time symphony orchestra, it had to have a major repertory theatre, it had to have a ballet company.

You saw it happening in the sixties. I don't care why it happened. It did happen. I think it's terribly important.

Mr. Lowry: As compared to the major league football teams, the theatre actually got there first in many cities.

Mr. Johnson: I would argue it wouldn't have happened without general support from the population.

Mr. Lowry: General support from the population—you mean attitudinal support, motivational?

Mr. Johnson: Attitudinal. I don't think you would have seen that happening in city after city, unless there was a general acquiescence by the people in that area. I don't think you would have. If they'd seen it as a frill, as compared to something else, I think those ideas would have foundered.

Mr. Zeisler: But that did change it; it turned it around.

Mr. Johnson: It did.

Mr. Erb: Incidentally, about your comment on Dallas. There was a bumper sticker all around the city at the time of the concert hall vote which I think reveals one attitude. "A great concert hall for a great city." A lot of things have nothing to do with what's going to go on.

Mr. Rathbone: But they knew it wasn't a bullring.

Mr. Erb: They knew it wasn't a bullring, right. As somebody who spends all his time in the trenches, giving concerts and writing, I'm just a little concerned that there may be so little real interest in what goes on in the hall after the bricks and the mortar are finished. I have seen the audience for some musical concerts drop in this country rather precipitously, particularly in the last few years, at least for the kind of thing that I do.

The Pop Music Spin-off

Mr. Lowry: Is the same true of the other artists?

Mr. Erb: My colleagues in the music field?

Mr. Lowry: Yes.

Mr. Erb: That depends. I don't know what it means at this

point, but there is a whole trend in music right now which is a kind of pop music spin-off, and it's doing rather well. This has to do with people like Philip Glass and Laurie Anderson. And so you know, I have to ask myself, at one point, am I relevant? But on the other hand, they are the only people doing well, and in their contact with television and other things, it's very clear what they do.

Mr. Lowry: Laurie Anderson was invited here, but she couldn't make it today.

Mr. Erb: Anyhow, I get interested in this split between what we're talking about on the one hand, and the realities of walking out on stage, and where there had been a thousand people ten years ago, there are 400 now.

Mr. Lowry: You just borrowed one of my generalizations, which is that audiences are running out of our cars. And I meant to include your field, too. I'll have to take another look at that.

Mr. Leavitt: That is true, but in my field it's true because of the blockbuster. If you took the commercialization of the shlock away, and then took away the phenomenon (using the media to take full advantage of the blockbuster show) I'm not so sure that you'd be really seeing a tremendous rise in attendance.

Mr. Erb: I find that the people who are coming to my concerts now are young people who have less and less talent for abstract thinking. Okay? And therefore, I leave you with that issue, because obviously in an art museum, you have something you can stand and look at.

Mr. Lowry: Don, if they have less talent for abstract thinking, why are they coming to your concerts?

Mr. Erb: Well, not very many of them are.

Mr. Lowry: Oh, okay. (Laughter)

Mr. Erb: Well, they do at some levels. For instance, a lot of the work that I do for the last ten, fifteen years has been commissions from major symphony orchestras, and, of course, they have their subscribers. On that level, I go to full houses.

Mr. Lowry: That's it.

Mr. Erb: When I give a chamber concert at a university, very few come.

Mr. Lowry: Really?

Mr. Schneider: Did they come ten years ago?

Mr. Erb: Yes, they did. About 1970, I did a concert in Sioux

Falls, South Dakota, and 2,000 people showed up. I remember that, because it was kind of a shock to me. I didn't expect it.

Mr. Lowry: The university and college concert administrators still say that the audiences are there for chamber music and so on, and we've got an organization here in New York that's putting out similar data all the time, Chamber Music America. Do you think those figures wouldn't hold up?

Mr. Erb: If you want my candid opinion, no. I don't think they will. I think you can create whatever illusion you want to create.

The Other Side of the Coin

Mr. Johnson: I do want to make a comment about this, because it seems to me we're splitting on our sense of the scene, and I don't think we really are so split. Maybe I'm always trying to see the problem as a unity. But I think you can see some very disturbing signs. I try to look at my own campus. I don't think you'd find that there, but you could probably show it to me tomorrow.

I think we ought to concentrate on the important points you just made, but also see the broader perspective. My own sense is that at the Museum of Fine Arts and the Boston Symphony we're getting continued strong involvement, and on the campus I know best, M.I.T., both in the Little Museum, which is not a bad one, a very, very abstract one, and in music performances, I don't see that decline.

So what I'm saying is, it's important to focus on the straws in the wind, because they tell you what's coming next, and yet I think we have to see the general case, too.

Ms. Weisberger: There is a point I wanted to make, because I guess there's a question in my mind, when we talk about art and society's values. Now, how is that measured by, let's say, the National Endowment? What do you mean by society's values? Is it numbers?

Mr. Lowry: National defense, certainly, has a value, if you reflect on the government programs for national defense.

Ms. Weisberger: It has a value for . . .

Mr. Lowry: For the society. Because that's a defense that couldn't be maintained without political backing. You couldn't

just do that with a minority vote, could you? Spend all that money on national defense.

Mr. Johnson: Yates couldn't do that all by himself.

Mr. Lowry: He tried. He tried to get a $3 billion carrier sunk and he failed. He came so close that he almost lost a lot of friends, but he failed, because the society's values there, unless I'm just using rhetoric, Barbara, in this kind of phrasing, were really reflected by the strongest kind of political lobbyists you could get. If that's an illustration, it's an over-crude one. We don't need to think about that when we think about the arts.

What Are the Measures?

Ms. Weisberger: It seems to me if you're talking about the response to it, or measuring a society's values by how popular or how much, rather than allowing for the diversity and the preferences of just a few, and does the government program foster that or permit that, then in many cases you could say support of an avant garde theatre or dance company or musician or individual artist would reflect society's values, if it's really measured by a marketplace. But are they doing that?

Mr. Lowry: There are some people around this table who think that the NEA's standards or values can be, and often are, watered down, too. But one of the things that we all have frequent reason to testify to is that there's been very little of what we would call pre- or postcensorship, and very few invidious choices that could be traced to particular political or social prejudices.

Now having said that, we'll say there's a lot of "expansion arts" and so on, that are motivated by the obvious desire to get affirmative action, to give a balance to the experiences of particular minorities that maybe didn't always have them, and so forth. So there are ways in which government programs reflect society.

Ms. Weisberger: But I don't know if that's the point here. Certainly that's one of the things that a national program thinks it's incumbent upon it to do. I don't want to question that, although I think it still has to go through the same process.

Mr. Leavitt: Of course, we speak from an interested perspective in the arts, and the arts do have value to us. I think it's

important to make some distinction between supporting the individual creative artists and the avant garde art, the things that are being created right now, and attendance at museums and concert halls and theatres, where most of the repertoire is pretty conservative, perhaps. Just because audiences are increasing doesn't mean that society consciously supports the activities of the creative artist.

Ms. Weisberger: That's exactly right. That's the point I'm trying to make.

Mr. Leavitt: I'd say that most of the exhibitions in America are probably contemporary, in a loose sense. But so far as adventurous—you tend to see the same thing in museum after museum.

Mr. Lowry: However contemporary it is.

Mr. Leavitt: Yes, it may be contemporary . . .

Ms. Weisberger: It's true in dance, and when I talk to those in theatre, it is true in the theatre. When one begins an organization, you recognize that there are certain compromises. The point is, how far does compromise go? When is there a loss of principle? At what point do you not compromise?

Mr. Lowry: What compromise are you talking about? Your audience?

Ms. Weisberger: Compromise in repertoire.

Mr. Lowry: For your audience, you mean? Okay.

Ms. Weisberger: Yes, there is "goal displacement," as Professor Paul DiMaggio has described it—a certain amount of goal displacement to get the audiences so that you can persist. You do your *Nutcrackers,* and that is an accommodation, if not a compromise. But it isn't an unrealistic one. It isn't one that one needs to be terribly ashamed of or unhappy about as long as it permits you to go ahead with certain things that you feel you must and will do, that more strictly adhere to your original purposes.

Mr. Lowry: There is some effect, too, from how *well* the *Nutcracker* is done, isn't there?

Ms. Weisberger: Yes. That's the justification for somebody who makes the decision to say, okay, I'll do the best one that exists.

Mr. Lowry: Not the best one that exists, but the best one that you can do.

Ms. Weisberger: That's what I mean, the best one you can do. Of course, that's where you don't compromise.

Motivation Again

Mr. Zeisler: The issue is why is it being done? To make money.

Mr. Lowry: For other things to be done?

Ms. Weisberger: That's right. If you can hold at least to that principle . . .

Mr. Lowry: But (Suzanne) Farrell dances about as well in the *Nutcracker* as she does in anything else.

Mr. Schneider: What's so awful about the *Nutcracker?*

Ms. Weisberger: Nothing is awful about the *Nutcracker,* and if you just look down your nose at something that will permit you to do something that you really want to do, or make life easier for you in other ways, as long as that isn't *all* you do . . .

Mr. Leavitt: It's like doing a Van Gogh show.

Mr. Rathbone: It's like treading water and moving forward, is what you mean, I believe.

Ms. Weisberger: Well, in a way it's treading water in order to move ahead. But that perception of why you're doing it gets lost somewhere down the line, not by artistic directors, but by boards of directors concerned about financial stability and by administrative people who are hired to build your audiences, who say, let's do it, and that will bring people in, and then ask you to compromise farther and farther.

Mr. Schneider: Peter's issue has something to do with the fact that everybody is doing *The Christmas Carol.*

Mr. Zeisler: No, no.

Mr. Schneider: Let me just finish this. There's the one theatre that does it once in a while, either a lousy *Christmas Carol* or a great *Christmas Carol,* or whatever, but all of a sudden, everybody's doing *The Christmas Carol* because they see it as a way out. That's not your point? Okay, I withdraw.

Mr. Zeisler: My point is that I resent the fact that artistic institutions are being forced to do this to make money.

Mr. Schneider: They're not forced to do it.

Mr. Zeisler: Yes, they are.

Mr. Schneider: They don't do it if they don't choose to do it.

Mr. Lowry: There are theatres that go through December without doing *Christmas Carol,* and there are ballet companies that have gone through December without doing . . .

Ms. Weisberger: Not too many. There's a certain pleasure extracted. The thing is that you don't have any illusions about capturing those who come en masse to *Nutcracker* and believing they will come to all the other things that you really want them to, because that's baloney.

Mr. Schneider: They have that illusion?

Mr. Lowry: Who does?

Mr. Schneider: Certain people have that illusion. They don't know that it doesn't work that way, but . . .

Ms. Weisberger: No, but it need not be dangerous. It's fun to see thousands of people in the audience. I must say I enjoy it. I really love to see so many people, and I know it would be much more difficult to bring them to a more esoteric repertoire. And there always is that small percentage who will come because they fell in love and we will capture them in that way.

Mr. Schneider: Did you just switch sides on the issue?

Ms. Weisberger: No, I haven't. You see, now I'm getting into that devil's advocate position which I don't want. I think the problem is much more complex.

Mr. Erb: Interestingly enough, to look at a slightly more positive side of this, the Endowment has now been sending letters with its grants saying careful consideration will be given to the performance of American repertoire. They don't force it. But it's having some result. U.S. composers simply want the United States to do what they've done in Canada, which is literally to force the artistic organizations. I'm familiar with the Canadian situation. In point of fact, when the Canadian government became the direct instrument of policy related to these matters, it created, I think, a rather decadent situation.

The Private Sector

Mr. Lowry: That's a good place for us to turn to number 3: "What are the implications of these issues for the private sources of policy about the arts, private patrons, trustees, foundations, corporations? What are the implications of these issues for the educational system?"

Well, we've already got into this a little bit, haven't we? Now the issues, of course, are everything we've talked about to this point, forgetting that we ducked making an exact distinction, as

that its emphasis on democratic access and so forth has impinged on experimentation and on many other things. I think that's absolutely true. What I'm talking about and I guess I'm jumping ahead, because I feel that if we continue merely to discuss what is best, we will forever be putting on band-aids, unless we begin to see this whole context, the whole changing environment and the hurdles that are in front of us, and try to find some new answers, whether they can exist immediately or not. When we have the understanding and courage, then we can have some constructive input. But if we say this is how it is and isn't that too bad and what can we do about it and go along with more and more band-aids then I don't think we'll get anywhere.

Mr. Erb: That's an incredibly good point. I'd like to address that just for a second, because I just had a recent experience relative to that. Again, I was invited as sort of a composer-participant to a meeting related to opera in Detroit at the end of August, and they did exactly that.

Instead of addressing the larger issues and trying to see where they were going and what it meant in a very large context, all they really did think about were band-aids. And the only reason they were there was to figure out how to make grant applications for next year. And they didn't address the issues of what is this going to mean to America twenty-five, twenty years from now. That interests me a lot, because that's where salvation really can be. They didn't talk about that once. All they were concerned about was how to pay for things.

The Question of Policy

Mr. Schneider: That's society, again. It's not just the artist.

Ms. Weisberger: That's copping out, though. It is our society, sure, that's a fact.

Mr. Schneider: It's a larger issue.

Ms. Weisberger: Yes, but it's an issue. It doesn't mean we cannot take certain steps toward finding better solutions so long as we have the picture in the long run, and there's some consensus about it.

Mr. Schneider: I think we have to do both.

Ms. Weisberger: That's right, we have to do both.

Mr. Erb: You have to get through next year, but what bothered me was, they weren't interested in anything beyond next year.

Ms. Weisberger: The foundations, in some cases, have been more enlightened and more constructive in the way they help than the newer kids on the block, and certainly more than the corporations. Corporations believe (and I feel this is a terrible cop-out) that what's wrong with "you people," not only in the arts but in all the nonprofits, is that you don't know how to manage yourselves. That's all I hear. You should learn how to raise money better, how to market your tickets better, do all these things, because you people have no sense of reality. You're quixotic, capricious, etc., etc., and you're led by artistic people who aren't managers, and so forth and so on.

It's very condescending and it's disdainful, and one can be immediately angered. It isn't productive just to get angry about it. What do we do? Just as you have pointed out, the amount of money from the government is not the problem. It is for *what* that is the problem. But we've talked about that for a long time.

Mr. Lowry: The business of ballet is not business, even though it should have a businesslike administration. In the company, it's not business.

Ms. Weisberger: It doesn't mean anything any more.

Mr. Lowry: I feel a little bit like Howard Johnson, that maybe this has improved that much, the understanding of this, but I don't know whether it has. Peter, you're trying to make a statement.

Mr. Zeisler: Public understanding about the role of the arts— isn't it rather significant that the two largest foundations in this country have both reduced their arts programs.

Mr. Lowry: The largest?

Mr. Zeisler: Yes.

Mr. Lowry: One large one and one smaller one? You mean Ford and Rockefeller?

Mr. Zeisler: I'm talking about the fact that there's no longer a Division of the Arts in the Ford Foundation. It's now Education and Culture or something.

Mr. Lowry: In fairness to Mr. (Franklin) Thomas, it's a half of education and culture, except for financing.

Mr. Zeisler: It's culture, not the arts. I know.

Mr. Schneider wanted us to, between "policy" and "attitude." So what are the implications of these issues for the other sources of policy, meaning private sources? Mr. Sachs, do you want to try that? You didn't hear all the discussion of earlier topics, but I'm sure you'll know anyhow. Do you want to start that?

Mr. Sachs: I would like to pursue the point you just left, right into this. I assume that number 2 flows into 3, logically. Namely, I suppose a case can be made that if public policy will not support the adventuresome or the avant garde, or the non–policy blessed issues, then there's a case to be made for cajoling private patrons, foundations, other nonpublic sources, as a court of last resort. But I don't know that I always see that in fact. But I think this is, perhaps, what public policy assumes in part.

Mr. Lowry: Here you're using "public" only as a direct synonym for "federal," aren't you?

Mr. Sachs: In that case, I guess, governmental aid.

Mr. Lowry: Let's talk about that, then.

Mr. Sachs: In other words, in the absence of federal support one can make a case for the implication that repertoire is the last resort in this country for private philanthropy, something that may or may not be dying.

Mr. Lowry: We need to be sure we're not inversely—I know you're not—getting into a Reagan-Stockman trap of holding that the government is the first resort and it ought to be the last. The private sector is the first, at least quantitatively, and even as far as accessibility is concerned.

Mr. Sachs: In gross amounts, you mean? In America?

Mr. Lowry: Yes. There are some people who can get money easier out of the NEA, in a shorter period of time, curiously, than they can from foundations or private patrons or corporations. But these are particular kinds of fringe group activities—most people can do it better or faster or whatever out of private sources. But that still doesn't invalidate your point. You think private sources are more amenable to supporting experiment and new repertoire, and so on; is that your point?

Mr. Sachs: Less restricted by policy.

Mr. Lowry: Less restricted by policy. In your field, doesn't the NEA pride itself on being adventurous about the visual or . . .

Mr. Sachs: Not in my recent experience.

Ms. Weisberger: But whether it is or not, should it be? I mean,

that's the question. I feel the opposite is true, except in the case of private patrons. I think that we are more limited in private sources of support, other than private patrons, by their own policies that will make it more difficult to give support to the process, or to the individual artist, and to experimentation and innovation.

Mr. Lowry: Foundations?

Ms. Weisberger: Well, we are not talking about all foundations.

Mr. Lowry: But are you talking about foundations?

Ms. Weisberger: I'm not talking about what all of them do; but I think that there are foundations that have limiting constraints and policies, but I'm talking more about corporate foundations.

Mr. Lowry: Okay, I think you should draw a distinction between foundations and corporations.

The Appropriate Roles

Ms. Weisberger: Right. But foundations are also, to some degree, limited by their trustees and their own policies and their own attitudes and directions and sense of purpose, and it is not a matter of saying what do they do, in my mind; it's a matter of saying, what would be the best suggested policy in the distribution of support, or their prime responsibility toward support?

I don't think we can do very much about private individuals, because again that is very personal and very taste oriented and emotionally oriented, but they will support those things that move them, or for which they have a particular liking, or they have a personal communication, that can move them.

The enlightened foundation will be able to see this. If the government, for instance, picked up where other angels fear to tread, would this not be a better situation? Would there not be greater freedom for experimentation and innovation . . .

Mr. Lowry: I'm not clear whether you're saying this goes on, or whether it should go on, Barbara. Is the government the place where people have justified hope?

Ms. Weisberger: No, it is not where it goes on. The policy of the National Endowment is very ambiguous and very unclear, certainly in that regard. And you talked about it very strongly,

know what to support best in the arts. Whereas in science, it's left to the professionals.

Mr. Zeisler: Tom Leavitt will remember an exercise about six years ago, eight years ago, when Nancy Hanks was trying to expand the boundaries of the Endowment, and was doing this study about impact on the society, where suddenly the arts—the constituency in this country—not only consisted of the performing arts and the fine arts, but then we got into snake farms, arboretums, science museums, the Gettysburg battlefield. Everybody that walked through that battlefield was an arts "participant."

Mr. Rathbone: Howard, what was the comparative figure for the Science Foundation and the Arts Endowment? Was it $500 million a year or something?

Mr. Johnson: No, it is much larger. This year, the total support—they put a lot of things in that that aren't really supportive for science. The R and D picture is much on the D side in most big companies, but nonetheless it's a very big number. It makes the number going into the Arts Endowment look like nothing.

Mr. Leavitt: Interestingly, the Reagan people, and I guess also the administration of the Science Foundation, reduced their education component down to $35 million last year. And this year Congress mandated that they put up $75 million. That's a tremendous increase. It was Congress.

Mr. Schneider: I knew that the arts were in trouble, but the fact that science is in trouble really scares me.

The Basic Research Quotient

Mr. Johnson: I don't want to overstate it, but basic science in this country is not getting as strong support as it did.

Mr. Lowry: We're putting it very much on the application side, and on support in the area of mathematics and physics.

Mr. Johnson: Well, since the Mansfield Act, they've been restricted in providing money for basic research, when we used to get most of our mathematics research support from the Defense Department, oddly enough. But we don't any more, because Mansfield believed we ought to make the Defense Department responsible. We ought to put all that basic money into the National Science Foundation and we ought to make the Defense Depart-

ment try and push its budget down, but it didn't happen. They said we should make them justify what they're spending money for.

It's a perfectly good point, but the trouble is the money never went to basic research and we had worked up a great behind-the-scene game with the Defense Department, which could be justified, for support of basic science, and it worked beautifully.

Mr. Lowry: We get into a question in the arts that Howard raised in the sciences, that it will be the next generation of young, talented, potentially able people who are going to feel what's happening now in the National Science Foundation. Is that true, about some of the things we're interested in, in the arts? I do believe that we have to think about that.

Access for the Young

Mr. Zeisler: One of the greatest problems now facing the arts is the fact that we have costed ourselves out of the business. Twenty years ago we were making arts accessible to the young people in the country. We're not any more. When the resident theatre started in the sixties, the top ticket price at every theatre was the equivalent of a film, and we established that as the guideline: the top ticket price was the price of a first-rate movie house downtown.

Ms. Weisberger: But who was subsidizing them? I thought the artist was subsidizing. Are you saying now the only way we're really going to exist is if we get back to that "pure" state?

Mr. Zeisler: No, no, but if you're going to say that the arts are intrinsic to society, they've got to be available to society, and if they're available to society, there has to be an alternative to the commercial marketplace. And when you see theatres and symphony orchestras charging the same kind of money that those rock concerts are charging, you're not making . . .

Ms. Weisberger: An alternative to the market is subsidy.

Mr. Lowry: When you see the rock concerts charging the same . . . ?

Mr. Zeisler: I don't care what they charge. That's a commercial entity. But I don't think that so-called nonprofit arts institutions should be charging the same thing that commercial . . .

Mr. Leavitt: I think that gets into the really basic problem,

the tremendous gulf between the cost of production in the arts and the amount that the user is able to pay to attend, and the tremendous gulf has got wider.

(Many voices at one time.)

Testing the Limits

Mr. Leavitt: Barbara's point is right. The problem is the gulf between the cost of producing something and the income that's realizable from people attending. One way they've tried to bridge that gulf is by charging higher admissions, and there's a limit to that, and it gets more and more elitist and cuts out whole segments of the population.

So what are the alternatives? One alternative is much more sophisticated management and fund-raising techniques, which I think have been effective. I think most institutions are better run now than they were a decade ago. But that's not enough. So then you've got to go to sources of support, and that's where we get into the public policy issues. They're very dependent on what people as a group, whether in government or in corporations or foundations, will pay for. And so far all we can do is complain. But there must be a way of formulating a policy that would be helpful in bridging that enormous gulf between the cost of production and what people can pay to enjoy the arts.

Mr. Johnson: Can we ask questions, other than your questions?

Mr. Lowry: Of course.

Local Versus Federal Policy

Mr. Johnson: On that question, I hear in our area, once in a while, from well-meaning businessmen that our support should come from the local area. We're a local institution, a quite broad one, a regional institution. But it is said that we ought to be proud of our New England heritage and we ought to be responsible, just as we always were, for raising our own money.

Now, how do you feel (and I'll be glad to tell you about my own view), but it seems to me that a policy of federal support along the lines that we've been talking about is going to be absolutely necessary on a consistent basis, not an up and down basis, if the arts are going to have a chance in this world that's

so marked by television and an international communications system. And I think one thing we ought to get to is a federal policy. We've been talking about it, in general, but is it fair to ask that question, Mac? A federal policy seen, as not an answer, but as a necessary . . .

Mr. Lowry: I'd rather give Tom a chance to comment on what you said first, because you asked it of him.

Mr. Leavitt: I think a federal policy is difficult because of the nature of our society. It's a pluralistic society. It changes from one administration to the next. The House is only a two-year term, and the Presidency is only a four-year term. It's subject to fluctuation. Any policy that the federal government develops would have to be a reflection of a much broader consensus among the public, if it were going to be sustained over a long period of time. I thought that's what we were trying to define in this session, if it's possible to do so. My confusion is whether we are trying to define what exists, in the nature of a public policy for the arts, or whether we're groping for what *should* exist in the nature of a public policy.

Mr. Lowry: I would like for you to relate the latter point to question 6, because we need more and more clarification of what exists. The only difference, or variation on that, is that when we come to government, we're going to have to consider principle, which also inevitably gets us into what should be and not only what is.

But in answer to Howard Johnson's question, one of the problems, and it's a great one, as I've said in a letter to each of you, is the distinction between policy and advocacy. I don't mind if it is stated as Howard just stated it, federal policy, because that means we're talking about only what we should advocate that the federal government should do. We're talking about what it's doing, right.

The Private Patron Again

Mr. Zeisler: Mr. Johnson made a point about the whole responsibility of regionalism versus nationalism, which is really the base of the problem.

Mr. Rathbone: I thought this might come up today. I think around 1960, the *Christian Science Monitor* in Boston asked me

a leading question, and asked me to answer it at some length: what is the basic problem of the art museum today in Boston and elsewhere? And the simple answer, of course, was money. And I'm very interested in what Howard just said about the present business attitude on regional support of the museum. I couldn't help but refer to the history of the Boston Museum, and a number of other museums in the country, that were founded when it was a matter of pride and certainly local ability to build that Museum, not with one building, but two buildings within twenty years, or thirty years, at the most, and supplied art and supportive staff, and supported excavations in different parts of the world, making a world reputation for itself, all on the basis of local money, which was given by people who were concerned for the arts, who were educated elitists.

Mr. Lowry: But they weren't businessmen; they were not corporations.

Mr. Rathbone: They weren't corporations. It was quite easy to point out that these great founding benefactions had been given before 1913, because the post–Civil War or the Civil War income taxes had been forgotten long before, and we all know that 1913 was the beginning of income taxes. And my point was that the income tax increased year by year by year by year, until those extra monies that had been quite abundant in a successful city like Boston simply weren't there any more, and the point of my little article was that it behooved the federal government to return that money that had been taken in large slices in personal income tax to those communities, to perpetuate and continue what local pride had prompted and sustained.

Mr. Johnson: Who said this?

Mr. Rathbone: That's what I said. I think I incorporated this in an annual report I wrote to the trustees back in those days, and unfortunately I retired from the Museum well before any federal money ever came to the Museum of Fine Arts, but did manage to squeeze some money out of the Commonwealth of Massachusetts by a rather devious device, I must say.

We had to impose an admission tax, an admission fee, which had been suspended since 1928—I think it was 25 cents or something. Anyway, we did it. That meant that the children of the Commonwealth would have to pay a quarter to get into this great fountain of knowledge. And we managed, with a little bit

of politicking and inviting the powers to lunch in the Museum and things like that, to have a bill passed which provided the great Museum of Fine Arts $100,000 a year, so that the children wouldn't have to pay. That was the beginning of any public subsidy.

Mr. Lowry: You had made it a fixed amount.

Mr. Rathbone: It didn't have an inflationary clause.

Mr. Zeisler: Perry said it's terribly important if we forget and we take for granted issues that are really very new. In 1961, not '41, in 1961, in Minneapolis, for the then Minneapolis Symphony, not the Minnesota Orchestra, but the Minneapolis Symphony, its annual debt was paid by three individuals. The entire deficit was reimbursed by three people. Now because of this villain over here (the Ford Foundation) within five years that was no longer possible.

Mr. Lowry: I think the question was what would happen to the services, to the musicians, and so on, right?

The Good Old Days

Mr. Erb: I don't know whether this is relevant or not, but it's one that's occurred to me over the years. Out of those thirty-five years I spent about fifteen of them out on the cutting edge, dead broke. You know, the question that's always troubled me is that the American artist in music had the expectation to live in the upper middle class. I really don't know why that's necessary. I don't feel it's necessary for me. I'd be perfectly happy as long as I eat and wear clothes. I've done better than that, but I had no expectations, and for a long time I *didn't* do better than that.

The Need for Consistency

Mr. Sachs: There is a point I'd like to raise. It may have been discussed earlier this morning. It seems to me, in a broader sense there is not an educated public policy in support of the arts, and I mean support in a nondirect, subventional way. If you are going to develop generations of school kids who will subsequently turn into patrons, or feel as you said in your preamble, that art is one of the birthrights of this nation, one of the great pillars that

makes for a healthy society, there is no evidence that I can see that there is a policy to support an understanding of that. School children are not being taught symphony music. One visit a year to the museum is not going to get the job done. We know we are a nation of visual illiterates.

The Corporate Role

Mr. Zeisler: I want to say something about the growing assumption by this administration that the corporations have a responsibility for the support of the arts in this country. And it doesn't seem to me that they have any responsibility whatsoever. And furthermore, I don't know that I want them to have a major responsibility.

Mr. Lowry: Let's hear about that. Why don't you want them to?

Mr. Zeisler: It seems to me that the corporations are about making money for their stockholders. They're not about being Maecenas to the arts in this country. Furthermore, the only reason they have any interest in the arts, or at least the primary reason they have an interest in the arts, is one of visibility and public relations. And the minute you're talking about that, then you seem to be denying the main tenet for the arts, which seems to be an exploration or a discussion or a forum about the society in which the arts are existing. And when the arts are doing that in any kind of critical level or base, they are going to make waves. And the minute they make waves, then they're going to make problems for the funders.

Mr. Erb: Can you give me a firsthand observation on that?

Mr. Zeisler: A few years ago corporations were getting a lot of publicity by retooling dramatic productions on public television. I would receive almost one call a week from corporations wanting to know what's being done around the country that they could transfer into television cheap, which really is subtext. And you would tell them the plays, and of course they were looking for exactly the same thing that Hollywood is looking for. They're looking for a play that's not going to offend a backward two-year-old. And the minute you gave them any kind of a production that had any kind of social content that could offend *anybody,* they were not interested in doing it.

Mr. Johnson: If the arts are wholly dependent on that kind of patron, then it could be very bad. If it's a plus, if it's an addition, if it could be seen only in that context, and if you could say no or yes to it, then I would make a very strong argument for it. I know corporate patrons who have done so much. But if suddenly the federal government says that this is the only source, it is completely different. As a plus, it's great, an aspect of American life. I really think that, as long as it's not a main piece.

The Tax Incentive

Mr. Sachs: I just want to make a comment on this, because I think there's an assumption here, or maybe a lack of assumption, in terms of policy. It strikes me that federal policy for corporations is one of directing, if you like, uncollected tax monies. U.S. corporations are allowed, as you know, to give 5 percent of their pretax gross earnings to their foundations or to charity or to whatever they want.

Mr. Lowry: More than that, now.

Mr. Sachs: And many of them are not doing this, as you know well. I'm fortunate to come from a state where it's well practiced. I think this may be a policy to encourage that aspect of the private sector, if you want to consider corporations part of the private sector, to get involved, to forestall the federal entry in collecting those 5 percents, if you like. The concept which corporations use to justify their not doing it is that, well, it's the stockholders' money and how can we do this? That's an argument that needs to be debated.

Mr. Lowry: But do you think that is the motive that Reagan and James Baker have given the Heiskell commission or is it really that if the corporations did do it, as Frank Hodsoll keeps saying, then the government could do less? I don't believe the administration is concerned about getting the corporations up to their 10 percent tax benefit for money that they give as charity. They may be concerned about it, but in the arts, they were specifically saying, why do we find the government in there at all? Why can't we turn it back to the private sector?

Mr. Sachs: I think that aspect of it is probably more to the point.

Ms. Weisberger: Passing the buck.

Mr. Sachs: Well, passing the buck or maybe just trying to keep government from going into it bigger. Of course, we would, with our vested self-interest think this is an area where maybe the federal government should be involved. When you say "doing less" it's hard to imagine doing a lot less.

Lack of Insight

Mr. Zeisler: There is even a greater problem on the horizon, which has to do with governance. I had lunch recently with the person in charge of the arts contributions of a major American corporation. And I sat there in horror for three hours as she told me what she liked and what she didn't like, and how she gave money and how she didn't give money, with absolutely no professional background, going purely on personal whim.

I contrast that to a performance I went to recently, the first performance of a major event funded to a considerable extent by a number of corporate foundations. The two program officers of those foundations came up to me at this obscenely lavish dinner after the event (which could have paid for twenty-five different arts events) both of them sounding like shoddy Broadway producers, saying, "Do you think we have a hit?" And suddenly I realized, here were the contributions officers of two corporate foundations really sounding like little chintzy New York producers, wanting to know did they have a hit, and that if they didn't have a hit were they going to be in trouble with their bosses? And this is how corporate foundations—these were grants of over $100,000 a piece—function.

Still to Be Encouraged

Mr. Rathbone: I think that a great deal of money has been given by corporations that's been used rather freely by the institutions that have received it and to great effect. You people who run museums these days know better than I do, because we never had any of these subventions in my day at Boston. But maybe your experience has been quite different. You would know, Howard.

Mr. Johnson: On many topics, one can cite cases on both sides. My own sense of it is that it is a great and positive thing for the American society, when a big company, let's say the IBMs and the Philip Morrises, has been committed to this kind of thing,

the Texacos, in another sense, and I don't have any trouble making that case to the American stockholder of that company. I think it reinforces the fabric of the economy, if they want to look at it in those narrow terms. I think we ought to encourage it, find ways to encourage it.

I think it's always a plus when it's an addition to the monies that go into the arts, but if it ever became in some kind of ducal sense, you know, the place where the arts had to go for support, then it could get worse. You'd become dependent in a way that never produces the right donor. Maybe you'd say that's the way the arts have always been supported. But I prefer to see it as just an important plus, just like the importance of any patron. I'd like the arts organizations to be able to say no, always. As long as you can say no, then we keep a pretty good society. If you ever had to say, "Whatever you want, master," it's wrong. I would prefer a diverse set of supports. Whenever museums deal with a private donor, and we do a little of that in Boston, we live with it, because it has to be done. And it adds to the institution. When it is a corporation, it becomes a little more clouded. I'm part of the corporate world, too, and I don't have any doubts about saying that.

Only in Diversity

Ms. Weisberger: When you come to it, it's the protection of the turf. The problem is, we all concur in the necessity for the diversity of support, as a protection, although we don't know exactly what policy each of those members of the pie may have had, in the way they give. We can't describe it with any sureness, and we don't know about its consistency and about its evolution.

But when it comes to getting money from a corporation, or even foundations in some cases, you hope it will not be the only supporter because there are things that must be protected by the artistic organization. How protective are we? Who is deciding what we are protecting? And when it's a corporation giving to your board of trustees who are themselves businessmen in a great number, they might be protecting the same turf or seeing it from the same light, and then we lose contact.

Mr. Lowry: You mean the same turf as the trustees?

Ms. Weisberger: That's right. So therefore everything is sub-

sumed by that, and the lonely voice that will fight to the death to say we will accept this and we will accommodate up to this point and never beyond is lost.

Mr. Zeisler: Tom Leavitt spoke earlier about the negative effects of a blockbuster mentality in art exhibits. At Theatre Communications Group we do a lot of statistical analysis of funding. And the two low boys on the totem pole of corporate support, historically, are modern dance and theatre, I think for very valid reasons. The big corporations are simply more interested in museums, also for very valid reasons, because museums are not going to threaten and they're not going to be doing performances that are really going to shake things up. I'm not describing museums pejoratively. It's just that they are not likely to make problems. If the theatre is doing its job, it is going to be making problems. But I also don't understand why two disciplines have to suffer in this society because of ideas and controversies.

Mr. Erb: I think that's a very important point. Actually, symphony orchestras are very easy things to support, because by and large they are noncontroversial. But I want to go back to an earlier point. One of the things that I think probably is very American and hope would stay in place is that we never look for funding at just one place. I think the idea of the private donor and the corporation always gives one an out.

One of my favorite cases when I was at the Endowment maybe illustrates something about this whole point. It was about the last year I was there. There was a program funded by Exxon Corporation and the Endowment called "Live from Lincoln Center." Do you remember it? Well, "Live from Lincoln Center" had not one American artist on it, not one. And I thought that was absolutely outrageous.

Mr. Schneider: That wasn't the sponsor's fault. That was Lincoln Center's fault.

Mr. Erb: Whatever. But the sponsor should have said, "Hey, look, come on."

Mr. Schneider: The sponsor can't say that either if you don't want him to tell you what you don't like him to tell you. You can't have it both ways.

(Many voices at one time.)

Mr. Erb: I don't think the sponsor should be a total patsy, either.

Mr. Lowry: Didn't Channel 13 have the ultimate decision making on "Live from Lincoln Center"?

Mr. Sachs: It leads me to add the caveat for arts organizations, particularly when they receive funding from corporations, wherever possible to seek support on a general level, not the specific level. Our greatest problems are funding specific exhibitions, specific concerts, specific theatre productions, rather than overall support of the organization.

Mr. Rathbone: That was the idea of David Rockefeller in the Business Committee for the Arts (BCA).

Mr. Lowry: They never raised any money for the arts. They never gave any money to the arts. As you said, Perry, they promoted the idea.

Mr. Rathbone: They promoted the idea. They raised money for their dinners.

Mr. Sachs: But many corporations hide behind the BCA and say, "Well, this is our participation."

The Positive Examples

Mr. Schneider: I find myself on the strange side of a barricade here. I don't quite understand it. But nevertheless, I'm trying to understand why Schweppes, whatever the hell that is, can back the Royal Court for thirty years. The Royal Court is far from a safe organization, and Schweppes has been backing that since the first day they opened, with a sizable amount of dough. It's not an oil company. It's an effervescent bubble company. But if we begin with an attitude where the corporations are going to back the program, the idea of the program, or the whole series, or whatever, and not tell us what to do, I don't see how we can object to corporate funding.

My objection is to their telling us what to do, either good or bad, but not to their backing us.

Mr. Lowry: Maybe you're saying (this is not a statement, it's a question) the way it is on public broadcasting, so that we know it's Mobil and that's all we know.

Mr. Schneider: Well, I don't know whether Mobil ever tells anybody . . .

Mr. Lowry: They don't tell PBS or Channel 13.

Mr. Schneider: But do they call up backstage, or do they tell somebody at a dinner party, we don't like what you did last week, or is it all such . . . ?

Mr. Lowry: I can't prove that they do or don't. I don't believe so, because I think we would see signs of it.

Mr. Johnson: But the model is Polaroid, who supports programs in the arts. Having dealt with them for twenty-five years, I know they will never tell you what to do.

Mr. Schneider: I think the hidden agenda is that if they don't like it over a period of time, then they won't help you next year.

Mr. Sachs: I think "period of time" is a very good footnote to put on that. It's a classic story of a major oil company that supported Tom's exhibition. It was a general across-the-board exhibition, and there was a work in the exhibition attacking oil companies. Well, that set up some curious problems the next year.

Ms. Weisberger: But that's true of any source of support. You can't count on it forever. And perhaps individual giving is more capricious.

The Artists' Influence

Mr. Lowry: And so we get down to number 4: "What is the responsibility and the opportunity of the artist to share in the development of policies? Is his or her part in decision making equal to that of scientists, industrial engineers, or others required in a democracy? Is it equal in the public sector? Is it equal in the private sector?"

Now, a few years ago, this question wouldn't have been asked. Does anybody want to talk to that?

Mr. Schneider: I don't think it is equal.

Mr. Lowry: To what?

Mr. Schneider: I have no proof.

Mr. Lowry: To that of scientists and engineers?

Mr. Schneider: I mean, because the scientist and the engineer is considered a rational creature who has a two and two answer, and the artist is not rational and not definable. I have no statistics.

Mr. Lowry: Are all the decisions made by the NEA subject to the artist's influence?

Mr. Schneider: By the NEA, but . . .

Mr. Lowry: I guess what we're asking is do you think that the panels and councils of NSF and the Pentagon and other things put the scientist in a better role in making decisions in his field than the panels in the NEA or the NEH give people to make decisions about the arts or museum services?

Mr. Schneider: I do, but I can't prove it.

Mr. Rathbone: I think the reason is that when a scientist gives his opinion in making a decision or establishing a policy he's dealing in matters that are unknown to the layman. Whereas, when it comes to arts, the whole subject is so subjective, and, as Alan said, in a sense, irrational . . .

Mr. Schneider: Indefinable.

Mr. Rathbone: Indefinable. It does not have the same impact. They just say, well, that's your idea, but it's not a matter of scientific, provable fact, and therefore it doesn't have quite the same clout or ability to convince those who are listening to the opinion.

Access of the Artists

Mr. Erb: I don't know on what level you mean that. I'm just trying to understand. I did work for the NEA for seven years, as a consultant, on various levels. And as far as I could see, most of the input that went into the NEA was from creative artists in all those fields. Those were the only people around. The music panel consisted of performers and composers.

Mr. Rathbone: There were no scientists involved.

Mr. Erb: No, but what they had to say about the policy of the NEA seemed to me to be pretty profound. I mean, they really did determine a lot of what the NEA did. I remember there was one large panel called the Planning Section which had people from all fields. Now, there were almost no laypeople there. The one layman on that panel was a lawyer, who was there for obvious reasons, when the question came up about the ramifications of what we were doing. But by and large, I thought that we had a fair amount of input into what the policy of the NEA would be, and actually formulated policies, designed new programs, and all those things, and they seemed to listen well.

Mr. Lowry: Do you think that's true in the dance, Barbara?

Ms. Weisberger: Are you talking about in the development of the National Endowment? I don't know.

Mr. Lowry: No, not the development of it. The operations of it.

Ms. Weisberger: In the dance panel? Yes. To some degree, to a great degree, yes. But Mr. Schneider said there was no logical, no rational way. Among practitioners, there's an extraordinarily rational way. The only rational way. I think there's not that problem.

Mr. Schneider: It's not objectively measurable. That's all we're talking about.

Ms. Weisberger: Externally. The form of measurement, internally, is the only way that it can be done, and that's the way it is done, with one's best judgment. And it evens out at the peer panel level. But I don't know whether that has to do with the formation of policy. It has to do with judgments within a policy.

Shifts in Control

Mr. Rathbone: I think it's policy we're talking about, isn't it?

Ms. Weisberger: It has to do with selections but not the policy of the National Endowment. The effect or impact of judgments by the peer panels on the overall policies of the National Endowment is negligible, I think. We had hoped that by some osmosis it would happen, but I don't know whether it has.

Mr. Lowry: People here have sat with the National Council of the Arts, which is not about an art field but about policy for the NEA. What about this question?

Mr. Leavitt: I think that, specifically, the NEA did rely on artists very extensively, but I'm afraid I have to use the past tense, because I think there is an increasing tendency to bring in outside people with no expert knowledge, only some kind of interest in the arts who happen to be friends of somebody or . . .

A Voice: In the last couple of years?

Mr. Leavitt: In the last two, three years—members of the Council, and to some extent, members of the panels. The field of the arts is a little different from science in that there is an intermediate group of professional managers, museum directors, curators, and theatre directors and so on. So that not all the panels, I

think, have been dominated by artists. Dance probably has, and others. Sometimes managers have tended to dominate.

Ms. Weisberger: It was about fifty-fifty when I was on it, about six to eight years ago, and I think it might be less now.

Less Involvement of Artists

Mr. Zeisler: Decisions about funding, decisions about support seem less and less to involve the practitioners. In the old days of the Ford Foundation, there used to be artists and directors who would advise the Foundation about what to do. That doesn't happen now. It certainly doesn't happen in any of the corporate support programs and doesn't happen in the private foundation support programs, and this administration of the Endowment has very cleverly and very carefully managed to extricate control away from the Council and away from the panels and put it into central administration. So Donald and Barbara are absolutely right, and Tom, historically; the panels' selections were really judged by the professionals. That's now less true.

But there's another thing on the horizon which I think is much more important, which is that there is the growing tension and growing disenchantment on the part of the artists against the arts institution. I just went to an NEA seminar on opera and musical theatre where I heard the composers and the librettists make the same complaints against the opera and musical theatre institutions that we at Theatre Communications Group hear from the playwrights and the directors against the theatrical institutions. In other words, less and less do the individual artists really feel a part of the institutions where the artists perform. Increasingly, I find a tension between the two, almost an adversary relationship.

Mr. Lowry: Actors versus artistic directors?

Mr. Zeisler: Actors versus artistic directors, and directors versus managing directors.

Mr. Lowry: Within the institution or in separate . . .

Mr. Zeisler: The artists hired to produce the work are feeling adversarial towards those that are controlling the institutions.

Mr. Lowry: Including the artistic director of that particular production?

Mr. Zeisler: Is that fair to say, Alan?

Mr. Schneider: Yes, but I'm not sure that it's that fundamentally different. It's just that the institutions are larger, more solidified, more ossified maybe as to change. But I'm not sure it's that different, I'm not sure, Peter.

Mr. Lowry: Is that true in the Acting Company?

Mr. Schneider: Sure, it's always been true. They've squawked since it was started.

The Impersonal Institution

Ms. Weisberger: It becomes more poignant and more visible, some things that were undercurrent, but even when it existed before institutionalization—if I can use that word—or before multimillion dollar businesses and all those things, it was still within a family. You had the antagonism and the push and pull. You kept it there and you worked together against the outside world. And so they were contained.

Mr. Schneider: And so the problem gets bigger, the antagonism.

Ms. Weisberger: We begin to see now the wedge getting wider and wider and the antagonisms more prevalent; and they affect more, and people get wider and wider apart.

Mr. Lowry: Are we just maybe catching up with history? We've had companies and groups long enough now that they can have some of the same experiences as those in Europe, and you know what the tensions have been between the performers and the managers and the directors in European institutions, long before the U.S. ever had institutions really, except a few orchestras.

Ms. Weisberger: I hate to bring up the unions, but they were part of that creation and that antagonism. The unions had to live on those

Mr. Erb: It's a very subjective experience, I know, but I found myself in recent years dealing less and less with artistic directors and more and more with managers. I've had a couple of really amazing experiences, recently, with managers. One manager of an orchestra had a go-round with my publisher about renting my music for a premiere. We're talking about $200, really. In the final analysis he said okay to my publisher, we'll pay the $200, and then he deducted the $200 from my contract. And that was the last word on that. It's one thing to deal with a conductor or

artistic director, but when you start dealing with somebody whose only concern is money, it's not much fun.

The Foundations

Mr. Lowry: When Peter Zeisler was complimenting the Ford Foundation, he said he didn't think that it was any longer true in foundations that artists were given influence and open participation in decision making. I don't know whether that's what you meant to say, Peter. It's what I heard.

Does anybody want to talk further about the private sector? We'll except the corporations; you have already said that corporations don't use artists enough to help them decide what to support. What about foundations?

Mr. Leavitt: Foundations do use museum directors, curators, and managers probably in other art forms, but I don't know of many that nowadays actually use artists. I think foundations make use of museum directors and curators and probably artistic directors and so on, but I don't know of examples where they are actually using artists, creative artists, in their decision making, or painters or singers or . . .

Mr. Sachs: They do, I think, in terms of soliciting opinions or written support. I'm not sure that that influences policy. The policy is already established that demands that they do seek opinions.

Ms. Weisberger: I don't see too many foundations initiating innovative programs of philanthropy coming from the core where they can get a true response to the field or the needs of the field.

Mr. Leavitt: Some, I think, are being quite innovative . . .

Ms. Weisberger: In whose terms?

Mr. Leavitt: In their methods of support of institutions. I think Marcia Thompson's work (National Arts Stabilization Fund) and so on—they're looking at rather innovative solutions to the funding of the arts institutions. But not of artists, too much, as far as I know. It's all institutional support.

Mr. Lowry: I don't know what you all, representing particular fields, are doing about it, but there are a lot of small and middle-sized foundations that are no longer insignificant because all of them taken together account for a good deal of money, and they're going out and making like innovators or like critics, as Zeisler said, and they think that their biggest task is to persuade

The Artist's Motivation

Mr. Lowry: Is there a responsibility for artists to share in trying to influence policy decisions in this field? Or should they just say, "Well, I've got all I can do to follow my own career"? Or if they are an artistic director or curator, they say, "I've got all I can do to help shore up this institution"? So they let other people like patrons, trustees, government officials, foundation officials worry about policies?

Mr. Leavitt: It would be awful if they all did. I think there have been a number of artists who have been involved in giving testimony . . .

Mr. Lowry: Largely advocacy, though; right?

Mr. Leavitt: Yes. And as I think we said, there have been artists who have in the past served very effectively on the various governmental panels, and probably foundations, too, to a degree. My own feeling, and it's just that, I have no figures, is that that has declined, and that there is less artist participation, more advocacy, perhaps, but less policy determination by artists in recent years.

The Burdens Inside

Ms. Weisberger: I do want to say I think what's happened here is that the artist and artistic directors, and I must put them together because they are usually on "the same side," their energies and their spirit have been dissipated, because they have spent so much time on artistic policies and protecting them and promoting them within their institutions that they have got farther and farther away from control. So that at the national level, it's very hard to look from the inside out, and be active in it when you're so taken up with what you might say were self-serving purposes. And then, very often, when you get out with other colleagues, their deep concern is again getting the support and advocacy, and they don't want to spend the time thinking about policy and what contribution they can make to that. And I think that's very sad, because it's going to be taken completely out of our hands by default.

Mr. Lowry: But is it not also true that even with all those informal caucuses in the arts that went on in the Ford Foundation

their boards to give them that autonomy. A lot of them are getting that autonomy. Anyway, what are you doing about these people? They do want to feel they're in bed with artists and artistic directors. Is that impossible?

Ms. Weisberger: Is it that when we're coming in with requests for funds, we're reading what people want to hear, and coming in to please them, with the hope that we will get money?

Mr. Zeisler: I think the problem is a lack of any kind of ethical criteria.

Mr. Lowry: For how to deal with them?

Mr. Zeisler: They're loose cannons; they're not controlled. There used to be a very clear separation between church and state, and voyeurism was really at a minimum. It is now going to the other degree, where all the funders are really trying to be artists and critics, and they're not being controlled.

Ms. Weisberger: It's harder to find. It fits into the analogy of getting individual support, broad-based individual support. It's much harder to get a few dollars from a lot of people than to identify the ones with a lot of money.

Mr. Lowry: The only thing that in dollars shaded the dominance of the private patron, even briefly, was the Ford Foundation in the sixties. This is not new, what you're saying.

Mr. Erb: I know it's not, but I did, at one point, as you know, benefit from the Ford Foundation, among other things, and now it seems to be other things, and that's all I'm saying.

Mr. Leavitt: I think most of us have had the experience, in the last couple of years, anyway, in spite of the small foundations who may be out there looking for a project in the arts, that we always get the line "I'm sorry, the social needs are so dominant right now, we're not going to be funding the arts for a while." And that's happened, I know, in Minneapolis and I think in other places.

A Voice: It's universal, in my opinion, with corporations

Mr. Leavitt: With foundations, too.

Mr. Erb: But Minneapolis is a good case in point. There's an organization in Minneapolis, as you know, called the Minnesota Composers' Forum, which gets all kinds of small donors, and they also encourage all kinds of individuals to write a check for 50 bucks, and they do an amazing job on that level. It's the only composers' organization in the country that I know of that has a really large budget just to take care of composers. It's really amazing

from '57 to '74, is it not true that now conferences, seminars, workshops about the arts, or one art, are so numerous that it's hard for any of them to be elevated to the level of policy?

Mr. Zeisler: You can't see the trees for the forest.

Ms. Weisberger: Yes, and those conferences are about the band-aids.

The Crisis Over Governance

Mr. Lowry: I think we must move on. Next on the agenda is: "What is the influence of the nonprofit charter on the governance of artistic groups? What are the roles of the artistic director, or producer, the manager, the trustee? What are the influences upon governance from the separate sources of public policy in the arts? What effects are there from the shifting cycles in the influence of voluntarism?"

Now, there's a topic and there's a mouthful. Perry, how are those scars? Can you talk about that right now?

Mr. Rathbone: Well, I can say, in my experience with museums, there was frequently a certain amount of criticism from the creative side of the artistic life. There was no representation of artists on the boards of governors or policy makers, painters and sculptors and others of the artistic life of the community. And I think that was unfortunate, and I think it ought to be taken into consideration, as it was at the beginning in the Metropolitan Museum, as you probably know. Artists were quite conspicuous on the first board of trustees. They belonged to a different class then. They didn't have their nice clubs, and things like that. But I think a lot of the troubles we had in Boston, and my predecessor had in St. Louis, could have been avoided if the role of the artist on the board of trustees had been respected, because the artists got the impression that they were being left out of any control of the artistic program of the community. It also got to the point where it became very, very racist, actually, in Boston, where the blacks were sure that they had been demoted in the social structure, because they weren't on the board and they didn't have any black art in the Museum and that kind of thing.

Had there been an artist there to speak for them, and there could have been someone from the Museum's school at least on

the board of trustees to speak for this sector. . . . I don't know whether they would have—it's very hard to say that the artist can be very sympathetic to the museum which is dealing with historic art, primarily, and not cultivating the artist of the moment. They usually feel rather antipathetic to the establishment of a museum.

Mr. Lowry: Do you think the trustees of the Museum of Fine Arts understood where their province ended and yours began?

Mr. Rathbone: You mean the director?

Mr. Lowry: Yes.

Mr. Rathbone: They did, perfectly well, when I went to Boston, but not when I retired from Boston, but that's for specific reasons. This problem had arisen, I think, back in 1905, when Edward Johnson left the Boston Museum to accept the directorship of the Metropolitan, because he felt the trustees were encroaching upon his territory and his prerogatives as director. So goes the little story.

Mr. Lowry: And in your own time, it was not confined to the MFA in Boston, was it, as far as American museums were concerned?

Mr. Rathbone: No. The same situation existed in St. Louis when I went there, where the board of trustees under the president had almost usurped the position of the director. That's why that director left. But when I went to Boston, just the opposite happened to me. My prerogatives were never questioned by Ralph Lowell and his board of trustees, but when his successor took the chair, it was his ambition to run the Museum. And it became very awkward; and that's probably beside the point here, but I do feel that the artist, the creative artist in the community, ought to be represented in making the policies of art institutions.

Mr. Lowry: We were talking about this subject in Fort Worth in 1977. We were also talking about another episode on the same scenario at the Chicago Art Institute. We were talking about what might or might not be happening at the Philadelphia Museum, and we had already seen some evidence of what happened to your successor (Merrill Rueppel) when he was at Dallas, although he was still in his chair until he came to Boston. Right?

Mr. Rathbone: Yes.

Mr. Lowry: Now, in your judgment or your observation, since

as far as the new companies are concerned. And there is a greater
pluralism of support. It's not just individual patrons who could
come up and take care of a deficit, single-handed. It is now in-
cumbent upon us, because of government support, even though
it's a very small percentage of what we get, to have a diversity on
the board, and to have representation from the community, both
ethnic and racial and social and whatever, so we do that.

But what it comes down to is—I hate to use this word, because
I sound very academic and God knows, I hate that—but *owner-
ship*.

A Voice: Why does that sound academic?

Ms. Weisberger: Well, because academic people talk about it.
Sociologists are talking about it that way. It's not an aesthetic
question. It's now becoming what you read about in books about
ownership, moral ownership. And I always feel as if I'm moralizing
when I use the word "moral."

But it really has to do with that. Are we serving the artists or
are we serving the public? The board says we are serving the
public, and the artists are fighting along, although they don't
articulate the fact, serving the artists, at least 50 percent. And
so anything can be justified by a board of directors, who are very
unclear as to where their responsibilities lie. Nobody makes that
clear, certainly not the artistic director, who never had the neces-
sity to make it clear in the first place, because nobody cared except
that person and a little group of artists who worked with him
or her.

Now suddenly there's a lot of money involved, and it's pres-
tigious, and many people are contributing to it, and we have
this and that responsibility to this and that agency and to those
people, and we have forgotten that it started because of this
original little group. I think that's the crux of it. But we must not
lament this and throw up our hands in hopelessness. We have to
come face-to-face with the fact that it's not all right and wrong,
but how we can balance it, because the fulcrum has gone all in one
direction.

Need for Balance

Mr. Sachs: A lot of ideas seem, in my mind, to meet here.
What you were saying about the business manager, what you
were saying about the deficit, and so on; I think policy has not

you've now had a chance to put it into a little bit of perspective away from the field, has this whole question, which as you say was historical, even to the point where Fry, was it, went back to London from the Metropolitan.

Mr. Rathbone: He did; Roger Fry left.

Mr. Lowry: Has this accelerated: has this become influenced by many other things happening, socioeconomically, in the arts? And the advent of bringing in a paid partner or paid president? Has this become a trend, in your judgment?

Background to the Changes

Mr. Rathbone: Yes, it's a trend, and one that has been governed by changing circumstances and conditions, one of them being the appearance of public money, principally federal money in the conduct of museums. That fact alone, it seems to me, has bureaucratized museums in a way that didn't exist at all when I commenced my directorship, lo these many years ago, in 1940. And it has put additional binds upon the practical functioning of the museum, which I think has really required the addition to the staff of a business manager. Not that that should detract from the artistic control of the museum by the art director, but I think today, given the personnel problems, the money problems, the problems pertaining to grant applications that have developed, a director would be overburdened not having a right hand who would assume responsibility for that aspect.

Mr Lowry: Should he be his right hand or the board's?

Mr. Rathbone: I think he should be the director's right hand. That's the classic argument.

Ms. Weisberger: That is the classic argument. And I think the most important thing you said—and I will not presume to talk about museums and the governance of museums, which have a far longer history than ballet companies or nonprofit theatres—is that we are beginning to feel the changing institution, and all the environmental influences on that changing institution, which we should have anticipated instead of being so shocked.

But that is ridiculous, in a way, because we couldn't foresee the problems or prevent them. We were too busy doing what we were doing. It has a great deal to do with very obvious facts. There's more money involved. There's more prestige involved.

kept pace with the fact that the tail is not wagging the dog now. The tail *is* the dog.

Ms. Weisberger: That's right. (Laughter)

Mr. Sachs: The business manager really is a function of the board. I think it's easiest to live with a business manager who reports to the artistic director. But the fact of the matter is, where previously the artistic director was there to do the job of art, with a capital *A,* and the trustees would pay for it, or figure out how to pay for it, now we are told, here's all we can raise, go do it. This is something in policy I don't think you can conceive of.

Ms. Weisberger: And if you don't, you're irresponsible, which trustees thought you were anyway.

Mr. Sachs: There is no policy that says that is the way it should be done, this is what we intend to do.

Mr. Lowry: You mean, therefore, the manager's role is, ipso facto, superior to the artistic director's? When you push this argument deeper, what values are visible underlying this? Is it a question of value? Who is to referee? I don't see where the referees are, ideally. They're not in foundations, they're not in the NEA, certainly.

Mr. Sachs: Ideally, they are in "the public," quote, unquote, whatever that is.

Ms. Weisberger: In the marketplace.

Mr. Lowry: These situations—there were three of them within a year, in effect, in Philadelphia. You and the Pennsylvania Ballet, Seymour Rosen leaving the orchestra, and Miss (Jean) Boggs leaving the museum.

Ms. Weisberger: All different circumstances, but the same.

Professional Leadership

Mr. Rathbone: My opinion has not changed. I look upon a museum as a cultural institution, and its policy and programing should refer to that fact. There should be a cultural expert on the staff, if it isn't the director. That's what he's hired for. And he's not there simply to balance the budget. He's there to attract support and that kind of thing, certainly, and to lead the staff, but he's not there to balance the budget, and he's not there to fulfill all the desires of the federal bureaucrats.

Mr. Leavitt: It may be just that since I've been president of

the American Association of Museums I see more signs. But it's my impression that the kind of problem Perry was talking about, the tension between boards and directors, is if anything getting worse. A couple of months ago we figured that there are seventeen museum directorships open in the art museum community with budgets over $400,000, which is a fairly small community, and many of these were the result of alleged irreconcilable differences between the director and the board of trustees. The incidence of this kind of problem, I think, is made greater by the financial pressures that all institutions are operating under nowadays. But it got me thinking. I wonder if there's something wrong with the system itself, and probably nothing could be done about it, but the notion of the volunteer community board of trustees, unpaid, and usually perpetuating themselves, and the underpaid director—is there something in that structure itself that is awry, and causing or at least contributing to some of the difficulties of arts institutions now? And if so, what are the problems and could anything be done about it?

Mr. Schneider: What are the alternatives to that structure?

Mr. Leavitt: Well, that's a good question.

Ms. Weisberger: Do you ever ask that question?

Mr. Leavitt: Yes.

Ms. Weisberger: I think we're sort of tied into thinking it's the only way.

Nature of Trustees

Mr. Leavitt: Well, if museums and arts institutions really are for the people and not for the board, as a club, maybe the selection of trustees should somehow be done on a different basis, some more public basis. Maybe we should pay trustees. Maybe if they had a vested interest in performing, or felt that they were employees of the public rather than "owners" of the institution, there would be just a different attitude toward what they do. I don't know, but there must be some things that could be done.

Mr. Lowry: What corporations do?

Mr. Leavitt: That's right.

Ms. Weisberger: The corporations have a built-in objective, making money. What do you do when it's a nonprofit organization?

Mr. Lowry: He has suggested, perhaps without saying so, that

the salary as well as the trusteeship might make enough motivation for assiduous attention to problems.

Ms. Weisberger: But it might be more assiduous . . .

Mr. Sachs: But it may also be the bottom line, in a true sense of the word, by the public. Many museum trustees in America are now elected by their "membership," quote, unquote.

Mr. Lowry: But it's usually self-perpetuating.

Fear of Government

Mr. Rathbone: Sam, I think what Bostonians feared from the beginning was the possible involvement of the city government. That's what they hoped to avoid at all costs, and with good reason. Therefore they even went so far as to buy the twelve acres of the Fenway, or in the Fens, on which the Museum stands. It's not public land and never was. The aim was avoiding all controversy. There was no such problem as was had with Central Park. They bought the land, built the building, furnished it with art. I must say the private sector in Boston has been admirable from the beginning, but quite insufficient, too, as time . . .

Mr. Lowry: More admirable, maybe, in the beginning than more recently.

Mr. Rathbone: Yes, I would say so.

Ms. Weisberger: If that were one course of correction, paying board members, would that solve the problem, the power problem?

Mr. Sachs: It would take money away from the arts.

Ms. Weisberger: I wonder if it would not.

Mr. Lowry: I don't think Tom has said, here's a solution.

Ms. Weisberger: No, no. What he is doing is looking at alternatives.

Mr. Lowry: What he is talking about is being talked about all over. It's not just in the American Association of Museums (AAM).

Ms. Weisberger: How many organizations have paid presidents, members of the board, chief executive officers?

Mr. Lowry: Too many?

Ms. Weisberger: That's right. But there is a strong move in that direction.

Mr. Lowry: Not necessarily.

Ms. Weisberger: Not with the proper justification.

Mr. Lowry: It's not the same move, either. Do you give members of the board a little bit of force toward equality if you force them all to take a salary?

Mr. Leavitt: That is, if they become an employee of the public.

Mr. Lowry: How they get elected, Tom, is really where we are.

A Change for the Worse

Mr. Sachs: I think museum boards would founder if such a nonvolunteerism system were put into effect. For better or worse, what I think we're all afraid to face is that the public doesn't give a damn, that if we closed our doors nobody would notice, and therefore it is the volunteer boards and those very limited numbers of people who really care, who make it happen. It's not all roses in that situation, to be sure. But to pay the board is to proliferate the paid president.

Mr. Leavitt: I wouldn't want to focus too much on paying the board. I think that's just one thought. There may be completely different ways of solving it, but we've never before now really looked critically at the actual structure of nonprofit institutions, to see whether they really are performing the role in society that we want to have performed in the nonprofit sector.

Ms. Weisberger: What we want them to perform has never been articulated. There isn't any prescribed role. There aren't even guidelines.

The Unknown Depths

Mr. Schneider: That's why there's been a tampering with the relationships. I think we can tamper with situations between boards and the artistic leadership, but there's a risk of opening up cans of worms that we can't begin to visualize at this point.

Ms. Weisberger: There is a fear—a great deal of fear of losing support through certain strong actions, you know. All these things have to do with the emotional deterioration, until you find you have an institution that exists for itself, and even artistic directors and the artist begin to lose contact with it.

Mr. Lowry: Yes. But after all, this is a very young country, and after the tax code changed in 1913 and 1916 people began to take advantage of the tax legislation to structure a greater and

greater number of nonprofit institutions, which in the arts, at least, were lying there ready for the Ford Foundation's response. I think this nonprofit beast is not yet understood even by the people who have taken advantage of it. It has not yet really been studied.

Mr. Erb: This is an observation that may be wrong, but I throw it out, looking at it from the standpoint of somebody who started his career wearing castoff clothes. But in my looking at the character of boards, I think there's maybe been a slight qualitative change, not for the better, that might be important. I started my career in the early fifties. The boards I had knowledge of in Cleveland had, for instance, a sprinkling of people from the medical professions, European intellectuals who had left Europe, and those people have been replaced by American businessmen. And I think that thereafter it's been a qualitative swing to what is considered the right thing to do. I do think that the dominance of businessmen on these boards may not be permanent, but who knows?

First of all, as Perry has pointed out, there are no labor union people—I don't say there should be. We haven't got proportional representation on these boards yet. But I don't believe that's going to last, because the corporations have not given the millenium that trustees hoped they would give financially.

Mr. Schneider: Aren't we leaving out something again? Maybe I'm just illiterate myself. Part of the raison d'être of being on the board has to do with raising money for the institution?

Mr. Lowry: Yes, but you don't have to be a businessman to raise money.

Mr. Schneider: No. But if you're a labor leader, well . . . okay.

Mr. Lowry: Suppose you're a college professor or a college president; they raise money you know. What about John Brademas? He's never been in business. He has been in Congress, but he loves fund raising.

Mr. Erb: For many years, one of the biggest fund raisers for many arts projects in Cleveland was a local surgeon named Jerome Gross, and he raised money for all kinds of things, and he was a doctor. He was cultured; he played the violin very well.

Ms. Weisberger: There's a generalization there, too, though. All businessmen aren't all bad. I think we are generalizing a bit.

Defining the Role

Mr. Zeisler: I wonder, when talking about the leadership we used to have—it was certainly true in the theatre, and certainly true in the music world—I wonder if it's not part of the problem, because there's never been a clear delineation or clear discussion of what the function of the arts institution is. I don't think people know what it is they're supposed to be doing on boards, and what function they're supposed to have in the society.

I can only talk about my own field, and we have no role models, because you have state supported theatres all through Europe. England only for twenty years has had anything like what we're trying to develop in this country. We don't really know what the correct balance should be of private and public funding into a theatre, and what the responsibility of a society in general is, from tax money, and what the balance should be from private—we don't know what it is about. Is it supposed to be just a convenience, what they're going to do in the evenings, go to the theatre?

Mr. Sachs: In the museum world, I think these questions may be a little more resolved, if not completely so. The AAM has published a trustee museum handbook which clearly defines what that role is. You've got to know what it is you're going to accomplish before you can even fail at it.

Mr. Leavitt: One of the weaknesses is that in too many institutions, a powerful individual can exert his will on the board, because the guidelines are not clearly defined. You get a very bad situation.

Ms. Weisberger: Because there's nothing articulated. That's exactly what happens. If you have enlightened leadership, then things can move smoothly for a long time, because on most boards there's either one leader or a small group of leaders, and the rest are passive and accepting.

Problem of Succession

Mr. Lowry: One of the questions we haven't got to is an assumption under this topic. We haven't really much proved, except in the museum field, that one of these dynamisms can be

kept under control beyond the life or career of one artistic director; transferring it will upset not only the artistic leadership but can also transform the managerial function, it can transform the board interest and complexity, and it can put the board into great controversy within itself. Nobody has proved yet, in the nonprofit fields of theatre, dance, opera, let's say since 1950, that the same kind of good will and communicating leadership can be transferred beyond one personality, who maybe founded it or took it through its best years or whatever.

If that's too long-winded, let's just ask ourselves, if Lincoln Kirstein were to retire in two years, George Balanchine having died, what about two of the most conspicuous institutions in the arts in the United States, the School of American Ballet and the New York City Ballet? How harmonious are those boards?

Mr. Schneider: Isn't it the nature of the arts to depend a great deal on the personality and psyche and value structure of the individual who is the artistic leader? How can we deny that?

Mr. Lowry: We can't, but let's turn that around. How do we best get trustees to understand that?

Ms. Weisberger: It's very, very difficult because there's very little justification. When you go . . .

(Several voices at one time.)

Ms. Weisberger: But they have to say, "I am here." It's the complete generalization of their purpose. When I had the problem, I spoke to one board member, a woman whom I had pressed to become a member of our board, and I asked her why she sat on this board? She said, "Because I want to see good dance in Pennsylvania." I said, "That's the problem. It's not good dance, it's the Pennsylvania Ballet you have to sit for." That's a specific "good dance," or we hope it is. That attitude is just symptomatic and permits justification of almost any action. The pretty little dancers or actors exist in some sort of artistic vacuum, and trustees can think it makes little difference who makes the decisions about their artistic lives. After all, they're promoting "good theatre" or promoting "good dance."

Mr. Schneider: I'll give you the same thing from another point of view. A member of the board of the Washington Arena Stage, not too many years ago—and they're pretty sophisticated people, not even businessmen, I don't know what they are, they're community leaders—at a party for the company, he said to the

leading actor in the company, "What do you do in real life?" I mean, Washington is not Hicksville. "What do you do in real life?" He meant that very sincerely. How do you educate boards of directors to understand that actors lead real lives?

Mr. Sachs: They can't imagine that a person is doing this for a living, because they know what it pays.

Ms. Weisberger: That's the answer to the question, why do artists think they have to make $80,000. I don't know if it's the artists—it's not what the artists think about not making it. It's what everybody else thinks of the artists' not making it.

Mr. Erb: Well, somehow or other, all I meant was the expectations that have been set up, however they were arrived at.

Mr. Lowry: You know, I would like to devote at least an hour to the most open question of all, so I'm going to bring this particular question to a close.

The Agenda for Policy

Mr. Lowry: So that most open question: "What are the most urgent remaining tasks to insure a public policy for the arts which comprehends them as a fundamental national interest?" The latter part of that sentence assumes continuity at least of what was written into the preamble of the legislation in 1965 for the National Foundation for the Arts and Humanities.

Mr. Erb: I'd like to go back to my issue, one that will have to be addressed over a long period of time. I'll use as illustration your Ford Foundation program with the young composers in the high schools, which for the money spent had more impact than anything I've seen in my lifetime in the field of music. And I think you know a lot of different organizations still address themselves to the problems that remain in education.

For instance, just a couple of years ago I had a daughter who was a senior in a good city high school. They had a choral festival, and they invited the ten other best high schools in the area to come sing in the festival. I went and listened to it. The entire day was spent on show tunes. I think we have to try, somehow or other, to make people aware it really doesn't hurt to sing Palestrini and Mozart now and again. It doesn't hurt to do Stravinsky. The kids can do it. I've heard it. Pressure has to be brought on organizations. You have to deal with the Music Educators National

Conference for instance, in some way. They have become a tacky organization.

The School Audiences

Mr. Zeisler: Two points. In 1964, in Minneapolis—the end of the first year at Guthrie Theatre, I was going to commit suicide. We were getting nothing but all those blue-haired ladies from Wyzata into that theatre. It was no more cutting across the population than the man in the moon. We got a Title 3 H.E.W. grant which mandated that every high school student in Minneapolis had to go to the Guthrie Theatre, as part of their English requirement, just as they all had to go to the Science Museum. Two things happened. Those kids came back on their own, and going to the theatre became a part of their life in high school.

Mr. Lowry: Who kept track of when they came back?

Mr. Zeisler: We did. More important than that, their parents came. Their parents, who were afraid of the theatre, didn't come near it. But their kids would come home and say, "Gee, we went to the theatre; we really had a good time." It's not just for Wyzata, it's really for everybody. Yes, it was. They went. Demographically, we turned that audience around in two years, thanks to a Title 3 program.

Point number two. It's all related to sensibility raising. Every year, for fifteen years, I have written the New York *Times* my letter, and I'm about to do it next week, pointing out that the New York *Times* considers itself the journal of record of the United States. Why do they publish book reviews? They're not appealing to the librarians of New York City. They review books every day because books reflect the societal concerns of this country. If they do it for literature, why in Christ's name don't they do it for the arts in this country? And until we get to the point where the arts are considered primary, exactly through examples like that, nothing is going to happen. That's the most important thing.

Assumptions about Other Countries

Mr. Rathbone: Mac, before we all gathered here, I was thinking about these problems, and I wondered if you or anyone else you knew has addressed some of these questions of our op-

posite numbers in Europe and Japan, because we assume, of course, that the Europeans and the Japanese are more literate artistically than we are, more responsive to ballet and symphony and all that.

Let me not say that, but let me say, at least, they are not faced with the same problems we are, and why aren't they? Is this because they are older societies? Older urban communities? Or what? Is it because we're so polyglot?

Mr. Lowry: Would you trade the museum problems of the United States for the museum problems of Holland or Italy or France?

Mr. Rathbone: No, I don't think I would.

Mr. Lowry: Okay.

Mr. Rathbone: Because as far as I understand them, they are highly bureaucratic. But that hasn't anything to do with the response of the public.

Mr. Lowry: Okay. I think you need to go on with that a little farther. Please, that's an interesting point. Say a little more.

Mr. Rathbone: Well, I know something about European bureaucracy. It's interesting; for example, the Kunsthistorisches Museum in Vienna, where there was the most unbelievable performance, the number of keys that had to be produced by the keeper to get me up the third floor and down the right corridors to the curator's office. That was just one lesson I learned there.

But they do have means of subsidizing the performing arts, certainly, I know, in Bavaria. And their museums, which are taken for granted, as far as I know, are accepted by the public as a fact of life. The museum directors don't have to spend their time raising money. They do have to live under a bureaucracy, and I've heard museum people from abroad envy the kind of personal atmosphere that exists in so many American museums, as a very attractive quality. But they don't have to be worried about the amount of money the nation spends to maintain chamber music, operetta, and grand opera in Munich, and so on. And how did they get that way?

The Effect of Tradition

Mr. Lowry: Three hundred years of tradition?

Mr. Rathbone: But we can't wait for three hundred years and there must be some philosophy that they also feed their public—

which changes with every generation—and which they find very appetizing, digestible, anyway. And life goes on in a way that we find quite enviable.

Mr. Schneider: Their television is just as bad as ours, when talking about our declining values and literacy. They use all our worst programs and they love them. They're popular. I think we romanticize the nature of their nirvana a little bit.

Mr. Erb: Europe is in a state of decline.

Mr. Schneider: Everybody is in a state of decline, except the Japanese motor industry.

Mr. Lowry: But, Alan, he's right about one thing, I think. The idea that the state supports these things is taken for granted in those places.

Mr. Schneider: We didn't have the Duke of Saxe-Meiningen in 1872, or the Court of Bavaria in 1782.

Mr. Lowry: But we had a guy that owned the Boston Symphony, and we had another one that owned the Metropolitan Opera, and they did very well.

Mr. Sachs: Exactly, and a lot of people that live there now came from that same tradition and culture, but somehow they haven't gone along with them. But the fact is, I think it's taken for granted, if you like, it is public policy—that this is to be done, and it is to be done regularly and well, and there are lots of statistics around to prove in Austria in particular how much is spent per capita. It puts us to shame.

Ms. Weisberger: It's not predicated on numbers, numbers that attend. I mean, they will support something and not only because a lot of people are going, that's the point.

Mr. Sachs: But the bottom line may be that if that support were to evaporate or be reduced or eliminated there, there would be a hue and cry. There wouldn't even begin to be a ripple here. This, in my mind, goes back to the educational system, where one is not educated unless one is also educated in the arts. Learning to read and write and balance a checkbook and turn on a television set is not sufficient there. The whole idea of what education is is different. They don't educate people to make ice cream.

Mr. Rathbone: There must be something in the Japanese educational system. I know that in the third grade, in fact, each child is given a violin or something, and they learn what the violin is all about. Isn't that true?

Mr. Schneider: We'd have people rioting in the streets, rebelling against repression.

The Cultural Boom

Ms. Weisberger: I think it's even more negative than that. To mouth the fact that the arts are important in our lives becomes cliché. I don't even like to hear it any more because it's so general.

A Voice: Maybe it's not true.

Ms. Weisberger: And perhaps it isn't true. But it is even worse because there is a negative feeling about art and artists. It almost gets to that.

Mr. Erb: By the way, it was actively promoted by the pop culture. I think so.

Ms. Weisberger: And also by the business culture. I mean, it's disdain, a lack of credibility, and it's a very important question that you asked. I don't even look for nirvana, or expect that everybody will agree. I accept the fact that some people question whether you deserve to exist if you can't earn enough money from the people who are going to come to see you, or wonder why you think they would give you money because there are poor people who are really much more important than that. That goes with the territory.

Mr. Sachs: Something just struck me, and I just throw it out for what it's worth. In this country, more than any other, not-for-profit is pejorative.

Ms. Weisberger: Absolutely.

Mr. Schneider: It's getting less so, is it not? I mean, can we say that it's getting less so?

Ms. Weisberger: I don't know.

Mr. Schneider: They didn't know what it meant when I started in the theatre. Now, they at least know, whether they accept it or not.

Source of Attraction

Mr. Lowry: Well, it's had a lot of publicity. Every year somebody wants another foundation, and you can't talk about a foundation unless you explain about not-for-profit. There are businessmen still who recoil when their lawyer comes, just the way

Henry Ford I did; he said, "I don't want our stock to get on the big board. I won't want stock to be issued." And his lawyer said, "Okay, the only thing you could do is make a foundation." And then later he said, "You mean I can't take it back?" And they said, "No."

Now, you think that's Henry Ford I who is a particular kind of legend in this country, but it's still happening right now, and you still have to explain it.

Barbara, you said there was an increased contempt for art and the artist by these business types. But if they want to be on your board and control it, if they want to give you some money and it's ballet of your creation going on, on that stage . . .

Ms. Weisberger: That has not to do with their decision. They would get on it, whether they expect a product or not.

Mr. Lowry: Why didn't they go and support the zoo?

Ms. Weisberger: Because it wouldn't give them the cachet or the visibility . . .

Mr. Lowry: Why? Why wouldn't it?

Ms. Weisberger: I don't even know if that was a thought. Maybe some of them would if that was the alternative given them.

Mr. Lowry: No, you didn't give them the alternative. You didn't say, "Take your money and go to the zoo." But why do you think they chose to do it? Why was it cachet at the time?

Ms. Weisberger: At what time?

Mr. Lowry: At the time they did it with the Pennsylvania Ballet?

Ms. Weisberger: It was very personal.

Mr. Lowry: With each person?

Ms. Weisberger: Almost.

Mr. Lowry: With each trustee, each businessman?

Ms. Weisberger: In the beginning. After that, it became farther and farther away from personal . . .

Mr. Lowry: Ten years later, there were still businessmen coming on.

Ms. Weisberger: It was all personal communication.

Mr. Lowry: Isn't that the answer, then? Isn't that part of the answer we have to figure out?

Ms. Weisberger: No, one personality, I'm talking about. They responded to . . .

Mr. Lowry: To you, okay.

Mr. Schneider: Terrific, that's the answer; that's always the answer.

Mr. Lowry: Now, isn't that always going to be central to this argument in the arts? It can also be suicidal, and it can also be murderous.

Ms. Weisberger: As we did find out. But the personal tie got farther and farther away, because it was a self-perpetuating board, and as the company grew there was not anything else. They came on because they responded to my enthusiasm, or whatever I could project, about the need.

Mr. Lowry: That wasn't contempt. You used the word. It was not contempt when they responded to you.

Ms. Weisberger: Oh, no, no. I'm not saying that those individuals who came on the board have that contempt. There was the contempt from other sources, the other sources of support, from which I tried to solicit funds, but there wasn't anything deeply serious about their commitment. I shouldn't say in every case, but in most cases. And it was something that they could let go without any great harm to their own lives and their own futures. It's a nice little thing. It was Barbara's little thing. I'll help a little bit; I'll come along if I can help. It wasn't their thing.

A Shared Commitment?

Mr. Schneider: Can it ever be, or should it ever be?

Ms. Weisberger: Wholesale, I don't know.

Mr. Schneider: Their thing?

Ms. Weisberger: In line with their own commitment and their own responsibilities, certainly. It's got to be the sharing of that, in whatever way they can. Not the sharing of my particular vision, or the artistic director's or the artist's particular vision, but the sharing, reaching something that's going to be shared. There's got to be an interlocking someplace along the line.

Mr. Schneider: I'm getting caught up in semantics. Of course, they've got to be interested, and they've got to have a commitment and enthusiasm, but . . .

Mr. Rathbone: The personal thing has to be translated into the national—it's that we're talking about, isn't it? How are we going to create an attitude on a national level? Isn't that right, Mac?

Ms. Weisberger: But it's a sorry case to think that it will be

completely dependent on one charismatic individual or the dedication of that individual, the personal God forever.

Mr. Lowry: Barbara, you just told us that that's what it was dependent on in Philadelphia.

Ms. Weisberger: In its beginnings.

Mr. Lowry: You don't have that individual there now. You've got a real problem there now.

Ms. Weisberger: But that doesn't solve anything. Even if there were a good job being done, it's not going to protect it from happening again in the future, because we're just looking at the surface.

National Diversity

Mr. Lowry: Well, maybe I didn't even answer Perry's question in his mind. I have a prejudice that it doesn't take one national ballet or one national theatre or one national museum to be "national." I think there is a national theatre movement, or whatever you want to call it, a national movement in ballet, and it has a distinctive personality going back even to ballet roots that I know, and I'm only seventy years old.

Mr. Rathbone: There is the beginning that the Kennedy administration made, that was very, very encouraging, and I certainly felt it like a tremendous electric charge. It was superelectric. I remember, I got a telegram—I think it was Kay Halle —if I would be willing to be on a committee to help press the whole artistic program of the new administration, something like that. It was absolutely exciting. Naturally, I said yes, and pretty soon I found myself involved in a minor way with what the Kennedys were doing. I found myself at the concert that Casals did at the White House, and things like that. It took somebody at the top like that, who also knew what he or she was doing. And if it were carried on—unfortunately, it was tragically cut short—but if it had I think the scene would be different today.

Mr. Lowry: How do you feel about life in the White House, speaking about "Live from Lincoln Center"? It isn't quite as exciting as it used to be. I don't mean because of Mr. Reagan. But even when Johnson or Ford or Carter—is it as exciting?

Mr. Rathbone: Not in any way.

Mr. Lowry: Why? Because it's not the beginning?

Mr. Rathbone: No, it's because there's not the education behind it, that's why I would say. I mean, both those people (i.e., the Kennedys), they were educated, in a sense, to a place of culture in life, and it certainly showed.

Mr. Schneider: He gave us the *impression* that it was. And he cared enough to give us that impression. Today, we get a different impression.

Mr. Rathbone: You're not going to find that again.

Mr. Lowry: All of this we've been talking about for the last twenty minutes is one more thing on top of education. Now, what else? What else here? Perry got us into this, and I think it was a very productive discussion. But what other remaining tasks? Education was one. The way of getting national recognition of the relation of the arts to the society, through what? Through personalities? Through artists, artistic directors? Is that another?

The Function of Art

Mr. Leavitt: I think, also, a reaffirmation of the function of art in society. I suppose that's another aspect of education, but maybe if we just had the kind of statement from public and private individuals in positions of prominence, that the arts are critically important to society, and individuals who embody those creative aspects of our life, are paid more attention to, I think that could have an important effect.

Mr. Zeisler: I'm sorry, I have to keep coming back to the communications industry. We are a continent, not a country, and until we have some way of making the events that are taking place in this country known by the population, we're going to perpetrate this myth that the artistic center is the northeast corridor.

Mr. Erb: That's generally believed in the rest of the country, of course.

Mr. Zeisler: Of course, because all this information is coming out of here.

Mr. Erb: If you go to the Dallas *Times Herald,* or the Dallas *Morning News* and try and tell them that you're important enough to write about in the paper, they don't believe you.

Mr. Lowry: Right, but think about it; nothing depends on the Dallas *Times Herald.*

Mr. Erb: I could translate to other newspapers around the country. When I said people believed that, I didn't mean people in the arts.

Mr. Lowry: I don't mean people in the arts either. But when they see what happens, even with John Crosby and with the chamber music that Sheldon Rich has in Santa Fe—has that no impact? I had a letter yesterday from a woman who used to work on my staff at the Ford Foundation. She's down in Arizona, in Tucson. She says, what a wonderful theatre, except it only puts on safe plays, but it's a good theatre, well run by a manager named David Hawkanson, whom Mr. Zeisler and Mrs. Thompson, Marcia Thompson, respect, which is true. The only thing, the dance people would have to be imported at least for a little while; people want to have dance there, but there's nobody there. I thought, why doesn't Barbara Weisberger go out and talk to them? Now, this is Tucson. She's not talking about people in the arts. She's talking about people she's met. She's not an Arizonan.

Ms. Weisberger: I don't say the northeastern corridor, I surely don't say that. The worst lack of chauvinism is in Philadelphia, the worst. And if you're talking about New York, I didn't think that was so absolutely true, outside of dance, and even then dance has become decentralized. I think there's a great deal more civic pride in the Southwest than there is in the northeast corridor.

Urban Mecca

Mr. Erb: I can tell you one thing—take 98 of 100 American composers and they believe the only place in the United States to make a reputation is right here in New York. Very few people believe it's worthwhile to spend your life anywhere else.

Mr. Lowry: Wouldn't that be true of British composers going into London?

Mr. Erb: I suppose. Maybe I'm wrong, but it's a by-product of the communicative power of the New York *Times,* which reports, by and large, music done in New York by New Yorkers. I think that's what Zeisler was getting at. For the younger composers in this country, it makes New York a kind of Mecca that they think they all have to come to in order to prove themselves.

Mr. Schneider: The test in the arts is acceptance in New York City.

Mr. Erb: Right.

Mr. Zeisler: That's their view. I don't think that happens to be true.

Mr. Lowry: This doesn't keep everybody from working.

Mr. Zeisler: It sure as hell is hurting theatre right now. It's done more to stop the growth of serious theatre activity around the country, because the artists will not stay long enough; they don't get visibility there.

Ms. Weisberger: There are more complex problems in theatre than that, than the fact that they are there. It's about the whole idea of an ensemble continuity. Ensemble companies in theatre cannot have continuity, and why is it that way? Because actors are drawn away, not only to New York, but to television and into all other possibilities. So it's hard to build that kind of thing. There's more to it. It's not the entire thing. But it's part of the discipline and the problem. And that is certainly true in dance.

Mr. Lowry: In theatre it may be partly used as defensive, also, because those aren't the companies that vanish. Not many Theatre Communications Group members have vanished, have they, Peter?

Ms. Weisberger: But the actors do.

Mr. Lowry: Well, the companies would vanish if the actors wouldn't play there, wouldn't they? What have you lost? About twenty of the little so-called alternative theatres since 1980? Not many.

A Pop Culture Coup?

Mr. Erb: Mac, I want to try out an idea on everybody. Some people in my business actually think that the people who control pop music in this country have actively set out to sabotage everything else in the field. There's really a prevalent view that Warner Communications and the other big outfits have really set about to reduce the market for other things because their idea of the great American free enterprise system is to kill the competition.

Mr. Lowry: Let me try something: if the schools in the primary and secondary levels were doing their job, the guys who sell pop culture or manage pop artists would be managing and selling chamber music?

Mr. Schneider: Is it possible for chamber music to please the

majority of people in the country, to the same extent that a pop artist can?

Mr. Lowry: If the people were educated?

Mr. Erb: I don't mean to that extent, Mac. He's right.

Mr. Sachs: That's an elitist point of view and deserves to be answered by another, which is that in the eighteenth century chamber music was pop culture.

Mr. Lowry: I know.

Mr. Schneider: But there wasn't all the other stuff as competition.

Mr. Lowry: When I made the first grant in jazz, Mr. John McCloy said to one of the other members of the Ford Foundation board who didn't like the grant to jazz, he said, "You'd have been against chamber music in the eighteenth century."

But how shall we handle this issue that Don Erb keeps bringing up? Is pop culture as big a menace to all of these things as we're saying? Do we have to give it a real place among our issues?

Mr. Schneider: Sure, it's a menace. I don't believe in his conspiracy theory, but I believe it's a menace because of Gresham's law. I'm sorry.

Mr. Rathbone: Repeat Gresham's law.

Mr. Schneider: Bad money drives out good. And I don't see how you can avoid that, and I don't care. The theatre, to which I've devoted a large part of my waking hours, is always going to be a minority art, and it doesn't worry me in the slightest. If it gets to be a majority art, it's going to be just as bad as television.

Mr. Zeisler: There has to be an alternative. There is no alternative now. Everybody is not going to go to chamber music, but everybody's got to have the *opportunity* to get to chamber music.

Can Critics Help?

Mr. Sachs: There's one foundation, I believe, and I'm not up on the statistics, that's currently either thinking of supporting or is supporting training critics in the arts. I think it may be a viable avenue, because after ten years of trying, the Minneapolis newspaper has just hired, for the first time ever, a visual arts critic. In a city with a lot of artists, two major museums, and so on and so forth, they absolutely ignored it for generations. It happens that somebody well trained fell in their lap, and they took a flier, after

I think also a lot of pressure. I think the idea was mentioned by Don about exposure, and encouraging people to think it's okay . . .

Mr. Lowry: To expose the critics?

Mr. Sachs: The critics will expose the populace.

Mr. Lowry: After the critics are what? Trained?

Mr. Sachs: Yes, after they become hired, let's say, trained and hired.

Mr. Lowry: Now, we have ten minutes. Does anybody have a few words of wisdom to drop on us? Sam?

Education Still Basic

Mr. Sachs: Well, there's certainly been a lot of wisdom dispensed here today. I still am stuck with the impression that our national policy does not coincide with our statements of purpose, if indeed one of our statements of purpose as a nation is to promulgate the arts and value them, then the national policy for their support seems to be in some disarray.

Mr. Lowry: Do you mean federal?

Mr. Sachs: I mean national, the works. I believe that there probably is more specific policy, the finer you hone the blade, and as you get down to the individual, there may be a very clear policy on a per person basis, where people are willing to put their dollars into something that they belong to, or they support. In trusteeship we talk about the three W's: work, wisdom, or wealth. It used to be only one of those, wealth, that was looked for. We seem sorely lacking in wisdom these days in many quarters, and work is probably increasingly hard to come by as well. I'm intrigued with the aspect that addresses both the proliferation of information about the arts, as a method of promotion policy, and also encouragement within the educational institutions. I think both of these are lacking.

New Paths for Institutions

Ms. Weisberger: I may want to reiterate without apology the problems of institutions and of the arts within institutions which seems to be my personal cause these days. It isn't that I am completely sanguine about the art and the artists. I think they will persist and they will continue to do, out of their own necessity and

out of their own sense of purpose and commitment. I am concerned about the life of the art and of the artist within the institution, and I feel we will find no answers if we huddle together and commiserate, which is the proper word, and don't open our minds to all the possibilities that might be new and strange and even frightening. It might be the only way that our true purposes can perpetuate.

The Use of Television

Mr. Erb: That's a beautiful opening to what I want to say. Actually I want to go back to one thing we didn't maybe talk about too much, and still something interesting, very hard to be understood. Mr. Rathbone said something, I think, that will help. He was talking about the time when the Kennedy's were in office and the things that happened in the country then. And I think one of the reasons that the arts enjoyed a brief period of sort of unparalleled prosperity after the President was killed was not only did the arts issue from the Kennedy Center, which was prestige, but also on television all the time, and they had great visibility. I think that we can have a bigger share of what's out there than we're getting now, and one of the ways to do it is to find ways to use that medium better.

Stimulation of Public Debate

Mr. Rathbone: I've been very impressed by the wisdom, knowledge, and experience that have been expressed at this table, and the conviction that we all arrive at without any difficulty, that is a major overriding conviction. Isn't there some way that we can devise or suggest to make this conviction heard in this country? I don't like to give up on that idea. It seems to me that there is some means, with the present organization in the U.S., perhaps, to do that. And I'm thinking in terms of the states arts councils.

They might awake to an idea if we could see to it that it was properly expressed and spread around, so they would make known this conviction, perhaps through the two Endowments, the Arts and the Humanities, to the two presidential candidates who appear, that the value of the arts to society is a very widespread

conviction of the people of the United States, that they are looking for leadership in the field to whoever takes the Presidency. It seems to me that maybe the moment is here, and perhaps the candidates will recognize it, and maybe even the media would like to publicize the idea that there is a real desire amongst thinking Americans that our national policy should be more involved with artistic existence.

The Arts and National Purpose

Mr. Schneider: I've always been more impressed with an eloquent or expressive painting of an ashcan than with a superficial illustration of a rose bush. And so the fact that we've had a lot of pessimistic or critical visions of the situation, far from depressing me, has made me more anxious than ever to continue our discussion. I always feel at the end of a day like this that I'm more stimulated by people's energy than I am by their pessimism. And I think that's a good thing. I'm looking forward to continued discussion. I've been carrying around all day this little quote from JFK, and I showed it to Tom Leavitt, and I'm going to get it on the record no matter what. You can elide it later, Mac, but it always impressed me. I don't know where I got it.

Kennedy said, "The life of the arts, far from being an interruption, a distraction in the life of a nation, is very close to the center of a nation's purpose, and is a test of the quality of a nation's civilization."

If we can get that attitude felt deeply by our leadership and by our populace, then we'll have no need for future discussions of this kind. In the meantime, I'm delighted to have been part of it.

Focus on the Professional

Mr. Leavitt: I think the most crying need is for a kind of consensus, which would not be a federal policy or a national, but felt by a broad group of people. However, from my point of view it should be focused primarily on the professional arts in the country, the search for excellence in the arts, not the avocational needs, which I'm afraid might happen if we turn to the arts councils for the composition of a national forum.

The central problem, as I see it, is this enormous gulf between

the cost of artistic production and what the public, as individuals, can be expected to pay to participate. And that can only be resolved if there is a national or public policy that recognizes the seriousness of the arts and proposes ways to cope with that gulf.

Mr. Lowry: I'm very grateful to all of you.

W. McNeil Lowry

6
Conclusion

In American history social goals have begun with individual citizens or in voluntary associations and moved across a wide spectrum of greater and greater organization. When they finally have reached a point on the tax rolls, they have become objects of public policy. *How* to support the goals continues to provoke controversy and changes frequently, but support for them in some fashion is accepted. In the alleviation of suffering, health, social welfare, science, medicine, education, the humanities, and the arts—each of these fields is still a complex of private and public support in vastly different proportions one to another. (Religious benefactions thus far have been the exception.) A more analytical public policy about the arts, in short, cannot be confined to the question of financial support by public agencies, and the arts constituency will continue to founder if it ignores this principle.

In Summary

This volume has addressed many issues, but it has been basically organized along the wide spectrum pointed to, which for the arts at least has also chronological sequence—voluntary societies and private patrons, foundations, corporations, and government. Along the way the influence of these sectors on marketing and the marketplace for the arts has been considered. Mr. Rathbone, writing in chapter 3 about a privately founded institution which early assumed a public role—the museum of fine arts—tends more than the other authors perhaps to equate "public"

with "government." (Note his reference to "the public policy of New York City.")

Though often in general terms, the pluralistic components of public policy are thus fairly well covered. And the key issues and current problems facing the development of the arts are to be found somewhere in the exposition. But it remains for the editor to emphasize that one of the greatest of these could have been left badly underplayed were it not for the colloquies in chapter 5. I refer to the influences of the mass media and of slackening educational standards.

THE DILUTION OF STANDARDS

As Mr. DiMaggio reminds us in chapter 4, P. T. Barnum knew very well how to popularize his exhibits and extract the greatest commercial return from advertising them. But even Barnum would have been shocked if his young contemporary, Colonel Higginson, had used the same methods in promoting the Boston Symphony. Perhaps some of his customers drew no distinction between Jenny Lind and Tom Thumb, but Barnum did.

As emerges in many observations by the members of the symposium, motivation and governance threaten the stability of arts institutions even more than do the difficulties of financing. But what attracts the press and television to the arts, save for a few individual critics, is their role as entertainment and the manufacture or recognition of celebrities. The public schools seem often to feel they are doing their bit if they play this same theme in amusing their students. American publishers and editors are extremely sensitive to the charge that they are concerned only with entertainment, for they think one is saying the paper is dominated by its advertisers. The trouble is not with the advertising managers but with the editors who decide where and in what vein to print any coverage of the arts. For the past several years, even the proudest of our dailies choose "Leisure" or "Style" to denote the vein.

DISPERSAL OF GOALS

Artists and the arts will survive all this, and as Howard Johnson, one of the symposium members, notes, they have survived worse. But more particularly the question here is about influences

on public policy, and the steady generalizing and blurring of criteria by the media now intensify other attitudinal changes. One is the easy temptation of public agencies including the National Endowment to proliferate programs and disperse funds so far that they end up treating welfare, community, and sociological ends equally with aesthetic or professional objectives. Another is the amassing of corporate and government funds in blockbuster exhibits or performances so that the sheer numbers in the audience take precedence over what is shown or the contributions of artists. "Have we got a hit?" Mr. Zeisler in chapter 5 reports corporate foundation officers asking him.

In his most recent (Spring 1984) document prepared for the House Appropriations Committee, NEA Chairman Frank Hodsoll does not address this question at all, but through another avenue comes closer to the criteria of art than to those of entertainment.

The NEA planning report states:

> There is concern that financial stability [of the performing arts] is being achieved at the expense of the art form. This includes popularizing to increase earned income, insufficient numbers of performers to perform the full range of repertoire, less rehearsal time in relation to performances . . . greater emphasis on guest stars and too great emphasis on product as opposed to process in artistic creation. There is never enough money. The perfection of art requires experimentation, failure as well as success, attention to quality in every detail.

THE HEART OF THE MATTER

It would be heartening to think that the National Endowment will hereafter be enlisted in support of the artistic process as a key federal objective. Such a conclusion is of course premature. But there may be gains in some quarters in the terms for debate. Professor Katz, concluding chapter 2, writes, "There is an inevitable tension between high culture and democracy, and as cultural policy moves from the domain of the private, the elite, and the artist to that of public and popular taste, there will almost certainly be impacts upon the artistic process itself." For Professor Katz, at least, there is a safeguard in what he calls "the first lesson," which is that to have no national policy is to *have* a policy: "That policy, in other words, means that we have made a decision (this going far back in our history) to leave to private and local institutions the determination of the decisions most

Index

overtly affecting the creation and conduct of cultural institutions."

This diversity of voluntary societies (which include our non-profit institutions in the arts) at least to date, Professor Katz says, has "interconnections between public and private . . . so complex and so intimate that it makes little sense to try to polarize our understanding of the policy-making process."

It is worth noting that the first priority on which there was unanimous agreement in the symposium reported in chapter 5 was that given to intrinsic values in the arts. Near the end of his life Henry James wrote to H. G. Wells, "It is art that *makes* life, makes interests, makes importance . . . and I know of no substitute whatever for the force and beauty of its process." But as Mr. Leavitt emphasized in the symposium, this essential preoccupation with the aesthetic by no means obviates any public policy about the arts:

> The experience itself is valued, I think, and by broad groups of the public. However, that doesn't mean that any work of art contains only intrinsic values. There's no such thing as a work of art that doesn't refer outside itself. And so the arts and the presentation of the arts are in themselves political and social.

FINAL REPORT
of the
SIXTY-SEVENTH AMERICAN ASSEMBLY

At the close of their discussions the participants in the Sixty-seventh American Assembly, on *The Arts and Public Policy in the United States,* at Arden House, Harriman, New York, May 31-June 3, 1984, reviewed as a group the following statement. This statement represents general agreement; however, no one was asked to sign it. Furthermore, it should not be assumed that every participant subscribes to every recommendation.

PREAMBLE

The arts have been moving toward a more central place in our national priorities. Some significant steps remain to be taken before this goal is fully realized. The people of the United States—and not merely the artists and the institutions in the arts—need a more clearly understood public policy. American artists, in their role as citizens, may have no more urgent mission than to take leadership in analyzing and expressing that policy.

Public policy in the arts has its roots deep in our history. These roots are found in a mix of private and public influences coming from the artists themselves, from the voluntary societies they use as instruments, and from the sources of patronage—private individuals, foundations, corporations, and now three levels of government.

The participants in this Sixty-seventh American Assembly—artists, managers, official and lay leaders—find this mix of private and public influences desirable. It encourages the great diversity of the arts in a large and complex country. It provides for the decentralization of judgment, choice, and expression. It makes possible development of the new and the experimen-

tal. The more we have examined them, the more plainly do our country's policies in the arts reflect the pluralism and diversity in which our society evolved.

In the diverse sources of patronage in the arts, we find also the best protection from the possibility of outside interference or control. We continue, therefore, to be heartened by the many voices in the society giving increased attention to the artists and to the needs of artistic organizations and groups. Clear public understanding of the central place of the arts is more important than any official national policy or any predetermined ratios in the mix of private and public support.

There are many reasons for this view. The United States is a long way from reaching the limits of private or public patronage. Greater support must be motivated by the needs inherent in the artistic process and by the financial needs of artists and of institutions. An increasing tendency in arts institutions and funding sources to rely upon earned income to bridge the gap between income and expenses risks compromising the artistic process.

The arts constitute one of America's great underused and vital resources. The insight and inspiration that our composers and musicians, our poets and novelists, our playwrights and actors, our choreographers and dancers, our painters, sculptors, architects, and photographers, our media artists, and others provide in our society are only a fraction of what would be possible if sufficient means were available.

Sources of funding for the arts inevitably exert considerable influence in the formation of a public policy on the arts. The nature and extent of support from governmental units, foundations, corporations, and private patrons help determine public awareness of and participation in the arts. But other influences are equally important: the attitudes of national leaders, the extent and quality of media attention, the values underlying the educational system, and the dynamics of the marketplace.

The most important of all influences on policy begins with the artistic impulse itself. The arts function in the national interest as a recorder of history and experience and as a force illuminating the human condition. The participants in this Sixty-seventh Assembly give conscious weight to the social, political, and economic uses of the arts, but we find the greatest priority in the intrinsic value of art itself.

FINDINGS AND RECOMMENDATIONS

1. We view with admiration the European traditions of funding in which governments have historically made strong public commitments to the arts, but as the arts in the United States have matured we find that the dynamic relationship between public and private funding sources is more suited for the development of creativity and talent throughout our own diverse and plural society.

2. One of the keys to public policy in the arts is in the hands of the daily and periodical press and particularly the large urban newspapers widely syndicated across the country. The growing tendency for even the most noted of these to treat the arts predominantly as "entertainment," "leisure," or "style" often inhibits any real insight into the primary questions of private or public policy or even questions of the development of careers of artists.

3. Appreciation of the arts is by and large developed through the educational system. The beginnings of attitudes and opinions about the importance of the arts have the same locus. We cannot hope to establish the centrality of the arts to this society or their value to the individual without a clear recognition of this fact. More support for the arts in education is needed, especially at the local level.

4. The goal of universal access to and availability of the arts is an essential component of a public policy in the arts. We

recommend that, whenever feasible, lower admission prices, more even distribution of arts facilities, and greater recognition of minority art forms all be encouraged.

5. The mechanism of the nonprofit corporation remains today, as it has for seven decades, inseparable from the institutional life of the arts in this country. It is grounded in the recognition by federal and state governments that art as an exercise in aesthetic inquiry, performance, and exhibition is inherently deserving of tax exemption. In the life of nonprofit arts organizations, the "bottom line" should be defined as the value placed on the quality of the artistic experience.

6. We have recognized that the artist must be more central in the formulation of public policy in the arts. To equip the artist and other spokespersons with information for this increased role, the arts service organizations should be encouraged to provide facts, figures, and information about government, foundation, and corporate programs.

7. The federal government has expressed its commitment to the arts in the law establishing the National Foundation on the Arts and the Humanities. It is recommended that the ideas contained in that document be extended to a broad range of federal agencies for valuable social, educational, and economic programs involving the arts.

8. While recognizing the critical importance of autonomy and diversity in the philanthropic programs of private and corporate foundations, we are hopeful that more systematic exchanges of information can help to guide their actions.

9. The efficient management of the nonprofit organization must not divert its artistic objective, which must remain the province of the artistic director. An understanding of the fiduciary responsibilities of the trustees is essential for the director and artistic personnel, while genuine sensitivity to the creative goals of the artists on the part of the trustees is absolutely vital. It is urgent that each element of the organization guard

against the erosion of high quality of performance and the integrity of the artistic process. A collaborative relationship in the structure allows for growth and development of the art to which the institution as a whole is devoted.

10. We are only beginning to experience the range of forms and shapes in which sight and sound can be electronically delivered. We hope that artists, managers, and other sources of policy in the arts will take the utmost advantage of the radical changes in the media and in new information systems. But of equal importance is the imperative need to support the primacy of direct access to live performing and exhibiting spaces.

11. Public television and radio are prime sources of dissemination of the arts. They also advance the art of the media themselves. If they are to survive, the government must assist in their support. We recommend speedy restoration of federal funding for the Corporation for Public Broadcasting (CPB) and Public Broadcasting Service (PBS). We also encourage an emphasis on regional programing.

12. A fairly common deficiency of arts groups is the absence of a clear statement of purpose and a long view, both artistically and financially. Planning is an important function, but too often financial planning by trustees and managers extends only to the annual rush to close the earnings gap. A more appropriate focus would be multiyear budgets and long-range plans for both arts organizations and funding sources.

13. The record of the National Endowment for the Arts and of state arts agencies in avoiding political interference in funding decisions has been good. Recent incidents, however, remind us that constant vigilance on this point is necessary to discourage any interference, especially in the support of artists and of artistic groups presenting art with social or political content.

PARTICIPANTS
THE SIXTY-SEVENTH AMERICAN ASSEMBLY

ARTHUR G. ALTSCHUL
Member, National Board
Smithsonian Institution Associates
Washington, D.C.

ALBERTA ARTHURS
Director for Arts & Humanities
The Rockefeller Foundation
New York, New York

STEPHANIE BARRON
Curator of Twentieth Century Art
Los Angeles County Museum of Art
Los Angeles, California

CHARLES BENTON
Chairman
Public Media Inc.
Wilmette, Illinois

ALAN L. CAMEROS
Chief Executive Officer
Flanigan's
Rochester, New York

SCHUYLER CHAPIN
Dean
School of the Arts
Columbia University
New York, New York

MARGARET COX
Executive Director
The Coca-Cola Foundation
Atlanta, Georgia

PHYLLIS CURTIN
Dean
School for the Arts
Boston University
Boston, Massachusetts

KENNETH DAYTON
Oakleaf Associates
Minneapolis, Minnesota

LAURA DEAN
Founder & Artistic Director
Laura Dean Dancers & Musicians
New York, New York

PAUL DIMAGGIO
Executive Director
Program on Nonprofit Organizations
Yale University
New Haven, Connecticut

MARCIA DUE
Photographer
Amenia, New York

LYMAN FIELD
Past Chairman
Missouri State Arts Council
Kansas City, Missouri

OFELIA GARCIA
Director
The Print Club
Philadelphia, Pennsylvania

DONALD R. GREENE
Secretary
The Coca-Cola Company
Atlanta, Georgia

JAMES HINDMAN
Assistant Director
The American Film Institute
The John F. Kennedy Center for the
 Performing Arts
Washington, D.C.

IAN HORVATH
Founding Artistic Director
Cleveland Ballet
Cleveland, Ohio

SARAH HUTCHISON
Program Officer
Hall Family Foundations
Kansas City, Missouri

C. BERNARD JACKSON
Executive Director
Inner City Cultural Center
Los Angeles, California

JOAN JEFFRI
Adjunct Professor
Program in Arts Administration
School of the Arts
Columbia University
New York, New York

† HOWARD JOHNSON
Chairman Emeritus
Massachusetts Institute of Technology
Cambridge, Massachusetts

† PHILLIP JOHNSON
Partner with
John Burgee Architects
New York, New York

JON JORY
Producing Director
Actors Theatre of Louisville
Louisville, Kentucky

*Discussion Leader
†Delivered Formal Address

ANNA KISSELGOFF
Chief Dance Critic
The New York Times
New York, New York

* THOMAS LEAVITT
Director
Herbert F. Johnson Museum of Art
Cornell University
Ithaca, New York

JOHN LION
General Director
Magic Theatre
San Francisco, California

W. MCNEIL LOWRY
New York, New York

MICHELLE LUCCI
Principal Dancer
Milwaukee Ballet Company
Milwaukee, Wisconsin

ROBERT F. LYKE
Specialist in Education
Congressional Research Service
The Library of Congress
Washington, D.C.

RUTH MAYLEAS
Program Officer
Education & Culture Program
The Ford Foundation
New York, New York

ROBERT MILLER
Chairman
Alaska State Council on the Arts
Anchorage, Alaska

RICHARD MITTENTHAL
Vice President, Program
The New York Community Trust
New York, New York

** DONALD A. MOORE
Executive Director
Dance/USA
Washington, D.C.

HENRY MORAN
Executive Director
Mid-America Arts Alliance
Kansas City, Missouri

CHARLES PARKHURST
Codirector
Williams College Museum of Art
Williamstown, Massachusetts

PERRY T. RATHBONE
Senior Vice President & Director
Museums Liaison
Christie, Manson & Woods
International, Inc.
New York, New York

DEBORAH REMINGTON
Artist
New York, New York

SAMUEL SACHS II
Director
The Minneapolis Institute of Arts
Minneapolis, Minnesota

J. MARK DAVIDSON SCHUSTER
Assistant Professor
Department of Urban Studies
& Planning
Massachusetts Institute of Technology
Cambridge, Massachusetts

ELEANOR BERNERT SHELDON
Former President
Social Science Research Council
New York, New York

ANA STEELE
Associate Deputy Chairman for
Programs & Director of Program
Coordination
National Endowment for the Arts
Washington, D.C.

** HOWARD STEIN
Chairman
Oscar Hammerstein II Center for
Theatre Studies
School of the Arts
Columbia University
New York, New York

ROGER STEVENS
Chairman
The John F. Kennedy Center for the
Performing Arts
Washington, D.C.

** WILLIAM STEWART
Managing Director
Hartford Stage Company
Hartford, Connecticut

ELIZABETH SWADOS
Composer & Playwright
New York, New York

ARNOLD SWARTZ
Past Chairman
Texas Commission on the Arts
San Antonio, Texas

MARCIA A.T. THOMPSON
President
National Arts Stabilization Fund
New York, New York

VERONICA TYLER
Soprano
Metropolitan Opera
Baltimore, Maryland

* Discussion Leader
**Rapporteur

STERLING VANWAGENEN
Executive Director
Sundance Institute for Film & Television
Salt Lake City, Utah

ESTEBAN VICENTE
Artist
Bridgehampton, New York

THOMAS WALTON
Coordinator of History & Theory
Department of Architecture & Planning
The Catholic University of America
Washington, D.C.

RUTH WEISBERG
Professor
School of Fine Arts
University of Southern California
Los Angeles, California

* BARBARA WEISBERGER
Founder & Director Emeritus
Pennsylvania Ballet
Kingston, Pennsylvania

DAVID R. WHITE
Executive Director & Producer
Dance Theater Workshop
New York, New York

JESSIE A. WOODS
Honorary Chairman
Urban Gateways
Chicago, Illinois

PETER ZEISLER
Director
Theatre Communications Group Inc.
New York, New York

* Discussion Leader

ABOUT THE AMERICAN ASSEMBLY

The American Assembly was established by Dwight D. Eisenhower at Columbia University in 1950. It holds nonpartisan meetings and publishes authoritative books to illuminate issues of United States policy.

An affiliate of Columbia, with offices in the Sherman Fairchild Center, the Assembly is a national, educational institution incorporated in the State of New York.

The Assembly seeks to provide information, stimulate discussion, and evoke independent conclusions on matters of vital public interest.

American Assembly Sessions

At least two national programs are initiated each year. Authorities are retained to write background papers presenting essential data and defining the main issues of each subject.

A group of men and women representing a broad range of experience, competence, and American leadership meet for several days to discuss the Assembly topic and consider alternatives for national policy.

All Assemblies follow the same procedure. The background papers are sent to participants in advance of the Assembly. The Assembly meets in small groups for four or five lengthy periods. All groups use the same agenda. At the close of these informal sessions participants adopt in plenary session a final report of findings and recommendations.

Regional, state, and local Assemblies are held following the national session at Arden House. Assemblies have also been held in England, Switzerland, Malaysia, Canada, the Caribbean, South America, Central America, the Philippines, and Japan. Over one hundred forty institutions have cosponsored one or more Assemblies.

Arden House

Home of The American Assembly and scene of the national sessions is Arden House, which was given to Columbia University in 1950 by W. Averell Harriman. E. Roland Harriman joined his brother in contributing toward adaptation of the property for conference purposes. The buildings and surrounding land, known as the Harriman Campus of Columbia University, are fifty miles north of New York City.

Arden House is a distinguished conference center. It is self-supporting and operates throughout the year for use by organizations with educational objectives. The American Assembly is a tenant of this Columbia University facility only during Assembly sessions.

NOW ... *Announcing these other fine books from Prentice-Hall—*

The Future of American Political Parties: The Challenge of Governance
edited by Joel L. Fleishman (paper $6.95, hard cover $14.95)

Technological Innovation in the '80s
edited by James S. Coles (paper $6.95, hard cover $12.95)

Youth Employment and Public Policy
edited by Bernard E. Anderson and Isabel V. Sawhill (paper $5.95, hard cover $11.95)

The Farm and the City: Rivals or Allies?
edited by Archibald M. Woodruff (paper $5.95, hard cover $12.95)

The Economy and the President: 1980 and Beyond
edited by Walter E. Hoadley (paper $5.95, hard cover $11.95)

The China Factor: Sino-American Relations and the Global Scene
edited by Richard H. Solomon (paper $5.95, hard cover $13.95)

To order these books, just complete the convenient order form below and mail to **Prentice-Hall, Inc., General Publishing Division, Attn. Addison Tredd, Englewood Cliffs, N.J. 07632**

Title	Author	Price*
	Subtotal	
	Sales Tax (where applicable)	
	Postage & Handling (75¢/book)	
	Total $	

Please send me the books listed above. Enclosed is my check ☐ Money order ☐ or, charge my VISA ☐ MasterCard ☐ Account #_____

Credit card expiration date _____

Name _____

Address _____

City _____ State _____ Zip _____

Prices subject to change without notice. Please allow 4 weeks for delivery.